Paint Watercolors Filled With Life and Energy

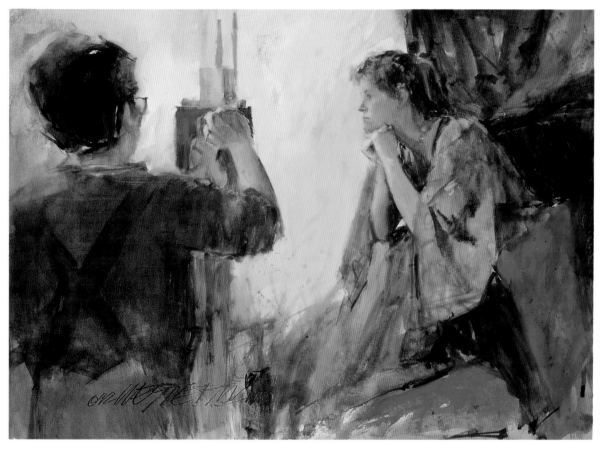

Kobayashi Paints the Model, 20″ × 28″

Arne Westerman

NORTH LIGHT BOOKS

CINCINNATI, OHIO

ABOUT THE AUTHOR

Arne Westerman is a people-watcher who paints people as if they were his friends, with warmth, understanding and not a little humor. His subjects live in London, New York, Portland, San Francisco, Amsterdam and anywhere in between. They are everything and anything from street people to ballet dancers. They are waiting, loving, arguing, reading, eating, sleeping, and they are all colorful and thought-provoking and they come alive in his paintings.

From a love of cartooning as a child to a degree in Journalism, to a first career running an advertising agency to a second career as a figurative painter, he has come full circle. Although largely self-taught, he has studied with Charles Reid, Sergei Bongart and other leading painters.

Artist and teacher, Westerman is a member of the National Watercolor Society, the Northwest and the Oregon Watercolor Societies. He has won a number of grand prizes and other awards in juried exhibitions and is featured in many one-person shows. His paintings are in public and private collections throughout the US.

Westerman makes his home in Lake Oswego, Oregon with his wife, Judy, two Himalayan cats, two finches (Martha may be expecting), some fish and a frog who is never seen but often heard.

Paint Watercolors Filled With Life and Energy. Copyright © 1994 by Arne Westerman. Printed and bound in Hong Kong. All rights reserved. No part of this book may be reproduced in any form or by any electronic or mechanical means including information storage and retrieval systems without permission in writing from the publisher, except by a reviewer, who may quote brief passages in a review. Published by North Light Books, an imprint of F&W Publications, Inc., 1507 Dana Avenue, Cincinnati, Ohio 45207. 1-800-289-0963. First edition.

98 97 96 95 94 5 4 3 2 1

Library of Congress Cataloging-in-Publication Data

Westerman, Arne
 Paint watercolors filled with life and energy / Arne Westerman.
 p. cm.
 Includes bibliographical references and index.
 ISBN 0-89134-559-0
 1. Watercolor painting—Technique. 2. Watercolor painting—Psychological aspects. I. Title.
ND2420.W42 1994
751.42'2—dc20 94-700
 CIP

Edited by Rachel Wolf
Interior Design by Sandy Conopeotis
Cover Design by Sandy Conopeotis
Cover Illustration by Arne Westerman

METRIC CONVERSION CHART

TO CONVERT	TO	MULTIPLY BY
Inches	Centimeters	2.54
Centimeters	Inches	0.4
Feet	Centimeters	30.5
Centimeters	Feet	0.03
Yards	Meters	0.9
Meters	Yards	1.1
Sq. Inches	Sq. Centimeters	6.45
Sq. Centimeters	Sq. Inches	0.16
Sq. Feet	Sq. Meters	0.09
Sq. Meters	Sq. Feet	10.8
Sq. Yards	Sq. Meters	0.8
Sq. Meters	Sq. Yards	1.2
Pounds	Kilograms	0.45
Kilograms	Pounds	2.2
Ounces	Grams	28.4
Grams	Ounces	0.04

DEDICATION
To my family . . .
my mother, Sonia
and my father, Simon
(who should have been an artist)

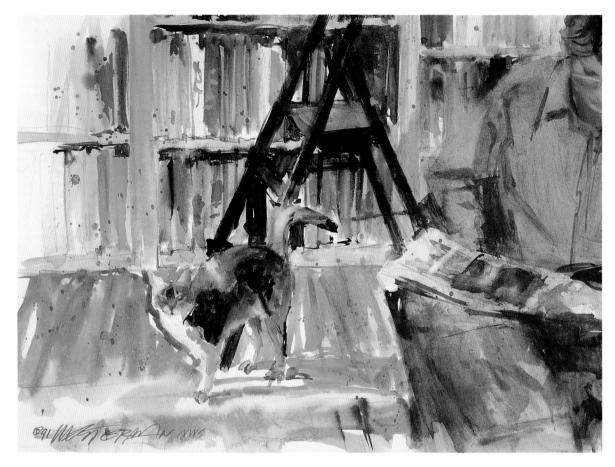

Book Store Cat, 13″ × 18″

I want to thank my wife, Judy, who patiently and eagerly offered comments and shared thoughts that were instrumental in creating this book. My editors were Rachel Wolf, Kathy Kipp and Anne Hevener. Thanks especially to Rachel for her ideas and efforts and for believing in me enough to wait this book out. Thanks also to George Hamilton, a truly dedicated artist and a wonderful teacher. My being an artist started with him. Judy Gehman made valuable suggestions like scrapping some of my sillier stuff, and Dee Frank cleared up some of the mystery of building a book.

And special thanks to Zantman's Galleries, San Francisco and Carmel, the Attic Gallery in Portland, and to my other galleries and my many collectors for their encouragement and for keeping me in business long enough to learn to write a book; to my students, who taught me as much as they learned from me; to my models, sung and unsung; to Meier and Frank Co., Portland's largest department store, which gave me free rein for material; and to Ballet Oregon, Neubert Ballet company, New York, and to those other schools and companies who kindly opened their doors to me.

Table *of* Contents

Successful paintings express *feelings*. I think paintings without emotional content aren't worth the paper. Clever technique alone has little lasting value. Superficial dash and sparkle fade pretty rapidly in interest.

A clumsily rendered piece with feeling is far more exciting and last-

Introduction

*Why you have to feel it
to paint it successfully*

ing. You can see the artist in it. That's what I want to talk to you about. I want to show you how you can follow your feelings to more successful paintings—works that express moments in your life frozen in time. Their content and approach will have meaning for you and evoke an emotional reaction that connects with your viewer.

The feelings you express in your work may or may not be shared in exactly the same way by your viewer. The effect on him depends on his own experience. But you must put your passion in to stir up an emotional connection.

For example, I remember painting a scene of a child, an immigrant just off the ship, with a small bag containing all his worldly possessions. He was all alone and bewildered.

A model who often posed for me saw it and wanted to buy the painting because, "He looks like such a happy newspaper boy." When I explained the painting, she changed her mind because she didn't like sad

paintings.

Moral: Leave the interpretation to your viewer unless invited to offer your verbal input.

LEARNING MORE THAN JUST PAINTING

I was fifty when I discovered watercolors. I had always loved to cartoon but never did much with it. After many years in another profession, I took my first watercolor class in 1977 with George Hamilton. The first leg of my journey to make a life as an artist started with that class. I wanted to create something permanent—something that would last long after I was gone. Perhaps, a way to cheat death.

George taught me more than just painting. He taught me to accept failure as part of the game. I would watch demonstrations get away from him and tell myself that even experts make mistakes and I didn't have to worry about being perfect. That's why I paint in a style that allows plenty of flexibility and why I devote a chapter in this book to ways you can get back on track when problems leave you frustrated or even comatose.

After all, everything we do is being done for the first time. We have to try constantly to expand our limits, and that exposes us to success as well as failure. But, we learn from mistakes, not by playing safe. Fear of making mistakes leads to timidity.

HOW I WENT FROM BARNS TO BEDROOMS

As a beginner in watercolors, I learned landscapes, but they didn't have the same emotional impact on me as the figurative work I enjoyed seeing in museums, galleries and art books. I knew I wanted to be a figurative painter, and that led me to study with Charles Reid, Sergei Bongart, Bill Reese, Milt Kobayashi, Alex Powers, David Leffel and many others.

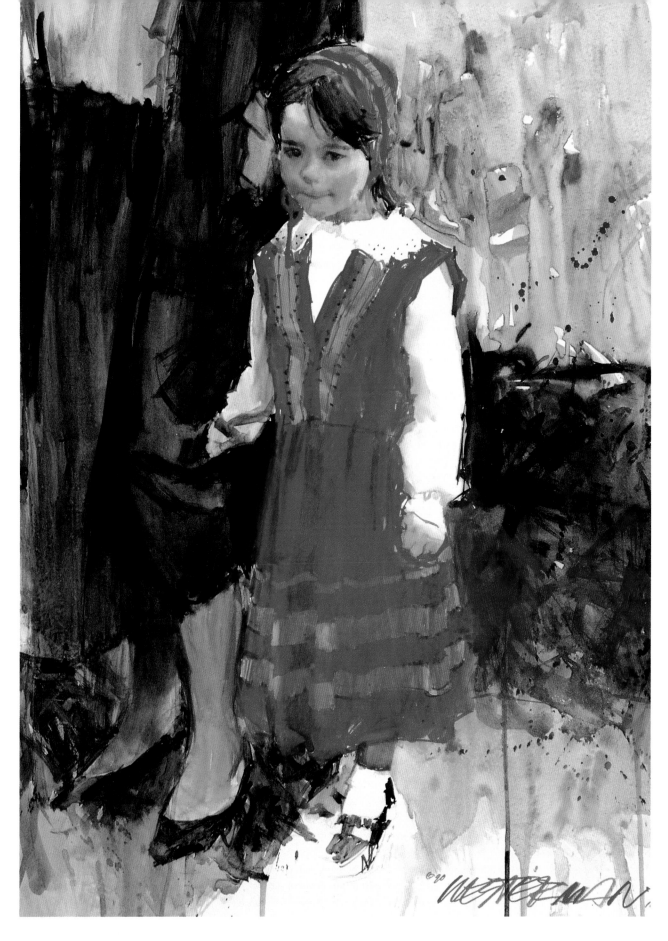

Brittany Child, 28" × 20"
My emotional connection is transmitted by the child holding her mother's leg to make sure she won't get lost. Isn't the fear of being lost universal?

So, this book is about painting people. My backgrounds may be city streets, or gardens, or ballet studios or whatever. But it's all supporting material. People are my stars.

RULES THAT ARE MADE TO BE FORGOTTEN

Watercolors aren't really nature's most demanding medium. All mediums are demanding, none more than another. But watercolors can seem scary when books on the subject insist we "not waste a stroke," "avoid ouzles," "always work light to dark," and that "you never get a second chance."

I think that most of those "rules" aren't really valid with today's papers and paints, and I'll talk about that in chapter fourteen. I think the act of creation is demanding enough without having to worry needlessly about the medium.

Actually, I found out that watercolors are pretty forgiving, especially the way I paint. I'll show you how, which might make your life a little easier. I'll also show you in chapter five that the most common problem artists have is not technique but design.

This book won't teach you how to draw. I'm guessing you already do that well enough, but I may suggest a book or two to help you sharpen

that skill. Just one word on the subject: It doesn't matter what your drawing style — abstract, naive, stylized or realistic — as long as it represents your feelings. The material I want to present to you will help you make that drawing come alive with watercolor.

I'll show you how to find the scenes that mean something to you, then a way of expressing them. You'll learn to work progressively so that by the time you start a painting, you've solved almost all the problems you're likely to encounter.

A clumsily rendered piece with feeling is far more exciting and lasting. You can see the artist in it.

One last thing. This book is easy enough even for *me* to understand, so you have no excuses. There are plenty of illustrations for everything and not too many abstract thoughts. My mother always said, "I'll give you a *for instance*." So, I'll also give you plenty of "for instances."

This book is not the last word on watercolor painting. It just shows you how, why, when, who and what I know (or remember) and paint. It's pretty much how I would teach you in a workshop, and I hope it will give you some ideas you can use and that get you excited.

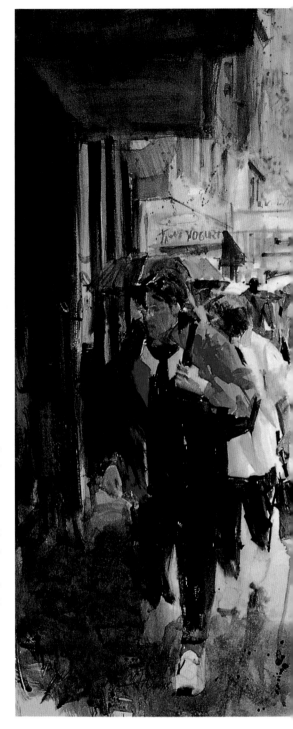

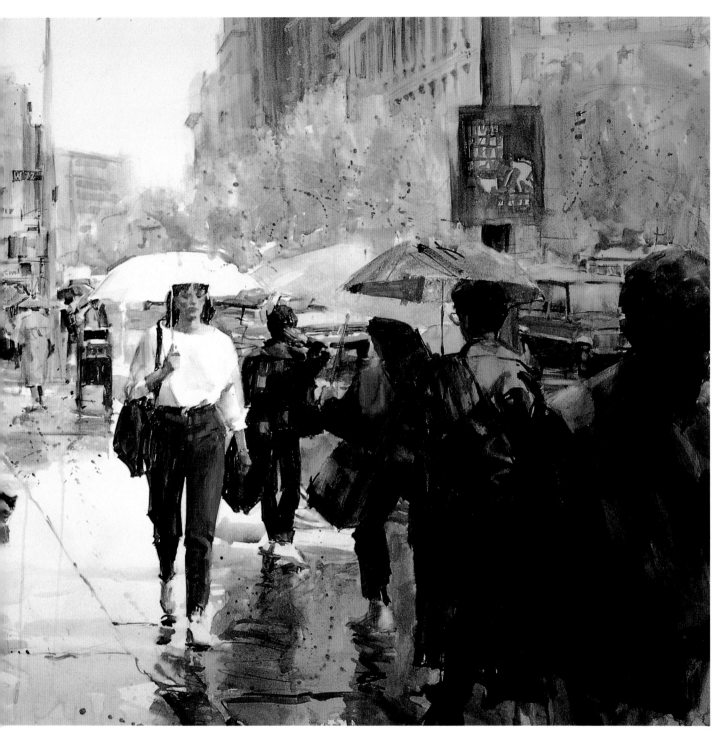

West 72nd Street, Spring Rain, 32" × 42"
A heavy downpour might feel ominous, but this scene radiates my pleasant feelings. You can tell that this is a warm rain by the light costume of my central character, and the airiness surrounding her is strengthened by the strong dark shapes at each edge.

Lizzie With Bandana, 10" × 14"

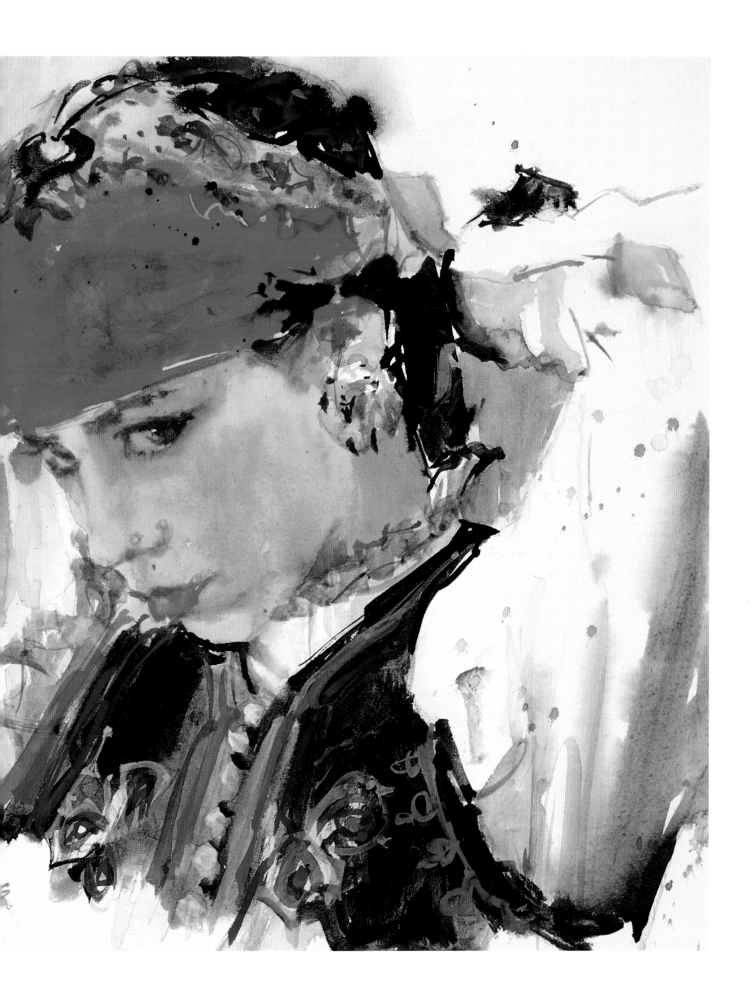

Exploring Yourself

and what connects you to your subject matter

"What makes me so special?" That's what I had to ask myself when I decided to try to make a living as an artist. Here were all these great artists, and many of them much younger than I. They were already good, and I was starting so late. What did I have going for me?

I said I was special because I was older (always use your advantages). I had seen more of life, and therefore felt I could decipher the feelings of my subjects better than they. And I have found that's usually true. My life experiences help me make emotional connections my viewers can feel in my paintings. That has been in large measure a source of my success.

I concluded then, that the more you know about people, and the longer you've been on this earth and had life experiences, the better figurative painter you will be.

Robertson Davies, in *A Mixture of Frailties*, has one of his characters say, ". . . people like you and me — interpretative artists — have to learn to recapture . . . feelings, and transform them into something which we can offer to the world in our performances." I believed that I did just this, and that all good artists needed to have many life experiences in order to transfer their emotions onto paper.

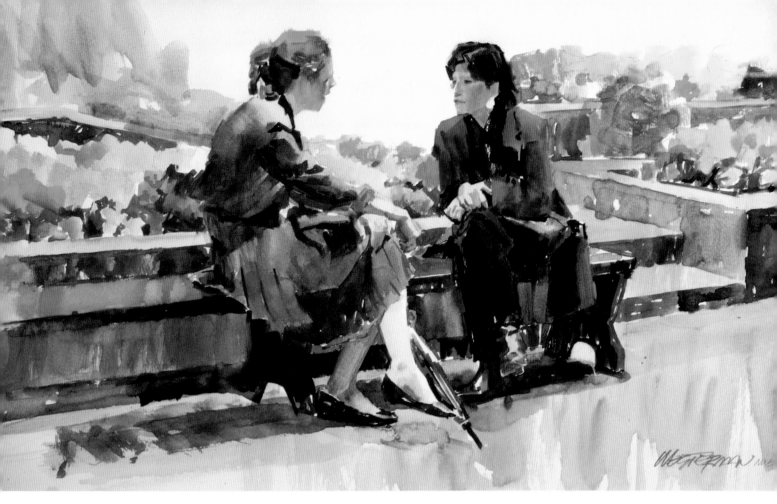

Flowers Never Tell, 16½" × 26"
This intimate scene took place in the heart of Rocke-
feller Center amidst crowds and buildings. The in-
tensity of emotion expressed through body language
was a natural for a painting. I simply eliminated
buildings and extraneous people, focused on the two
women, and developed a flower-like setting which
would never reveal their conversation.

THEN I LEARNED A THING
OR TWO AT A WORKSHOP
I WAS TEACHING

One of my students, Lisa, chose to
work from a photo she had taken in
a restaurant. The figures seemed un-
interesting to me. I couldn't connect
emotionally with any of them and
out of curiosity asked her why she
wanted to work with this material. I
was surprised when she said that the
heads formed an interesting shape.
In other words, she related to this
scene in purely abstract terms.

Ann wanted to paint a scene of
Boston's Faneuil Hall. The painting
would include lots of flowerpots, a
number of people, and some archi-
tecture to identify the location. All
those details! The final work was to
be a gift for her mother in a nursing
home. I wondered about her mo-
tives. Was it because she loved the

scene and wanted to give something
pretty to her mother? Was it a scene
her mother loved? Did the flowers of
Faneuil Hall represent an event they
shared?

My last "for instance" is that I'm
always surprised at the five or six
artists in each workshop who want
to paint loved ones from snapshots:
a husband leaning against a Ford
truck, a smiling child on a stair or a

**My life experiences help me make
emotional connections my viewers
can feel in my paintings.**

mother sitting on a bench staring at
the camera. The artist wants to seize
the opportunity to create a likeness
of a loved one.

Those few examples show us how
varied our emotional connections
can be. I connect to the feelings in

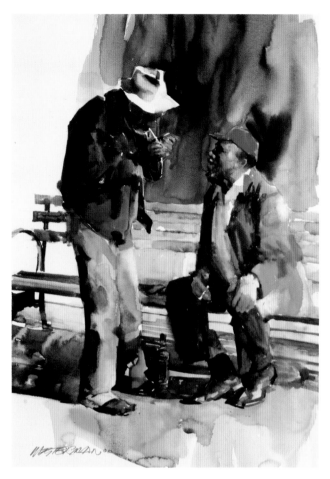

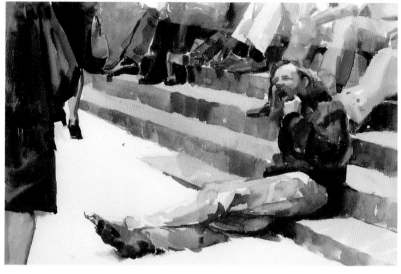

A Different Perspective, 18½" × 26"

This is one of many paintings of street people I do, and I thought I could almost get inside the head of the yawning figure on the ground. Surrounded by well-dressed people in shiny shoes, he sees them all as "phonies." Thus the title — seeing things from a different perspective. He was his own man.

Calip and Herschel, 25" × 17"

Action provides ideal material for a painting, and the gestures, laughter, drinking, smoking, and talking of these two conveyed a wonderful feeling of friendship. When I told them I wanted to paint them, they willingly posed, and the result won an award.

others and transmit them via my paintings to my viewers; another connects to shapes; another connects to an event; another connects to loved ones. In short, there are many possible emotional responses:

1. *The artist's*, based on her own experience;
2. *The artist's*, based on what she's learned or heard of (which may be dramatically different from what is going on emotionally with the subject);
3. *The viewer's* to the completed painting, based on some shared and other individual emotional experiences.

INTERNAL AND EXTERNAL EMOTIONS

I painted a street person in San Francisco lying on some stairs in a public square, surrounded by well-dressed people having their lunches (you could see only their legs). He wasn't

wearing shoes, I remember, but the soles of his feet were black as tar. He stared with seeming contempt at the passing scene, and I could imagine him saying, "Damned phonies." I titled the painting *A Different Perspective.*

A couple of years later, I saw that character again in exactly the same spot. I tried to hand him a twenty-dollar bill and thank him for being such a good subject. Not only would he not accept the money, but he blew me a string of curses. I knew what he meant. He had his pride, and he wasn't going to sell out to me and join the phonies.

I understood his anger and pride because I've shared those same feelings. We recognize emotions we've actually felt, such as fear, distrust, anger, fury, awe, wonder, love, worship, joy, pleasure, surprise, shock, thrill, ecstasy, weariness, exhaustion, humiliation, embarrassment,

insecurity, pain, worry, defeat — physical and emotional, frustration, bravado, sickness, skepticism, contempt. We also have reactions to things, such as color, sounds, music, shapes, textures and materials (like wood, wool, velvet).

We also have vicarious feelings. We see these in others. We recognize (or think we do) the words of others, their facial expressions and body language. We know about these feelings because we've read about them, seen them on TV or in movies, heard about them from others. But we haven't necessarily experienced them personally. We transfer experiences we've learned about to people we see who interest us. We may be driven to do a painting based on a feeling that we think we see or want to see, but which is not even remotely correct. But it doesn't matter; all we need is an emotional reaction on our part, no

matter what provokes it.

So any subject is valid, provided the artist has an emotional reaction to it. Even an intellectual response can be translated into emotion. For example, Mondrian's squares, intersecting lines, blocks of color, can lead from intellectual respect to emotional response.

Why do some people react to certain colors, for instance? Maybe their response is based on emotions that can't even be verbalized. Psychologists claim that the color blue is calming, and suggests steadiness, wholeness, and satisfaction with oneself. But if we haven't heard this particular theory, we can still react to the color blue on an indefinable gut level. Is a blue cap on a little boy

Any subject is valid, provided the artist has an emotional reaction to it.

enough to grab the attention of an artist? It is if the artist's emotional response is strong enough that he wants to save that blue by putting it into a painting. Then the little boy in a blue cap is a valid subject, provided the painter then asks himself all the technical questions that will determine whether or not the subject will make a good painting.

Obviously, emotions are wide open. Anything goes. But the artist must know that his emotional connection is only the starting point for a meaningful piece of work. There must be a passion that drives the painting, followed by the creation of a solid composition. Thus, the final rectangle will not simply be a statement of feelings or mood or a picture of something. It will be a complete painting with shapes, values, rhythm, color and balance, as well as subject matter.

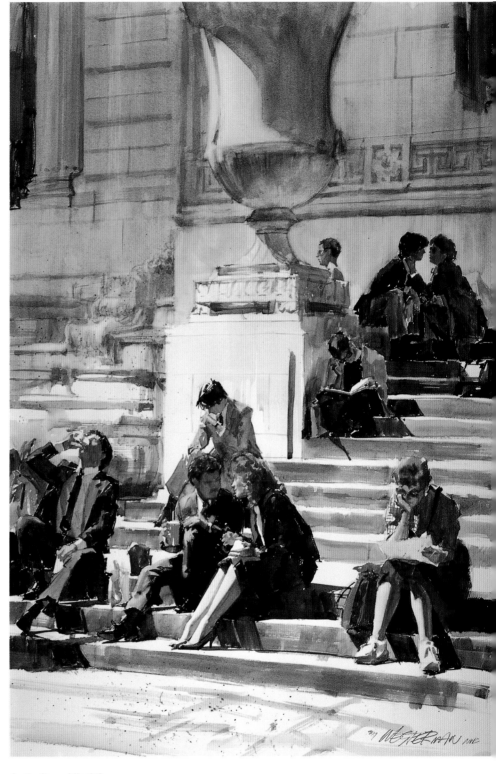

On the Steps, 36" × 25"

Lunchtime and more color and action for a painting. Here on the steps of the Forty-Second Street Library, people are eating, drinking, talking, reading, alone or with friends. We relate to them because often, that's where we are. The large urn was too interesting and became a problem. I nearly scrubbed through the paper to minimize it.

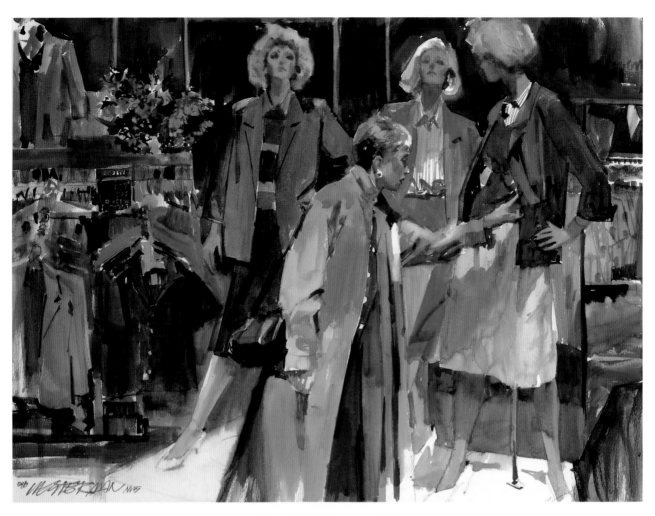

Customer with Mannequins, 18" × 24"
A familiar scene to anyone who has watched shoppers. It evokes tactile experiences in us, we can almost feel the texture of the coat the customer is examining. The challenge in this painting was to make sure the shopper is seen as a living, breathing person and that the mannequins look like store dummies.

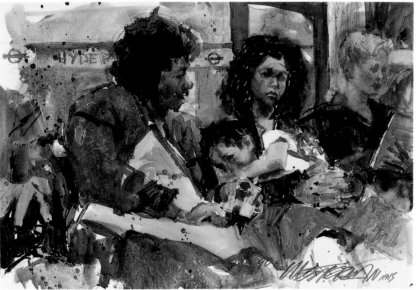

Hyde Park Station, 10" × 14"
This is a study for a larger painting. I seem to connect to the child. He doesn't look too happy to be going wherever Mother and Grandmother take him. I think the study works well because of the sketchiness. I added two other figures to make up a strong horizontal.

George The Tailor, 25½" × 20½"

Anyone working at almost any job is interesting. The face, concentration, hands, task, arrangement of elements, the lighting are all emotionally stimulating and fair game for a painting. I wanted to show George and Vasso scrambling to keep up with the growing mountain of garments waiting for the scissors, flashing needles and presser. The trick was to suggest the action without the background overwhelming the characters.

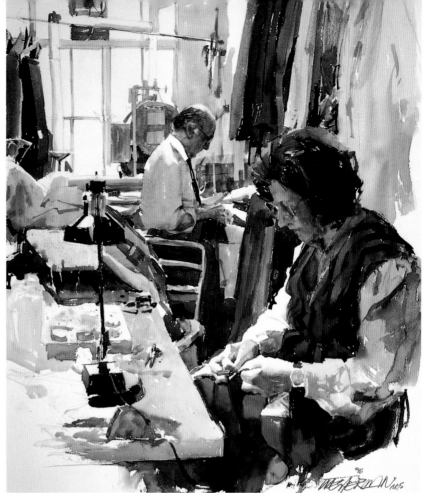

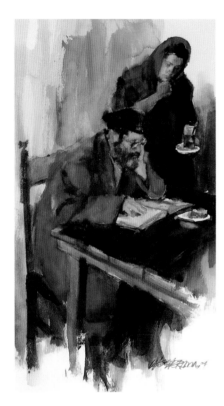

A Glass of Tea, 17½" × 10"

I grew up with this scene. It seems to be an Eastern European habit. At least that's how tea was served to my grandparents and parents—in a glass with a spoon in it to keep the glass from breaking. I had my son, Alan, and his wife, Karen, pose and created the costumes as I painted.

Lipstick, 17" × 13"

Applying lipstick is a very sensual act. Pretty to watch, a hint of perfume and the suggestion of physical contact. In this painting, the lighting is quite dramatic, and the strong red tones add to the intensity of the event.

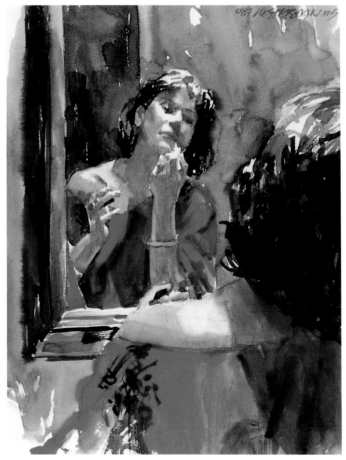

The Dramatic Idea

How to find it, feel it, paint it

You've got to feel it if you are going to paint it successfully. That means you have to be where your feelings are.

Don't paint horses if you don't like them. Don't paint figurative works unless the results warrant the challenge. Don't paint anything that doesn't interest you. You will be bored, and your boredom will show in your work. You have to be excited to paint exciting things. Involve yourself emotionally, and you will involve your viewer too.

Some years ago at a wedding, my friend Harold found himself seated at a table with a civil engineer. The man was introduced to him as a specialist in soil testing; that is, he determined if a building could be supported on its soil foundation or if it must be supplemented by the use of shafts or piers.

No topic brought up by my friend could get much of a rise out of the engineer until the subject of dirt came up. Dirt brought the quiet one to life, and he couldn't stop talking about it. More to the point, the engineer was so excited about his subject, he also made the discussion fascinating to my friend.

See what I mean? Even something as common as dirt can be stimulating in the hands of someone who loves his subject.

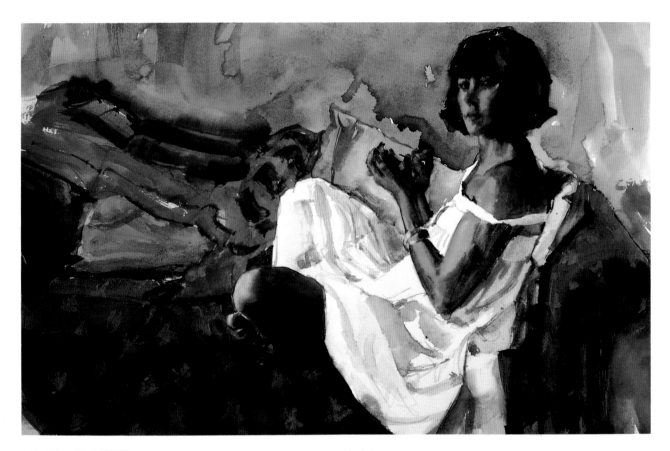

BE AT THE SCENE YOU WANT TO PAINT

You'll do your best if you paint the things around you that connect you emotionally—your world, your children, family, friends, your setting, the house, horse, barn, farm. Start with the things at hand—the things you feel most deeply about.

Choose subjects or scenes that get under your skin, things that make you feel something: happiness, sadness, thoughtfulness, curiosity, empathy, indignation, sympathy. Watch for meaningful gestures, body attitudes, physical relationships between people, unusual clothes, scenes you can actually interpret and translate for others into a painting.

Expose yourself to different emotional situations. Watch people. Try to read what they're feeling or expressing. Open yourself up to the energy around you. Watch a marathon, a religious service; go to a picnic, outdoor concert, youth rally; talk to some teenagers, talk to a butcher.

A Minor Interruption, 15½" × 24"

What does the expression of the young woman say to the viewer? Annoyance at an interruption while doing her nails? Curiosity? A chance to make a remark? I chose to let the viewers make up their own stories. At any rate, the pose is intriguing. The proportions of positive and negative space also make a good design.

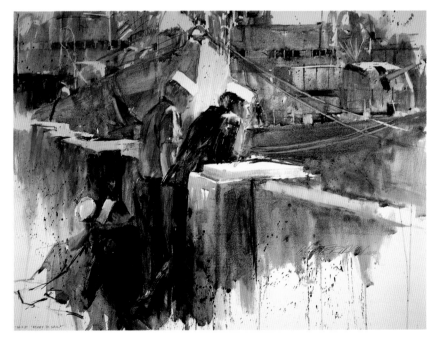

Work Party (Ready to Sail), 26" × 37"

Sailors preparing to weigh anchor stir up many emotions. For the crew of a warship, their family and friends, it's usually sadness. Fighting ships are an assemblage of details. I used liquid frisket to hold some of the structural details, and I tried to lose most in a mass of warm, light blue paint.

If you want to paint people, study people.

How about these possibilities?

Rodeos: Great for cowboys, horses, crowds, color!

Fairs: What could be more colorful? People with animals, amusements, midways, lots of activity.

Parades: Lots of possibilities, before, during and after.

Schools: Always some activity on the schedule.

Little League: Plenty of action here, great scenes. They don't have to be your kids. Probably better if they're not. You won't have to worry about likenesses.

Sports events: Professional athletes have agents who expect payment. Amateurs will give you all the exciting scenes you want.

Birthday parties, weddings.

Church, temple, synagogue: Ask first.

Farms and ranches: People working, tending animals, riding— all good stuff.

The workplace: Any scene is fair game. Pumping gas or changing a tire can make a good painting if it's designed well and is dramatic. People concentrating on their tasks have wonderful emotional appeal.

People with children: Anywhere. A natural!

Outdoor vendors: Color, crowds, plenty of interest.

Swimming areas: Lots of movement, skinny bodies, heavy bodies, lots of connecting shapes.

Courtrooms: Trials, faces, gestures, dramatic lighting, wow!

Protest marches: Crowds; signs that add strange shapes.

Ice-skating rinks: Like ballet, nothing more graceful.

Theater rehearsals.

I could go on for the next ten pages (or you could), so let's stop here and catch our breath.

To find out about events, dates and places, check your local newspaper or entertainment guide. Ask friends belonging to organizations about special events. In a private event, learn who's in charge, explain your interest, and find out if either sketching or taking photos is permitted. If appropriate, send samples of your work in the form of slides or prints. Remember that you are making contacts with people who can help you in future events.

An Apple and the Paper
21" × 28½"

Dancers aren't like ordinary humanoids. They lift things off the floor without bending their legs and rest in the most contorted, seemingly agonizing positions. That's why paintings of dancers are always so different and dramatic, as is this one of dancers catching their breath and stretching at the same time. Notice the connections between their bodies and background and the unfinished space that offers a feeling of movement about to happen.

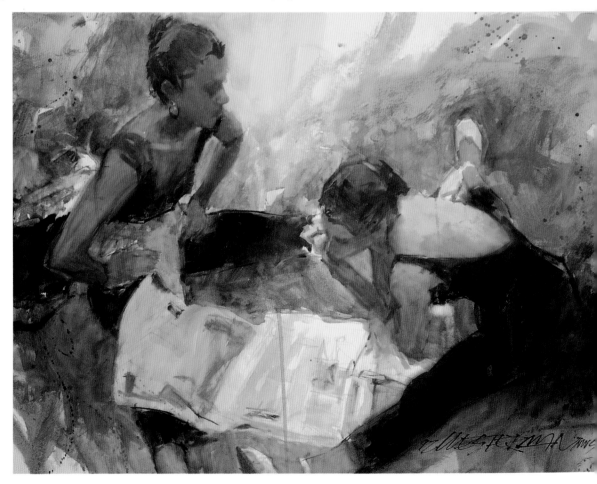

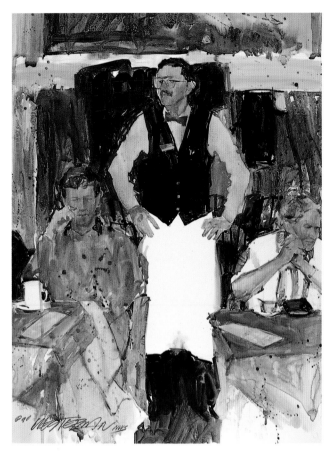

Outdoor Restaurant, Amsterdam, 28" × 20"

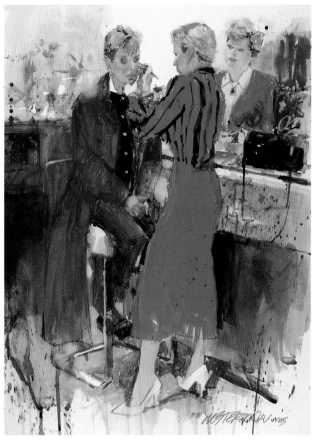

The Makeover, 27" × 20"

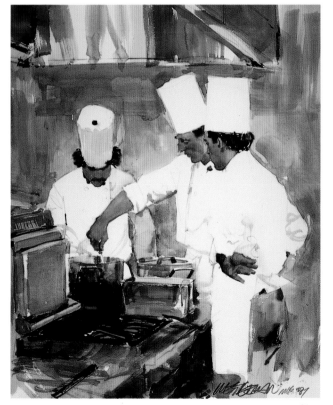

The Master's Touch, 23" × 19"

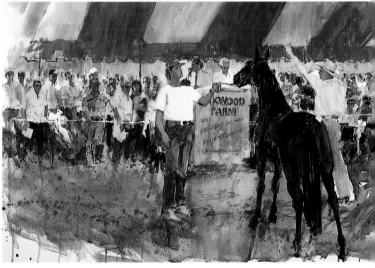

Tennessee Walking Horse Auction, 26" × 39"

You can find dramatic scenes anywhere, anytime. Take the frustrated waiter. He seems to be waiting for dawdling customers to pay their checks and free up his tables for more customers and more tips. Or a scene that takes place every day in any department store where customers' faces get recreated by salespeople selling cosmetics. Or watch cooks preparing a sauce. It's all there right in front of you.

THINGS I LIKE TO PAINT

There are special things I like to paint — although almost any scene with people alone or interacting with others is a potential painting for me. I like to paint ballet dancers — not when they are performing, but when they are practicing, when they are perspiring and not smiling at an audience (ballet dancers don't sweat, they perspire).

To get the scenes I want, I either make arrangements with a ballet studio or company or hire dancers and find an appropriate setting. On a couple of occasions, I've built a replica of a ballet barre and had the dancers pose in my studio. Problem: Create a background. My preference is to pose my dancers in a studio with high ceilings and good old-fashioned windows.

If you are interested in painting dancers in a company or studio, find out who the contact person is — owner, general manager, ballet master, etc. Ask for an appointment, and

Noon Concert, St. James Park, 21" × 29"
Any park is a natural for interesting subject matter. Look at the faces, physical expressions, actions, children, pets, whatever — they're all exciting subjects to paint. This is a typical noontime concert in St. James Park in London. I mass the crowds into larger shapes that will not unduly intrude on the main focus of the painting.

Mickey Mouse, 24" × 17½"
I find dancers at rest or concentrating on the look of their bodies and positions much more interesting than when performing. Also, the rehearsal costumes are often wild, funny, colorful, baggy, or all of the above. Here, a dancer relaxes, fixes her hair, and has fastened a Mickey sweatshirt around her waist, thus the title.

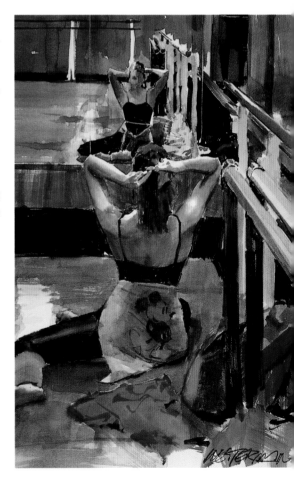

bring slides or prints of your work to the meeting. Some companies and studios welcome artists. Some don't want photographs taken. None allow flash.

Stay where you belong. Don't interfere with the action. Don't move around, particularly if you've been

Don't paint anything that doesn't interest you.

advised of a danger to either yourself or the participants. Your movements could be disconcerting. And no talking. The best advice, whether sketching or taking pictures, is to make yourself invisible.

If you have a camera that has whistles and bells, turn off the noise. When using a camera, don't make a show of focusing and getting wonderful angles by either climbing walls or writhing like a snake on the floor.

Don't interrupt the exercises or you will be unwelcome. If you want

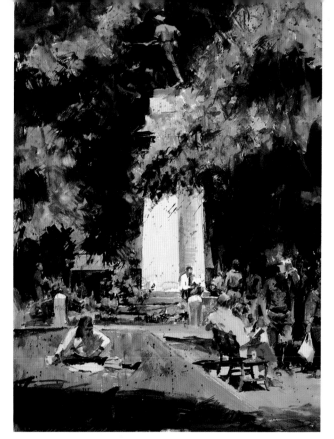

Lownsdale Square II, 40″ × 28″
A strong, central element in this park is the column and statue memorializing an Oregon regiment of volunteers who fought in the Spanish-American War. My object in the painting is to treat the people in the park as my center of focus while retaining enough of a suggestion of the memorial to place the scene.

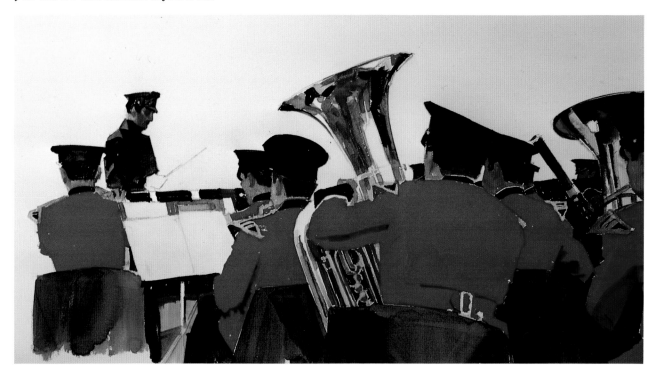

Concert in St. James Park, 18″ × 26″
This is the Guard's band, which was playing for our friend in the park painting on the opposite page. So now we add another element—not just the people in the crowd but the attraction as well. Perhaps it is the attraction seen from the back (maybe a performer in silhouette?) and the crowd facing us as small bits of color. This was painted a few years before *Noon Concert*; it shows much more detail than I use these days.

special poses, arrange for the dancers to be on their own time, and pay them. They usually earn less than you. Ask your dancers about an appropriate rate.

If you are sketching or photographing class activity, obviously there is no expectation of payment. If you can, you may want to donate a sketch or money to a ballet company that gave you an opportunity. Most companies can use all the help they can get.

Dancers and other models get paid for their work, the amount to be negotiated. The best way to make a model fee minimal per artist is to divide the cost among a group of painters.

PUBLIC VS. PRIVATE PLACES

Taking pictures or sketching in public places is usually OK. Taking photographs in private settings may require approval by the management. Store managers or department heads are understandably cautious about people taking photos in their stores, because they're not sure if you are disturbing their customers, stealing their merchandising ideas, or simply creating a traffic problem. Shooting indiscriminately, you take a chance of being surrounded by plainclothes store detectives. Ask for the manager, show your work and discuss your plans.

I love park scenes. I can't recall walking through Central Park or Union Square, or any park, when I didn't see ten or twenty scenes that could translate into great paintings.

After I get a quick shot, I will usually introduce myself as an artist, tell them how wonderful they will look in a painting, and try to learn something about them. Most often, they are flattered and will speak freely and pose for me if I need additional material. Rarely do they object. If they do, no painting. Most people like to talk, and you meet so many nice ones, it's almost like making instant friends.

SEE THE SCENE BUT VISUALIZE THE COMPOSITION

You can't paint everything you see even though so many interesting elements are begging to be included. Be brutal. Ask yourself what the essentials are. What expresses your feelings and what is excess baggage?

You can compose with a camera viewfinder. A piece of cardboard with a small, rectangular hole cut out will serve the same purpose. But your most important goal is to get your basic information with a snapshot or sketch. You can always deal with composition in your studio.

One last word: Don't waste your time going after cute scenes. The little child on a sunlit veranda, capped in a beanie, licking an ice cream cone, can be awfully trite unless you have something unique in mind.

Before you spend your hard-earned hours on throwaways, just ask yourself if the result will wind up as a painting or as an excuse for one.

When you're in a studio setting and there is any kind of action going on around you, keep well away if you want to be invited back again. Don't snake around looking for those tricky shots. Dancers can't watch out for you, and accidents may cause injuries.

Wherever you are taking pictures for a painting, you want natural light. Turn off the flash. If you're photographing dancers, it's not allowed. It blinds them. Try getting along without flash for family pictures, too, if you can.

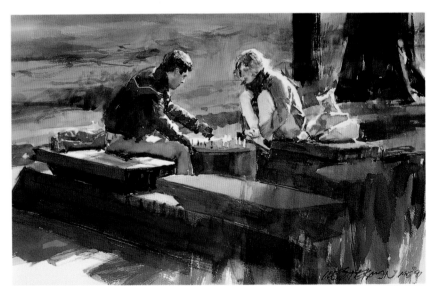

Winter Chess Match, 17" × 26"
This scene takes place on the Portland State University campus. I found these young people sitting on cold stone, the chill of the day warmed by a winter sun, which gave me exciting highlights. The details of the grounds and background have been eliminated or simplified, so you really focus on the figures. Notice how the girl sits. Would you have thought of posing her that way? Probably not.

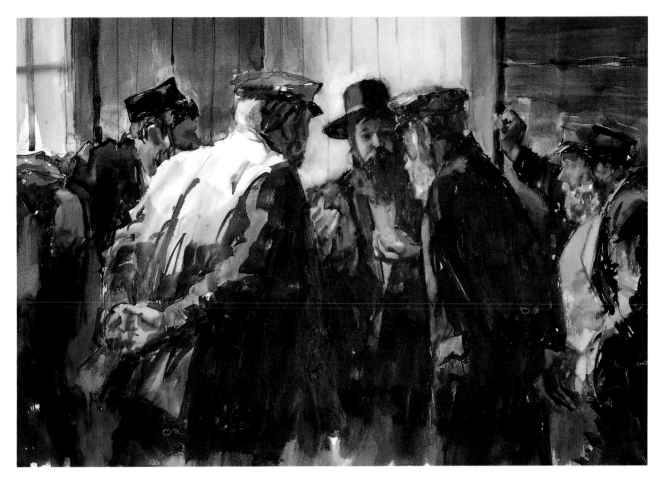

The Rebbe Explains, 17″ × 26″
This idea connects with my growing up in a Jewish
neighborhood and seeing old photos, so I created
this scene suggesting turn-of-the-century Jewish vil-
lage life. Members of his congregation crowd around
the Rebbe to hear his explanation of a point of reli-
gious law. The people I posed and costumed all have
varied backgrounds, ranging from a radio announcer
to an auctioneer. Rabbi Moshe Wilhelm in the center
is a real Rebbe.

Greene Street, Rainy Day, 25″ × 36″
The cold moodiness of this painting is accented by
the dark buildings on the right, the suggestion of
passing rain, wet streets, and the distant expression
of the principal figure. The scene gains wonderful
movement through diagonals created by buildings,
sidewalks and streets. You may have to stand
around taking a number of pictures of street scenes
to get the one or combination you want, but it's
worth the effort.

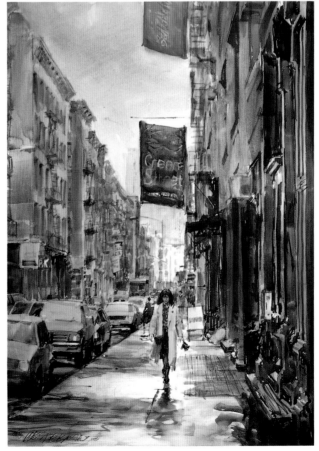

The Dramatic Idea

Source Material

Using a camera to capture what you see

If you want to capture a fast-moving scene, nothing is easier than clicking a no-brain camera. However, where speed is not critical, make it a point to do some drawing or sketching on location. Besides sharpening your skills, you see things large as life. Prints are small and slides smaller still. The image drawn from life allows you to follow contours more easily, get the significant details, and eliminate unimportant material (because you don't have time to draw it all anyway). You can see your subject from a variety of angles instead of being fooled by what a flat, photographic image hides.

The more drawing you do, the better you become at your craft. Besides sketching scenes, make it a point regularly to exercise and sharpen your drawing skills.

I find I work best by doing my drawing and painting in my studio. It's just easier for me, and I think the majority of artists today go this route. Street scenes involve people moving around so fast that it's more convenient for me to go armed with a camera. My approach is to capture most scenes on film because I'm looking for a fleeting expression. Then, I take what images I need from each photograph and start sketching.

Photography is ideal for figurative action. It doesn't matter how fast-moving the action. The camera can capture it instantly. The artist has the luxury of time to look over results and reflect on approaches she might take in executing a painting. She can see things she might have missed at the scene. In short, she can "get it all" if necessary.

A prefocused camera is lightweight as well as easy to carry and use. It is relatively inconspicuous and, if used properly, does not intrude into the lives of one's subjects. Photography doesn't attract the same kind of attention as painting on the scene (which I think is more appropriate for landscapes than for fast-moving figures). The artist is not pestered by people looking over his shoulder or jostling him. He is not an obstruction on a crowded street. The changing light doesn't affect him.

A camera is a valuable tool for portraits and paintings of children, who couldn't sit still even if their lives depended on it. It's a time-saver in doing portraits of adults, who have to sit around for only a short length of time, compared to a series of live sittings. Most people don't seem to have or want to take the time. The artist has the luxury of taking a number of different poses and selecting, without the pressure of the moment, what she thinks may make the best approach.

Last but not least, film is pretty cheap, and processing is almost immediate. What's an hour to wait for the results? If worse comes to worse, the artist might have a second chance.

PHOTOS ARE ONLY FOR REFERENCE

I'm aware that many artists disdain working from photos and that a number of teachers discourage their use. I agree that if the painting is merely a blown-up photograph, why bother to paint when an enlarged print will

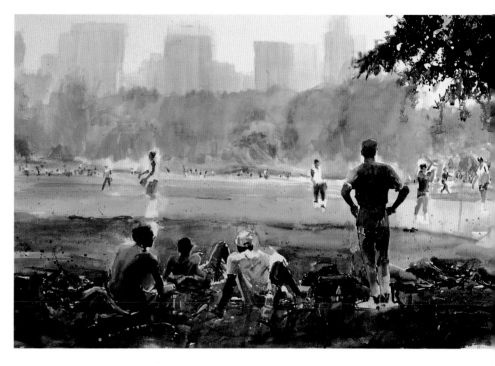

serve as well?

On the other hand, I think photographs make great raw material. It's easier for me to design from prints, manipulate elements, move objects around, change colors, eliminate or deemphasize, than when looking at the reality. The plein-aire painter may be more likely to be faithful to the scene he sees in real life than someone who is looking at two-dimensional objects on a flimsy piece of paper.

Occasionally, I see some artists copy photos line for line. They possibly imagine that the viewer will compare the photograph to the painting and then know what the artist left out or didn't paint perfectly. So everything is included, even the kitchen sink and unidentifiable objects just because they were there.

Most of my students, however, learn that a photograph is just like clay. How they use it and what they design from that source depends on their own creativity. Everything is fluid—shapes, colors, light, line, transposition, everything and anything. The quality and uniqueness of the final painting is its only value.

So here's our first ironclad rule:

Ball Field, Central Park, 27" × 40"
Snap the action with your camera and manipulate the material by sketching in your studio. I like this ball game among friends in Central Park because it shows the contrast between play and work. The men playing on this field Sunday are going to be working over there Monday. See those buildings?

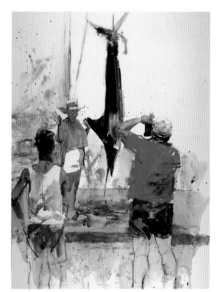

Los Cabos, 27" × 19"
A snapshot is all you will need to paint a scene like this. Only the characters change and sometimes the fish. The challenge is to paint something that doesn't look like a snapshot.

The photo is simply raw material. Don't let it boss you around. Use the parts you need to create a painting, and when you're satisfied with the results, throw the photograph away or return it to your file. It served its purpose.

The camera is a wonderful tool. Shoot wisely and don't hide in shame if you use one. The Impressionists used photographs in their work, particularly Degas and Toulouse-Lautrec. Most modern painters work all or in part from photos. I'm sure that if cameras had been available in their day, the early Egyptians would have gotten the eyes right.

USING PRINTS OR SLIDES

I use prints rather than slides. Prints are just easier for me to see, and they don't require projection equipment. The colors aren't as true as in slides, but I try to create my own colors anyway.

Color film has some basic drawbacks. No color film can register the colors you see in nature. The camera adds to the problem because the meter reads averages, a balance between lights and darks. The result is often loss of the real or *local* color in light-struck areas. If you want to compensate for the difference, you can make a notated sketch.

Here's how: After you've shot your scene, take a bit of time and make a rough sketch, the smaller and simpler the better. Just make sure it includes details of areas where there are colors you want to remember. Label your colors *R, Y, O, B, G, P, Br, Bk, Gr, W*, which stand for *red, yellow, orange, blue, green, purple, brown, black, gray* and *white*. Add a value number from *1* for lightest to *5* for darkest. Or if you prefer, use the specific color name, like *CB* for *cerulean blue* and *BS* if it has a touch of burnt sienna in it; then your notation would be *CB + BS 1*.

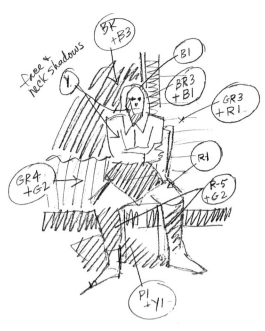

A notated sketch. In this instance, I may have wanted to remember the yellow in the face and neck shadows. The background color is a blue-black, which I may mix as ultramarine blue and burnt sienna to approach that deep color. The shadow parts of her leg are made up of a mix of full-strength red and medium green. Get it?

Moment Before Class, 13″ × 20″
If you are photographing interior scenes, don't let outside light influence your exposure. Take a close reading on the fleshtone, and use that setting for your shots. For things outside the window, let the camera take an average reading, and take another shot, or just make a quick sketch.

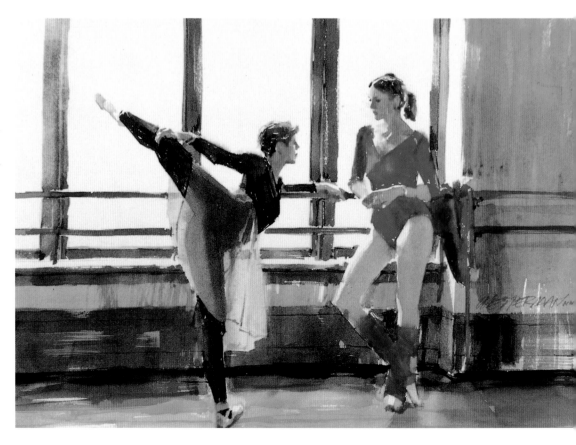

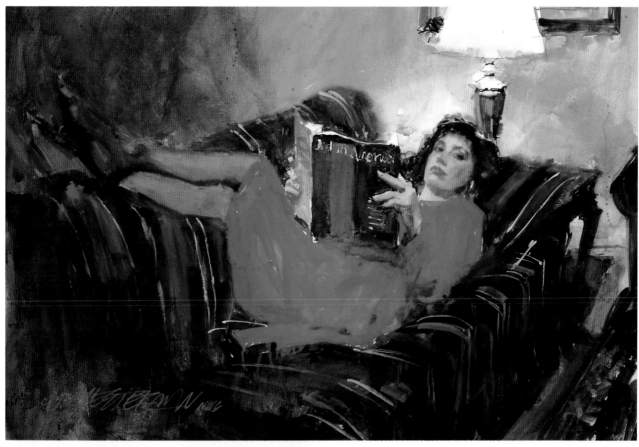

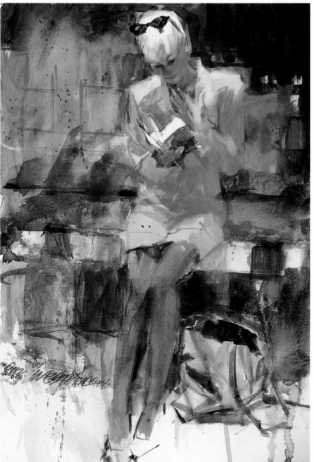

The Red Dress, 21" × 29"

A camera allows you to get instantaneous expression. I posed my model in the furniture department of a store, sitting on a sofa, reading. After a few moments, she put her feet up and said, "This is really the way I read." I snapped some pictures and we were on our way. I sketched it from the prints in my studio. Notice how flat I kept the red on her dress.

Cliffhanger, 14" × 10"

Luckily I had camera in hand when I noticed this young lady reading. I asked if I might do a painting of her and suggested she put one hand to her throat as if she had gotten to a clincher in the story. I caught her expression, modified the background, and arrived at this small painting. Just another reason to keep your camera with you.

USE A NO-BRAIN CAMERA

On my walks, I usually carry my autofocus camera. When I spot something interesting, I shoot. I don't compose. I take a picture quickly so that everything and everyone is perfectly natural, recorded at the instant it was most exciting to me. The end result is a photo that doesn't have to be sharp. It just has to give me enough information to get me started.

A small, 35mm autofocus camera can be used nearly anywhere, any time. It takes no skill or memory to operate. One with a built-in, 35mm wide-angle lens costs about one hundred dollars. That lens covers a field of view large enough that you don't have to aim too accurately. More expensive autofocus cameras come with interchangeable lenses. If you can afford one, get a 35mm to 70mm zoom lens—they're very practical.

If you have an expensive, older camera that requires focusing, you can make it prefocused like an old box camera. Film manufacturers

The photo is simply raw material. Don't let it boss you around.

usually include a printed table with each roll of film, showing camera settings for average lighting conditions, such as bright sun, overcast or cloudy. Follow instructions, set the recommended f-stop and shutter speed and everything should be sharp from three feet to infinity.

If you own long lenses, like 135mm or longer, you might want to leave them at home. By the time you finish focusing and zooming, your subjects will either vanish, cover their faces, or turn their backs. Nothing kills spontaneity like someone fussing over them with a camera. Also, I don't know why, but people have a sixth sense they're being photographed even if you're standing behind a tree and they're ten miles away.

Just remember, you're not taking a photograph. As I said earlier, you're after a memory jogger. You can always pose friends or cats or whatever you need at home to provide material to finish your painting.

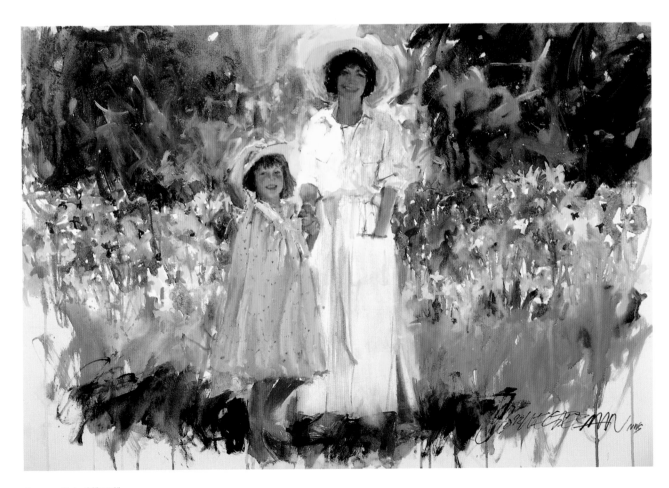

Summer Hats, 28" × 40"
The photo is only for reference. Much or most of the creativity takes place in the studio. The background was a golf course. It became a flower garden. I modified costumes, and the result is nothing like the original.

RAIN OR SHINE

Sunlit scenes are easy. But how do you keep your camera dry in snow and rain? Make a little house for it out of a plastic bag, and cut a hole for the viewfinder and lens. Or, hold an umbrella with one hand and the camera with the other!

Exposing for snow scenes and brilliant sunlit beach is the same as shooting skaters on an ice rink. Your camera meter will be fooled and calculate for lots of whites because ice is white and your figures are smaller and darker. Result: underexposure and loss of detail. Use a larger f-stop. Same kind of problem when a small, light figure is surrounded by a large, very dark background. The meter will overexpose for the darks. Use a smaller f-stop. Make color notes if you want.

Wait 'Till You See My Slides, 20" × 13½"
Maybe one camera isn't enough, but it was enough for me to capture the man with three cameras. This scene made me think that the figure would wind up with hundreds of slides to show friends. We've all been there, haven't we?

A word about exposure control. Occasionally you have to make adjustments in your camera to get proper exposure. A dark figure against light background: open up the lens (increased exposure). A light figure against dark background: close down the lens (decreased exposure).

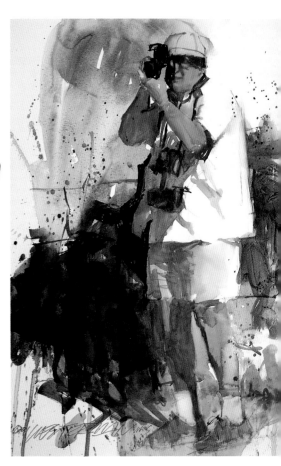

You shoot quickly because there is something in that scene that connects to you. But the camera isn't selective. It gives you *everything* that's there. This is the picture it took. What I *wanted* to remember was the girl writing and stretching her feet.

This is how I might modify what the camera saw. To bring that girl with the feet into center of focus, I might move the two women at the far left next to, and perhaps even overlapping, her. They would be in shadow. I would add a walking figure coming toward us — also in shadow. The painting needs that vertical shape to stop it from just drifting. See?

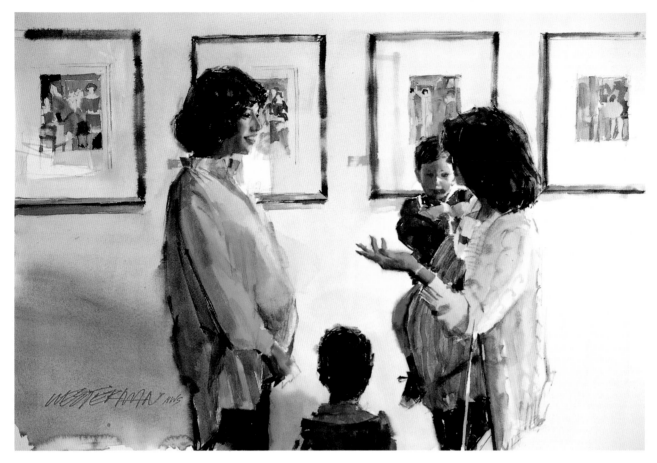

Kiddie Culture, 20" × 27"
Shoot for the gestures. Snap a number of photos to get one or two good ones. Don't be afraid to waste film.
This is a scene in an art gallery. I remember hearing that if you're pregnant and want your child to grow up
to be an artist, go to art galleries and museums. Could we have two more artists in the making?

LOOK FOR RICH, MOODY SCENES

Rain scenes are wonderful . . . dark or colorful umbrellas, great reflections. Use faster film. Just keep your camera dry. *You* can get a little wet. Just kidding. Use an umbrella or find an overhead shelter. Make notes if you want to remember special colors — your film will see mostly grays.

Late afternoon . . . shadows are dramatic. Faster film works better. Evening scenes offer wonderful contrasts of small, light areas against masses of rich, dark shadows! Bring fast film, even a tripod. It might be easier to make a sketch.

DON'T LOOK LIKE A TOURIST

Nothing puts the local inhabitants on their guard faster than someone with one or two cameras strapped around the neck with attached film canisters and a big black camera bag with fourteen handy pockets slung over the shoulder.

Be unobtrusive. Go lightly. Need an extra roll of film? Put one in your pocket. Wind the strap of your camera around your wrist. (That will also

Don't be afraid to use enough film to get at least one good shot.

keep your camera from getting ripped off if it's dangling from your neck.) Practice taking pictures with one hand for speed. Use two hands when you can or with low light.

Your camera is now in your hand, and your finger is ready to push the button. Find something interesting?

Bring your camera hand up to your eye. Shoot. Put your hand back down to your side. It's that fast. Shoot again for insurance in case the first shot didn't work. If you have a wide-angle lens, you may not even have to bring the camera up to your eye. Shoot from the chest. That takes practice. Just like getting to Carnegie Hall. Go ahead and waste a roll or two trying it.

See? You haven't intruded yourself on the action. You haven't bothered or annoyed anyone by standing in front of him fussing and squinting and shifting from side to side getting the perfect angle with a black box aimed at him as if he were an animal in a zoo.

When you're done with the shoot, you can tell the people about the

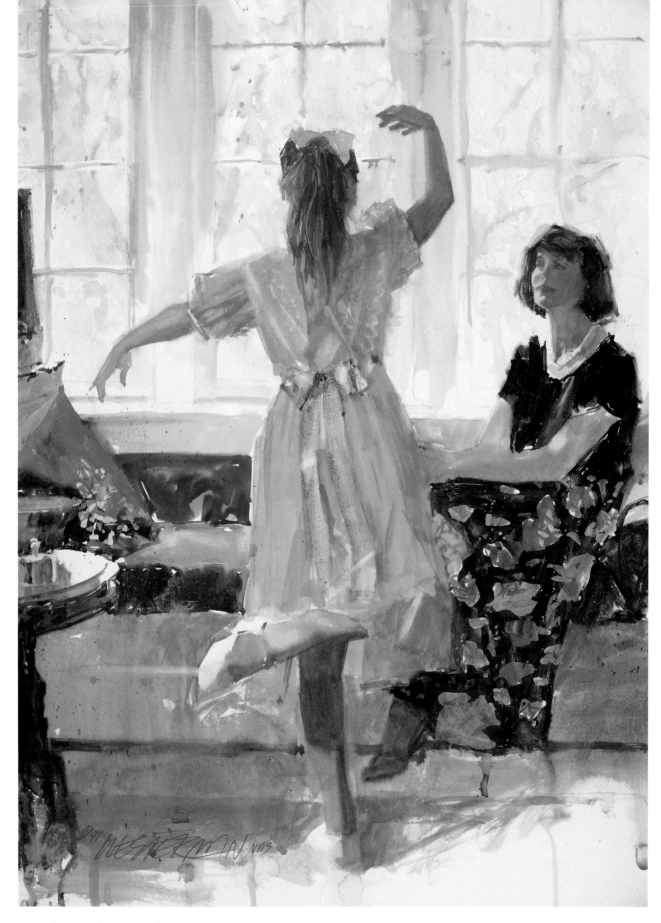

Caitlin Strikes an Attitude, 27" × 21"

A pose like this will be much easier for a child to hold for the few moments it takes to snap the shutter.

Just remember to expose for the interior. You can always sketch the things outside the window.

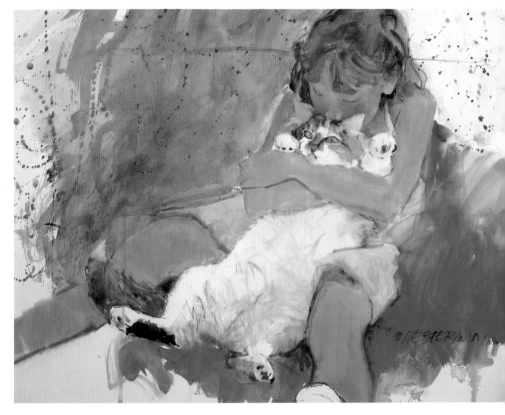

Delali, 11" × 14"

The speed of using a camera: This young woman works in a building a block away from my studio and posed for me for a few minutes during her lunch break. In that little time, I was able to get a number of photo impressions. This is the result of one of them.

Kitty Love, 19" × 28"

No question about the value of a camera in capturing scenes with animals. Cats have a tendency to move rather quickly when you hope they won't. Just snap fast. Dogs are much easier. In this case, I think the title is a little understated. The cat was most likely getting even more love than it could handle.

painting you have in mind. They will probably love it—may even want to pose. Find out more about them. Tell them about yourself. Some will give you addresses where you can send photos of the painting if it turns out. However, if you're in the wrong neighborhood or are afraid you might get hurt, you might just keep moving. My insurance doesn't cover you.

There's a good reason I take snapshots *first* and introduce myself *after*. Once you've announced yourself, your subjects will smile and pose, and you'll waste your time. Keep it natural. Get the picture first.

Some people feel guilty when they take pictures of people they don't know. If that's how you feel, tell yourself this: "I am going to use the material for a painting. The figures are not designed to be intentionally identifiable. They may bear little or no resemblance. I have avoided intruding in the private lives of my subjects." Feel better?

You needn't use flash for our purposes. Faces come out flat and pasty, and shadows are strange. Superfast film is available—up to 1000 ASA. Natural light is best anyway.

Last but not least: Your camera is expensive. Your time is valuable, and

the scene may never be repeated. Film is cheap. Waste it. Don't be afraid to use enough film to get at least one good shot.

Before I leave the subject: Don't use pictures by others even if you have permission. You may certainly adapt an idea, but you can't paint someone else's image. You must cre-

ate your own.

When you use people in public places in your paintings, keep the rendering loose and suggestive. Remember, you are not painting portraits of people you don't know. Paint portraits of people you know, you pay, by whom you are paid, or you are adequately related to.

TAPING THE ACTION

Another method of capturing the scene that is gaining momentum is the use of tape, camcorder, VCR and TV. A camcorder can work in low levels of light, so there is no concern about film speed. Tape offers immediacy. No processing time. Preview while you shoot. The disadvantages are the weight of the camcorder and batteries, battery life between chargings, and the initial expense of equipment. You can't get a quick shot, because it takes more time to focus and film the scene.

There are attachments like the Sony XV-D300, or complete VCRs that will freeze the precise frame you want long enough to do your sketching and painting. That makes a great tool. Watch some sporting event replayed in slow motion and you'll see what I mean about the peak of an action.

A taping system would work nicely in many public events where cameras are allowed, as well as for fast action that takes place in relatively low light, like a dance studio or gymnasium. To find out more about taping scenes for painting, ask your nearest TV or camera dealer.

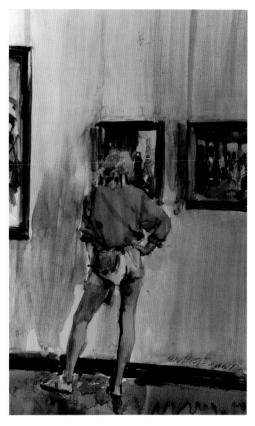

Rijksmuseum (Amsterdam), 19″ × 11½″
Many museums don't allow cameras. None allow flash. If you're lucky enough to be in one where cameras are allowed, watch the people looking at paintings. They are often more interesting than the works themselves. This is one of the few paintings I ever did on illustration board.

Pink Ribbon, 10″ × 6″
I just happened to be in the right place with my camera at the right time. It was a cold day in Boston, where I saw this woman sitting bundled up on a bench writing a letter. I'm particularly proud of this early painting. I don't think I knew what I was doing, but I seem to have known enough to connect her shape to the background.

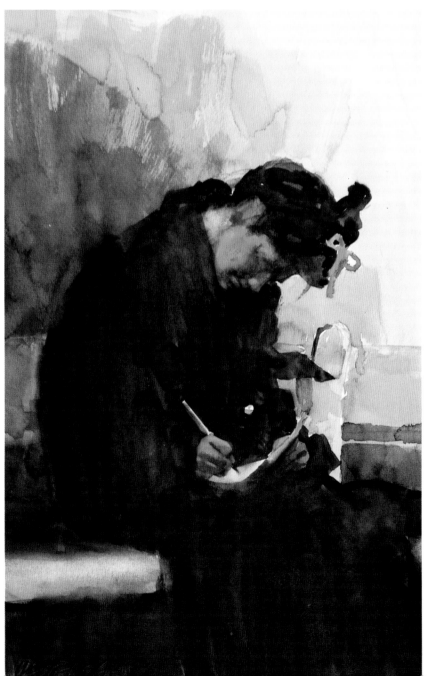

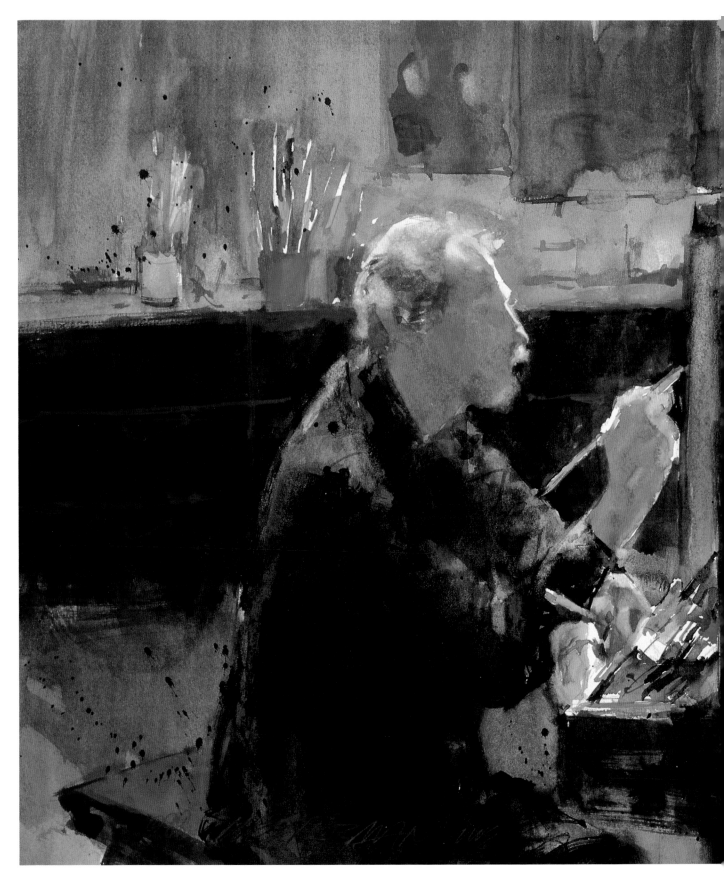

David Paints Flowers, 15" × 22"

PART TWO
The Craft of Painting

Materials

What you need to do the job

My studio is in a downtown building because I often paint city scenes and I like the hustle and bustle of the city. The studio doesn't have north light. In fact, the windows face a light-well. I paint purely with ordinary tungsten lightbulbs, a warm yellow light, just like the kind people use to light my paintings hanging on their walls. It really doesn't make a difference. I have yet to see one of my paintings shown by either daylight or north light.

The space is large enough for all my mess. I believe that anything that hits the floor was meant to stay there. The studio gets cleaned up only after I start tripping over things.

I use an old, cast-iron easel with a large plywood top and a small kitchen table I picked up at a garage sale to hold my materials. I bought some steel file cabinets for storing papers and matboard. I have a cutting/matting area (although I do very little matting or framing these days). I have a large library of art books for inspiration, and a sitting area for company—makes things pretty comfortable. However, I did some of my best painting when I was working in a basement room. Great studio space is nice for the ego, but not mandatory for creating good work. In short, an artist can work almost anywhere.

Two water canisters—one for dirty, one for clean. Fill them only halfway up, and leave room to strike excess water from your brushes.

Small supply of frisket in film canister. Leave the rest in the bottle so it doesn't dry up.

Small plastic bottle of soapy water for cleaning brushes immediately after use with frisket.

Tissues and paper towels.

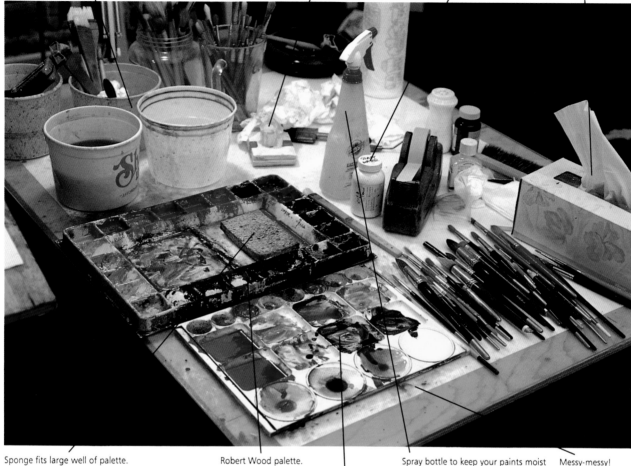

Sponge fits large well of palette. Keep it moist, and use to soak up excess water before or after dipping brush in paint.

Robert Wood palette.

Extra palette for working up mixes.

Spray bottle to keep your paints moist with a little spray. Use it for texture and softening in your painting.

Messy-messy!

PALETTE, PAINTS, ODDS AND ENDS

Over time, I've settled on certain paints, palettes and papers that seemed to work best for my way of painting. Although subject to change, these include:

Robert Wood palette. Large wells with plenty of room for paint and big brushes.

Absolutely permanent watercolors in tubes. See page 63.

Two water containers.

Liquid frisket. Keep a small, plastic bottle of soapy water handy to clean the brushes immediately after use. Otherwise it ruins your brushes. Don't use a good brush in this stuff.

Liquid frisket will keep longer if you transfer a small amount you plan to use for the next month or two to a small, plastic film canister. Keep the main supply in the original bottle with the lid on tightly.

A roll of absorbent paper towels or tissues.

No. 2 pencils or the automatic ones if you prefer.

Kneaded erasers because they don't leave much of a mess.

Spray bottle is very useful.

Tube squeezer is economical.

Odds and ends—your choice.

BRUSHES

My preference in brushes is simple: Use anything that works. I once believed that only sable brushes were any good. I don't anymore. They seem to lose their points and wear out just as fast as the cheaper kind. I generally use synthetic bristle brushes. My brushes take a lot of abuse and don't cost much to replace. I use hake brushes (pronounced "hockey") or old brushes for washes and textures. I will use stiff, old brushes or oil bristles for lifting or scrubbing. I also use no. 7 through no. 14 rounds and 1-inch aquarelles.

PAPER

I've settled on Lanaquarelle hot-press. It's acid-free and works beautifully for my style of painting. I usually use 140-lb. Smaller sketches may be done on 90-lb., although I've done full sheets with it as well. Larger works (29″ × 41″) are usually painted on 555-lb.

I was always looking for a paper where the paint dried with almost the same intensity it had when it went on wet. I wanted the surface to be slick but not so slick that subsequent glazes lifted the underpainting. It had to give me plenty of paint texture, visually similar to the kind of thing you get from a bristle brush squeezing out oil paints. And most of all, it had to be washable, so that I could scrub things out—even dyes—and not feel I have to worry about taking all kinds of risks.

Tom Jones, a wonderful painter living in Seattle, steered me onto Lanaquarelle. I've used their hot press ever since, have been delighted with the results, and have recommended it to my students. Their cold press is just as scrubbable and may be easier for some to use.

TO STRETCH OR NOT TO STRETCH

A gallery owner once told me that my watercolors should be completely flat so there were no shadows showing between them and the mat. I now think an original watercolor can have a little bit of wave to it. Then at least it doesn't look like a print.

I used to soak and stretch my paper then look at that pristine surface and really be intimidated. It nearly killed me to go through all that bother and wind up with a loser. So I chose to just paint, let the paper get completely out of shape, then stretch only after it was a winner. I would just turn it over, wet the back and tape it down on half-inch plywood with Elmer's Glue and heavy kraft tape. Incidentally, with that process, the paper dries overnight as tight as a drumhead.

I've grown out of that system too. Now, I start my painting by taping down all four sides of the paper with masking tape onto a drawing board called "Gatorfoam." This is a foam-core sandwich board covered by a tough plastic skin. It's stiff, has a surface which can take repeated tapings, and is very light.

Here's the procedure: Tape the paper down flat with no gaps between board and paper, or the watercolor will dry with ripples. Make sure the tape hasn't loosened during the painting process and the paper is completely dry when you finish. Remove the tape carefully to avoid any chance of tearing the paper. The finished painting will be flat enough to mat and frame as is.

Paper towels, folded and taped down, soak up excess water from the brush and help the bristles come to a point.

One of many lightweight Gator foamboards I used to work on several paintings at a time.

Scratch paper taped down for testing colors and pointing brushes.

Masking tape on all four sides will keep painting fairly flat after paint dries. Make sure that the tape is down flat and there are no open spaces before you start painting.

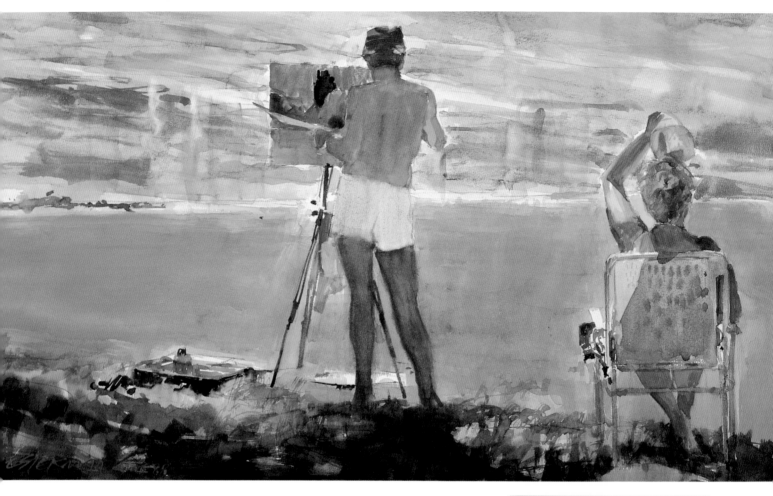

The Sunday Painter and His Patient Wife, 17" × 26"
This involved a tough decision—whether to show what he was painting and add a castle and walls and stuff, or keep it simple and allow the viewer his imagination. I chose the latter.

Don't forget your magic apron. Without it, you are just a humanoid about to get paint on your clothes. With it, you become Master of the Medium.

The Design

Turn your raw material into a painting

Most paintings that fall short share a common problem: They may include technical skills and contain some well-done portions, but as paintings, they just don't hold together.

The missing ingredient is *design*. The work frequently is the result of the inspired artist who has rushed headlong into covering the paper with a beautiful thing, and the thing has come out beautiful but the painting hasn't. Why? How often have you looked at a painting you thought finished and wondered why it never got there? This is where we find out.

When designing a car, fussing with the exterior may be fun, but it has to have a structure, or it won't go anywhere. Likewise, we have to have a framework for building a painting—that is, a design. Before we put brush to paper, there are some decisions to make on the structure and composition of our painting.

The first decision starts with the basic rectangle. That's *all* we have to work with. We'll need to decide which rectangle— horizontal or vertical—offers the most exciting potential for our subject matter, and only then can we begin to create a painting.

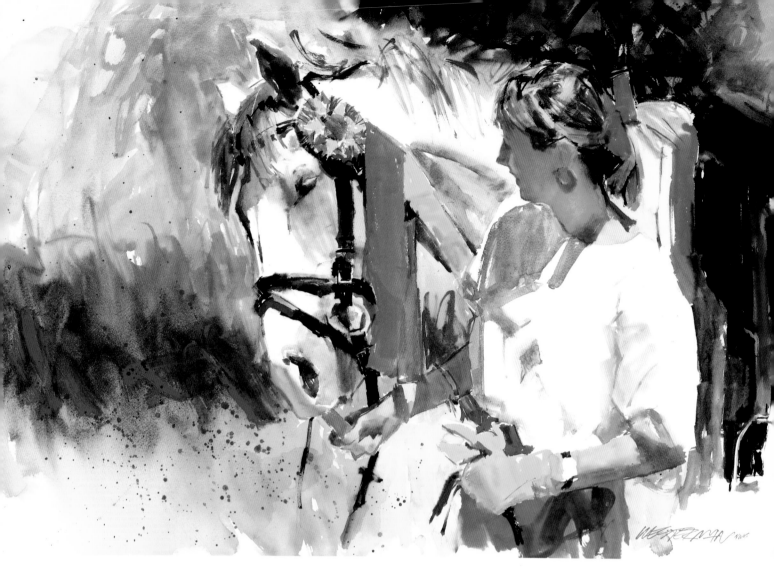

A Carrot for the Winner, 25" × 36"
A unified rectangle that consists of a vertical block composed of horse and rider taking up about two-thirds of a horizontal rectangle. I made the connection to the left side of the painting with a purple shape, which starts from the shadow on the rider, past the horse and to the edge.

Vertical or horizontal? Someone's daughter, niece, friend, daughter of friend, etc., and if it's going to be a painting, you have two choices:
- Will it be most interesting as a horizontal?
- Or a vertical?

A CRASH COURSE IN COMPOSITION

Make the Rectangle Cohesive

Unify the rectangle with lines or shapes that connect to all four sides through upward, diagonal and sideward forces. Even when they are interrupted, the eye bridges the empty spaces and mentally makes connections to the sides, bottom and top of the painting. Bridging the gaps in a form or within a painting is called *closure*.

Structures

Some basic patterns offer the artist ready-made designs to hang her painting on. Three of these are the *pyramid*, *axial* and *divisions of space*. (See Suggested Reading, *The Artist's Design* by Marie MacDonnell Roberts.) Most often, the subject matter may suggest the design scaffolding.

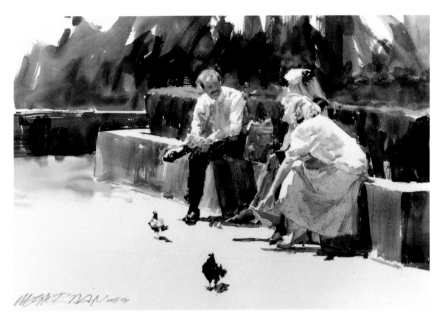

Union Square, Noon, 18" × 25½"
Bridging spaces. A strong, diagonal thrust connects the sides of the painting. I have also connected to the top of the painting, and the pigeon is my connection to the bottom. See how your eye bridges the gap. Cover the pigeon with your hand, and you'll see that the painting doesn't work as well.

Horizontal and vertical connections. The eye will bridge the space between a broken horizontal, diagonal or vertical line, and mentally fill in the connection. Thus, vertical or horizontal thrusts may have breaks and still seem connected to make a cohesive painting.

Closure. What lines or things can you leave out to add sparkle to your work? The viewer is delighted to make the connection and appreciates the opportunity to use her imagination.

The vignette. Even a vignette must appear to connect the sides, the top and the bottom of the rectangle.

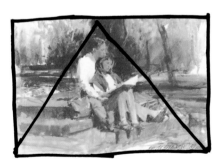

1. PYRAMID STRUCTURE

2. AXIAL

3. DIVISIONS OF SPACE

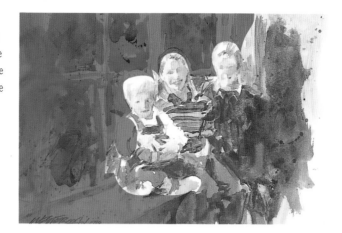

Lane Children, Study, 26" × 37"
Balance. This portrait of three children displays a nice balance between positive shapes and negative space (represented by the red area). Notice how the figure forms are connected to each other and to the background.

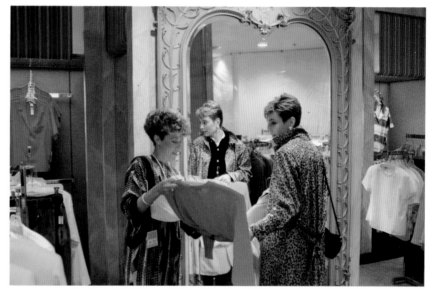

Dominance and simplification. A typical retail scene, which connects the experiences of most of us. If we include everything the photo tells us, the painting will look like the number-three special from a Chinese menu. Let's start by choosing a single focal point and simplifying.

Rhythm

Repetitive shapes create a feeling of movement or flow. The shapes needn't be perfectly similar to generate this effect.

Balance Your Elements

Arrange positive shapes to balance negative shapes, large shapes against small ones. Your paintings must have balance and variety to keep them from appearing static and uninteresting.

Combine several elements, and you create a larger shape to balance others. You can use light and dark values, lines, shape, texture, and color to create a balance.

Focal Point or Dominance

Your composition must have a single center of interest, a clear message. The viewer's eye will go first to your area of most interest through contrast, color, size, or the most interesting shape. The painting should convey immediately what's most important and areas of secondary interest. In a portrait, the face will invariably be the starting point.

Entrance and Exit

You decide on the areas of progressively less importance and encourage the viewer to travel the path you design. A door, window, or patch of sky can offer a subtle exit.

This is the abstract shape of the painting if we make the shopper our center of interest. Her mirror reflection and the salesperson have been subverted by combining shapes and adding tones.

We could eliminate much of the mirror and frame, and tie the salesperson into the background with lost shapes. The reflection of the customer drops in value and is tied closer to the mirror. We bring the lighter value suggested by the blouses up to the dark back of the customer; that along with the light of the mirror makes the customer's head the dominant feature of the painting.

Subject Matter and Shapes

Subject matter is the beginning, not the final piece of art. Look beyond the obvious shapes of heads, bodies, buildings, etc. Try to find interlocking patterns and variety. Change many of the obvious shapes and create new ones. Look for patterns in background or foreground that can tie elements together and add excitement or interest to your composition.

Simplify! Simplify! Simplify! Cut out the junk that can complicate your composition. Eliminate anything that doesn't express your feelings simply and clearly. (Maybe your painting doesn't need all twenty-four people in the background plus the

Simplify! Cut out the junk that can complicate your composition.

fire truck and the telephone pole.) Subordinate, combine or delete. Keep background shapes in the background.

Value: Light and Dark

Establishing good, strong values in your composition is more important than technique or color. It makes your painting read and identifies your meaning. Create stronger contrasts to attract and direct attention to important areas and to improve composition. Connect contrasting areas with middle tones.

You can test how good the composition is. Reduce it to black, gray and white; squint to let your eye see it that way. Color can be misleading and may often camouflage a mediocre piece of work.

Abstracting the shape. A beautiful ballerina, but. . . .

It's only a vertical line in a rectangle.

It needs additional shapes to create a complete painting. How about including a larger figure on the left and perhaps a smaller one on the right? Look for connections with other dancers, wall and floor.

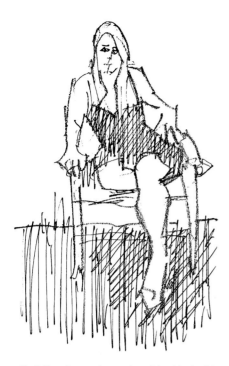

Building shapes. A seated model, a blank white wall and a dark floor are all I had to start with. What elements must I bring to the mix in the way of background and new shapes to create a painting?

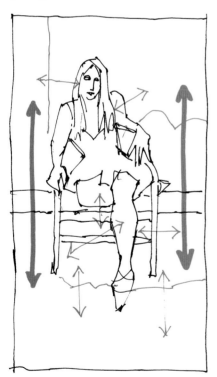

I want to go beyond the edges of the figure and build new shapes. I let some of the background color invade the hair and arm on the left, and come in strongly on the upper arm on the right. Much of the chair and the dark sides of her legs are lost in a shadow shape I invent.

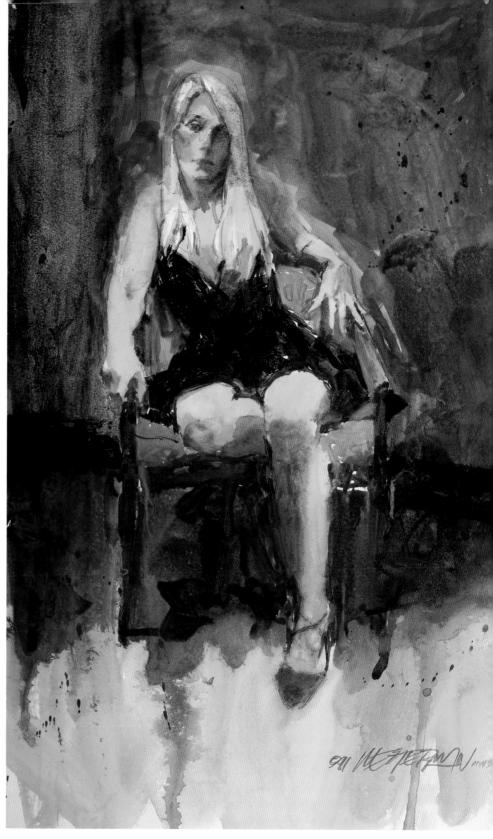

Christina, 20" × 11"

In the final painting, I have added something blue to break up the background. Could it be a curtain? I have made the background heavy to build a feeling of melancholy. I have also devised a blackish floor moulding on a slight diagonal to create additional tension.

Lines

An effective design element. Lines serve to outline shapes, express movement and generate strong interest. Horizontal lines impart feelings of tranquility. Diagonals convey action, movement, conflict. The eye follows the line wherever it leads (both *into* and *out of* the painting) and automatically goes to the point where lines come together and cross. Avoid lines that go to the edges and draw your viewer right out of the painting.

Use lines with some discretion. Don't slavishly color inside lines the way we learned as children. The results remind your viewer of a coloring book, and you wind up with lots of little, boring shapes in your painting. It's time to get out of the habit. Draw lines you paint past; lines you erase to eliminate divisions between shapes; lines you add while you paint or after your paint dries to describe abstract shapes. Subtract lines to lose edges.

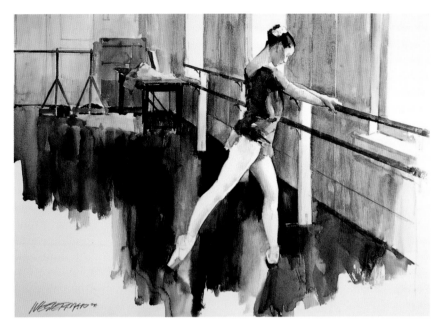

Repetitive lines create rhythm. In this ballet scene, repeating diagonal lines of the ballet barres, leg and floor create action. In "Hats and Scarves," rhythm is created by repetitive circles.

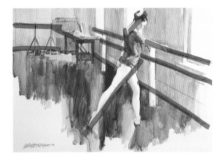 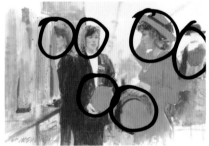

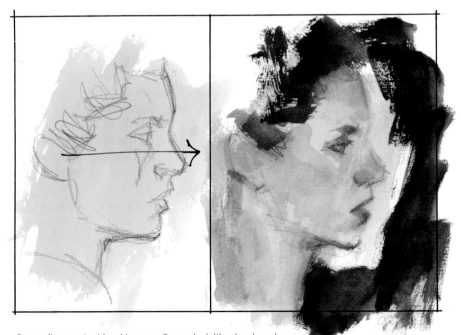

Cutout figures. Avoid making your figures look like they have been cut from magazines and pasted on your painting. You can make them belong by keeping them loosely drawn and tying them into the background.

Lost and Found Edges

Sharp edges attract attention. Lose edges to create movement, to lock the figure or thing into its environment. What is left out is more important than what is left in. Create new shapes by tying together areas of similar color or value and by subtracting lines between shapes. Lose edges and blur details because the area outside your central field of view is naturally blurred. If you need to restate a line or portion, you can always do it later.

Avoid *tangents*. These are lines that run parallel to the places they touch and may serve to confuse shapes. An example might be the edge of a building that touches and follows the edge of an arm. Better have it intersect at the shoulder, or simply pull it far enough away from the figure. Also, look out for things that appear to be growing out of your figures, such as telephone poles and other strange objects that seem to show up after someone else sees them.

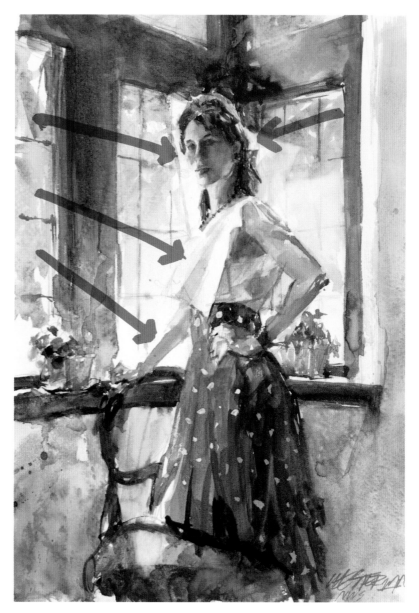

Hilary, 14" × 10"
Lost and found edges. A painting of Hilary, showing how I lost light-struck edges of the figure against the lights of the background. Yet, in spite of the subtraction, the parts "read" clearly.

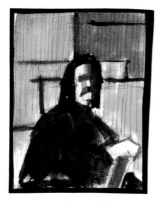

Intersecting lines in the self-portrait by Poussin represent background shapes and come at the figure at near right angles.

Tangents confuse the shape. Avoid lines that connect with parallel edges.

Avoid things growing out of your figures. Move the telephone pole away from your figure or forget it.

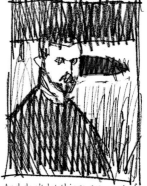

And don't let things grow out of someone's face, as in this sketch from the self-portrait of Gustave Caillebotte.

Texture

Gives the viewer the vicarious experience of feeling a variety of effects. Decorative texture in the form of patterns in the wallpaper, clothes or furniture may add movement, depth, and excitement to a painting. See the paintings of Vuillard for his wonderful use of pattern. Note that where his figures and background are similarly patterned, only the figure has volume; the background is

Always allow resting space in your painting to balance the more aggressive elements that demand attention.

flat. Minimize natural textures like stone or brick. They can become too prominent and monotonous.

Drips and spatter add another textural dimension. Wet paint on hot-press paper dries with a special effect. Scrub with watercolor or oil brushes to get a look similar to oils. Don't confine texture to a single area. Use it throughout your painting.

Gradation

Any gradual transition in color, line, value, size, etc. Gradation creates the illusion of curvature and volume. Objects appear to recede. Gradation can also suggest movement, acting almost like an arrow drawing the viewer into an area of opposing contrast.

The Illusion of Depth

You add depth to your painting through perspective, gradation, comparative size, advancing and receding color, and overlapping shapes. The creation of a foreground, middle ground and background adds the three-dimensional illusion.

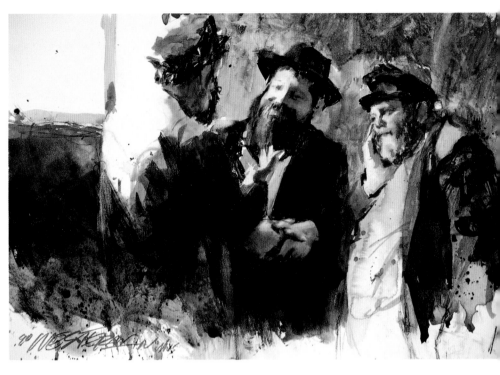

The Old Schul, 9½″ × 13″

Texture adds dimension and interest. One of the effects in this painting is made by a combination of bearing down with a brush and spraying, which loosens and separates the paint. While it was wet, I set it somewhat vertically to get some nice drips. I've added spatter by simply throwing a brushload of paint at the work.

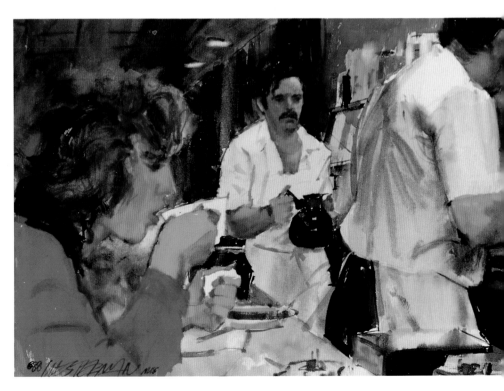

Coffee at the Counter, 14″ × 20″

Illusion of depth. I have used an advancing color and an overlapping shape to establish the foreground. Another supporting and overlapping figure creates deep space for my center of interest. Try a large, partial figure in the foreground, or a large tree or whatever (King Kong?) and watch the effect.

Flat Shapes

The Impressionists, following the influence of Japanese prints, simplified shapes by flattening them. The result is more exciting than defining folds and contours, which may look too photographic.

Neutral Space

Always allow resting space in your painting to balance the more aggressive elements that demand attention. (Why do so many painters feel compelled to make every square inch important?)

Isolation of Elements

An isolated figure or element will draw attention to itself. This device may be useful in presenting your principal point of interest. An element placed near a picture border tends to have greater attraction than one placed in the center. Similarly, an isolated element may have more weight and interest than when it's more closely related to others.

Warm or Cool Colors

Warm and cool colors play against each other. Cool colors recede, and warm colors advance. A warm color against a cool background will draw attention to itself.

Local or Arbitrary Colors

Do you want to paint what you see or what you feel? *Local color* means the actual color of the object. *Arbitrary color* is any color you select for dramatic effect.

High Key or Low Key

Are you going to design your scene to be a light, airy painting or a dark, moody, dramatic one? You choose the effect that your feelings and subject matter suggest. Look over some paintings you like to see where these elements were used in making them successful. Look over your problem paintings. Are their shortcomings in the area of composition?

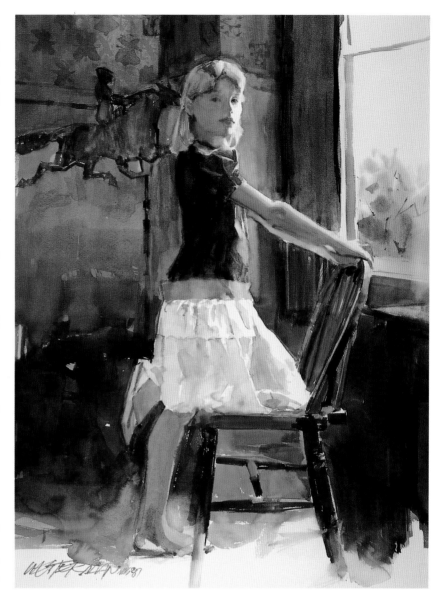

The Antique Weathervane, 24½" × 16½"
Flattening shapes. Kiley's costume is made up of a blue velvet top, pink sash, and ruffled white satin skirt. Since the suggestive is more interesting to me than the explicit, I paint the colors flat with little or no feeling of volume. I leave some light-struck areas and add various tints to represent white satin.

The isolated figure draws disproportionate attention. Although the bulk of space is devoted to a mass of figures, the eye bridges the gap and goes automatically to the isolated one. Why?

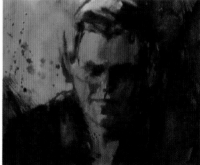

Arbitrary color. Will the design be affected by a choice of arbitrary colors? Will you paint things as they appear in nature, or will you change colors to correspond to your feelings and subject?

As an oldtime-movie buff, I often wondered how an actor could light a candle in a scene and that would be enough to bathe a whole room in light. Weren't you curious, too?

The Light

Intensify dramatic effects with creative exaggeration

All I know is that it never seemed to work for me. If I lit a candle when the electricity went off, believe me, most of the room was still pretty dark. Yet I was perfectly willing to accept this bit of fakery in a movie.

I know now that motion-picture candles get a lot of help. Staff electricians can flip up any or all of a zillion watts of candlepower when an actor strikes a match.

It's the director who calls the shots.

In the film *Day for Night*, the director, Francois Truffaut, shot a scene in daylight, only he convinced us that it was filmed at night. He did it with filters.

You can do the same things with light. Now, you are the director; you call the shots. You can change anything about the light you choose. You can change shadows in intensity or direction, or add new ones. Change colors. Subdue or eliminate light. In short, you can do anything you want to add impact, flow or clarification to your composition.

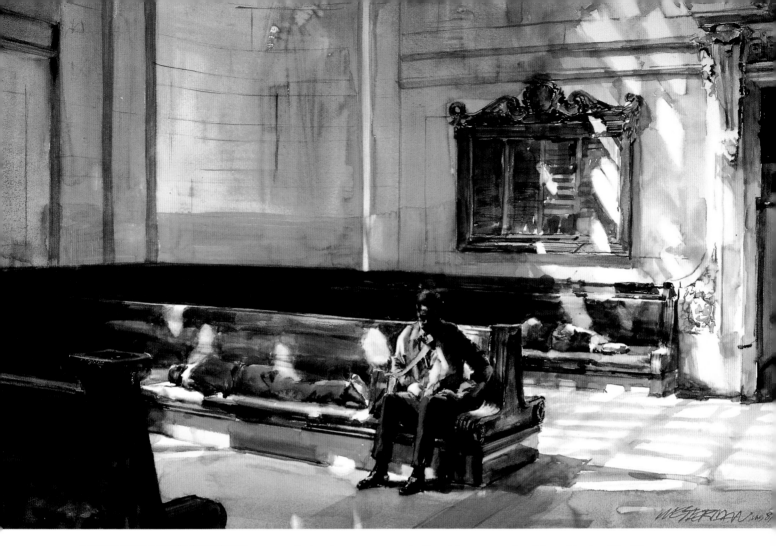

MAKE THE LIGHT EXPRESS YOUR MOOD

Make the scene high-key—bright, happy, cheerful, suffused with light. Make it low-key—dim light, somber, dramatic . . . moody street scenes, for example. Change the direction of the light, sprinkle snow on the ground, make the pavement wet after a rain. Turn day into night. You have all the magic of a Merlin.

Changing from day to night or wet to dry pavement takes some doing, but it can be accomplished with observation and planning. It may require posing friends, spouse, children or model in a comparable light setting. It may require comparing the material you have with photographs, memories, or sketches of snow or rain scenes that give you the information you need for color, contrasts, reflections and the like.

What power! Just keep the candle trick in mind. Your lighting manipulation has to appear believable.

Now that you know what a wizard you are, let's get practical.

THE LIMITATION OF LIGHT IS LIGHT

All light is no light. White uniformly used throughout your paper won't offer much to look at. It's just like "all headlines are no headlines."

You have to give up some light space and introduce dark space to see light. The white of our paper must be set against or surrounded by darks for us to appreciate its luminosity.

Light is expressed through values and contrasts. The greater the contrast, the more brilliant the light. Juicy contrasts make your picture come alive. The opposite of contrast is camouflage. Even if you have grayed down or colored the white area, it will still look like light if it's contrasted against a darker value.

Grand Central Station, 24" × 35"

Light is the unifying element in this painting. Entering the massive, elaborate windows, it plays on many surfaces of the room and creates exciting patterns and highlights on the figures. It accentuates the strong contrasts between the ornate images of an elegant past with the present somber gloom that hangs over the homeless using that waiting room. I focused on that contrast, building a painting that would communicate the mood I felt on being there.

The scene no longer exists. The waiting room has been turned into restaurants.

Everything is relative. We accept both a medium gray in a dark painting and a bright white in a high-contrast painting as tokens of light. The difference in impact on the eye is short-lived. Very quickly, the eye compensates and sees light in both renditions similarly.

To make a good painting, you start by resolving the arrangement

Juicy contrasts make your picture come alive.

of lights, darks and midtones, as we will discuss in our three-stage approach starting with chapter eight.

Gradation of light offers an accent and develops movement. The viewer's eye will follow the darkening tone to the areas or objects it touches. A graded tone that stops without touching or blending into another surface will end like a line. Decide what that line is meant to do and in what direction it focuses attention.

Call Your Agent, 19″ × 25″
In New York City, who knows which waitress, messenger or salesperson is an actor working for feed money? That's why my title for this rain scene suggests that the messenger is supposedly calling his agent.

Melody (Naomi), 9½″ × 13½″
I painted this scene at night. So why is there daylight coming in through the windows? Easy. I just thought it would add an interesting element. The strongest light on the figure looks like it would be coming from a light over the piano. The subdued light entering the window doesn't materially affect the light on the model or in the room.

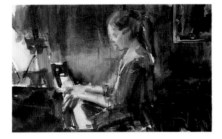

Altering the scene. Would the painting have been more dramatic if I darkened the room and eliminated the windows? Then the light on the model might remain the same, but I would have to observe or imagine how the lamplight would illuminate the wall. Wouldn't it be lighter near the floor and darker near the ceiling? Doesn't it depend on the *kind* of lamp, too? Is there a pattern on the wall I could use? Could I add a sofa for more texture and color?

Would another element, such as a painting on the wall, break up some space?

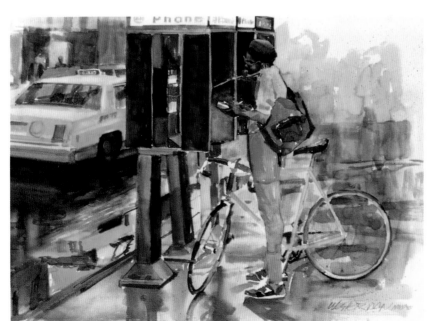

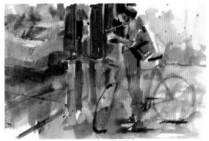

Call Your Agent, color sketch
However, since he is an actor in my play, I can just as easily put him on dry pavement, as I did in this fast sketch. I just eliminate the reflections on the pavement and suggest shadows. I could also have made it a sunny day for him. He might have liked that. I would choose the angle of light and incorporate some strong shadows.

EXPRESSING DOMINANCE

Choose a single center of interest. Make full use of contrast to create the most dramatic effect. Make only one light-struck area dominant. Don't waste the light and diffuse the drama, or you lose impact. Where there may be conflicting light areas in your raw material, amplify the important single light and subordinate everything else.

Make viewers' eyes see what you want them to see *first*. What will best dramatize your placement of the focal point? A small, light area set against a large, dark mass or a small dark in a large, white or light-toned one? Introduce harmony to the composition by connecting lights and darks with a variety of midtones.

The greater the contrast, the more brilliant the light. Notice that white surrounded by black appears to be even more intense than the white of this page.

Moderate contrasts. A light or medium-gray area surrounded by a dark still looks like light. The eye quickly compensates for the difference.

Only one dominant light. The strongest light in a dark mass or the strongest dark in a light mass immediately tells your viewer this is *your* point of greatest importance. (This also applies to the attraction of the strongest color.)

Don't confuse your viewer with two or three equal centers of interest. Only one per painting. All others are secondary in order of decreasing importance. Otherwise your viewer doesn't know where to look or what you're saying.

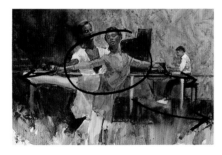

Joseph and Elena, 20" × 27"
A graded dark leads the eye directly to the intense white of Joseph's shirt, which becomes a background for the strong green costume of Elena, my center of interest.

This is typical of overhead lighting found in many dance studios. Lighten planes of the body facing the ceiling, such as foreheads, noses, cheeks, shoulders, etc.

If I had it to do over, I would darken the shirt and shoes of the pianist, and not make the dark leading to Joseph's head so intense.

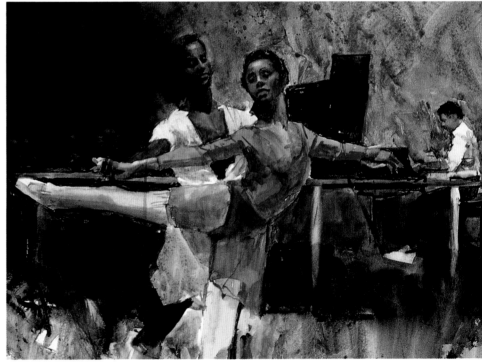

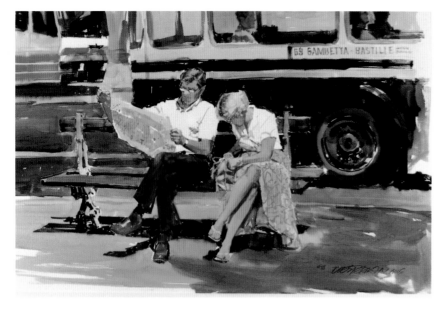

In this painting, and in *Entering the Arena* (at right), the eye will always see my center of interest first because I have made it the area of strongest contrast.

Paris Tourists (He to the Map, She to the Nail File), 32½″ × 36½″

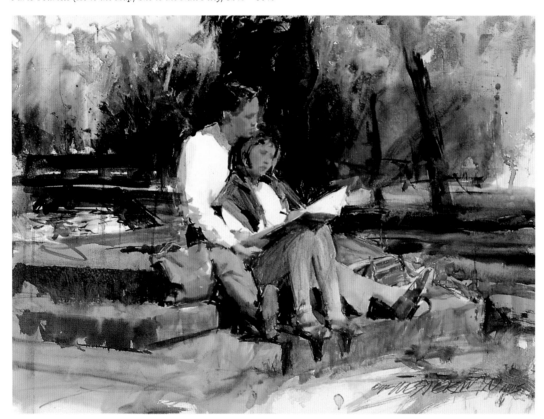

Spring on Campus, 21″ × 29″
By eliminating the distracting elements and simplifying the scene, I was able to focus viewer attention immediately on my figures. This is where I placed the strongest light against the darkest darks.

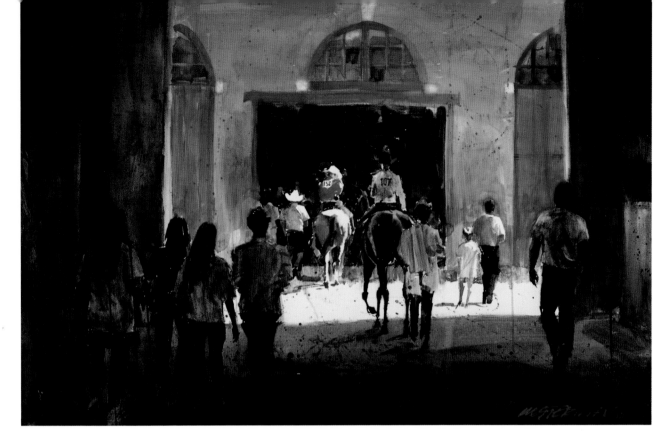

Entering the Arena, 26" × 38"
Light creates a highly dramatic, exciting bull's-eye effect when it is confined and bordered by a large, dark mass as we have here. The dark space also adds great depth.

CONSISTENT LIGHT SOURCE

If the light is coming from one direction, maintain that lighting plot. Conflicting shadows give your viewer a nagging feeling that something is amiss. You can change the scene by making it lighter or darker.

Secondary light may be used to soften shadows and keep areas from dissolving into the background. Personally, I like strong shadows and lots of disappearing edges, and a single-source light makes things "easier to read" as solid forms.

Secondary light may be reflections or weaker, distant illumination. In a scene where skylight is dominant, reflections may come from the ground or adjacent surfaces. Incorporate only those reflective lights that actually are important. Don't replace clear values with camouflage by making the secondary reflections too prominent.

Here are a few examples of how a feeling of volume is communicated through strong, uncomplicated shadows.

Light from below. Shadows hit receding surfaces. Could be direct or reflected light.

Overhead light. Planes facing upward are light.

Side light. Half the form is light, half in shadow.

Rim light. Light behind subject. Light at edges.

Typical sunlit cast shadows.

The changing reality of light. In preparing a
portrait of a thirteen-year-old skater, I had her
pose at a nearby ice rink. This is a sketch of the
actual scene. There were clusters of skaters in
constant motion, stores and shop windows in the
background, people walking on the balcony
above.

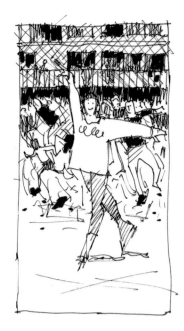

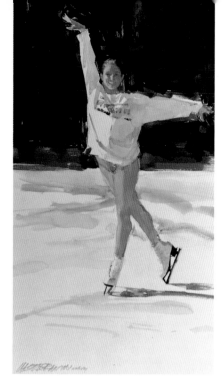

Jordana, 24" × 12"
The first illusion. This was painted as a commis-
sioned portrait. I have eliminated the real back-
ground completely and brought deep darks down to
my figure to create a theatrical feeling. There is
enough texture in the background to ask the viewer
to guess its composition. I have added colors to the
white ice. Though I've brought the dark halfway
down the painting, Jordana's posture prevents the
painting from looking like it was cut in half.

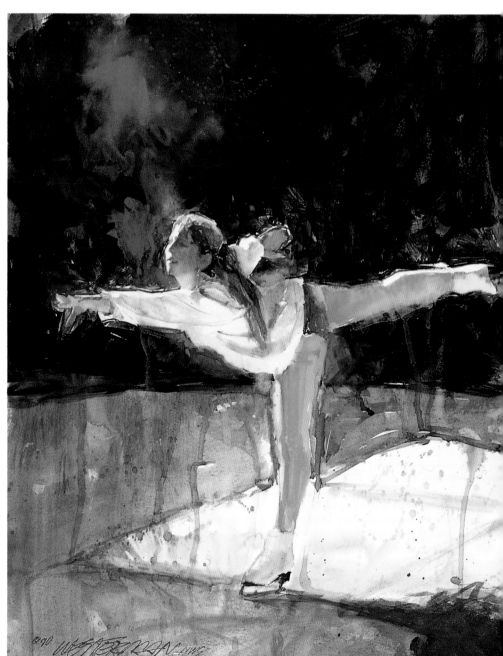

Ice Dancer (Jordana), 27" × 21"
The second illusion. This was painted for a gallery
show. I've changed the lighting completely. The
highly textured background with a blue lumines-
cence (cerulean) leads to Jordana, now caught in a
sort of spotlight. The ice is now purple. I've lost
many edges and allowed some to drip (painting in
wet), which gives my ice dancer an image of con-
stant motion. A yellow reflection connects to the
base of the painting.

USE WINDOWS AS BACKGROUND ELEMENTS

Place interior subjects near or in front of windows and take advantage of the sparkle. There is something downright poetic about the glow of window light on a figure in a room setting.

For years, I had a frustrating problem: how to keep what was happening outside the window from intruding on what was important to me inside the room. No matter how subtle I seemed to get, it was never unobtrusive enough for me.

Then one day, I saw a painting by Valentin Serov of a young girl seated at a table with her back to a window. But the window stayed "outside." He simply painted in sunshine colors and a suggestion of leaves, but kept the definition out. I've since kept things loose; here's how you can too.

First, mark out the window area and spray on some water. Then dab on dots and dashes — varied touches — of yellows, blues, and a wee bit of burnt sienna or cadmium red, and let those colors flow into the beads of water. Just avoid anything that looks like brushstrokes or defines forms that attract attention.

Don't try to fill in all the spaces; leave white space too. If you've covered too much with paint, sponge some off with a tissue. If the colors seem too strong, give them another light spray, hold the paper at an

There is something downright poetic about the glow of window light on a figure in a room setting.

angle close to vertical, and let the stuff dilute and drip. Use some of your colors to spatter the paper too, and if you want, give the spatter a light spray of water.

The unobtrusive window. This is a sort of springtime scene suggesting sky and leaves but nothing to demand attention. Run some of the mix of blues, yellows, and a little burnt sienna from the window into your figures, but leave some white space.

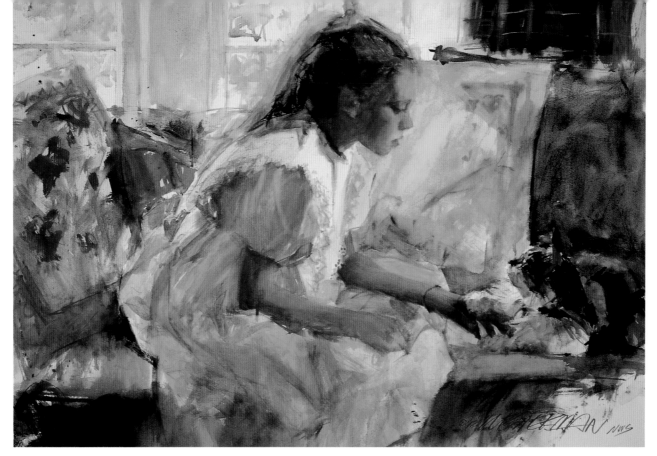

Cat's Paw, 21"×29"

Window light. This scene is lit by two windows, as you can see by the small diagram at right. I intensified the light from the second window facing Caitlin to give me dramatic facial highlights and rich shadows. We have such creative latitude, I could have altered the light to change the feeling. I want to reemphasize here that my viewer only knows what I tell him via my painting. I only have to make it *look* right.

If there weren't a second window, I would have used a lamp to get that light on her face. If I wanted to suggest that light was from a window, I might have made the colors cool. If it were coming from a lamp, it would cast a reddish-yellow light.

THREE WAYS TO LIGHT A FIGURE

Backlighting

If the window is directly behind the figure, the figure is backlit and will appear to be a silhouette. How much the figure is illuminated will depend on the artificial light in the room, or how much is reflected from the window back onto walls and ceilings. For the silhouette look, see the paintings of washer women by Degas. There may be some rim light in which one edge or both edges of the figure are light against the darker shape. Let some of that rim light disappear into the window light. A line or two can always be added later if needed to identify an edge (see *Hil-* *ary* in the preceding chapter).

Darker figures against a window seem to offer a more dramatic approach, especially where light-struck areas add rich contrasts.

Side Lighting

Add a measure of volume to the figure by having the silhouette modified with a strong or weak sidelight. The light may be created by another window or by a lamp. This allows more facial expression and is still very dramatic.

Sidelight is easy to read and can be quite dramatic. Lose some edges of the light-struck area of the figure into the lights of the window, or use the outside window midvalues to offer a contrast. Your choice.

Frontal Lighting

This approach can offer a type of pleasant flat lighting. A figure facing a strong light source with a light window background can be a very charming, high-key solution to a painting. The light source may be another window, strong room reflections or, of course, artificial light.

For a wonderful example of a front-lit painting in a similar vein, see Berthe Morisot's *The Little Servant Girl in the Dining Room.*

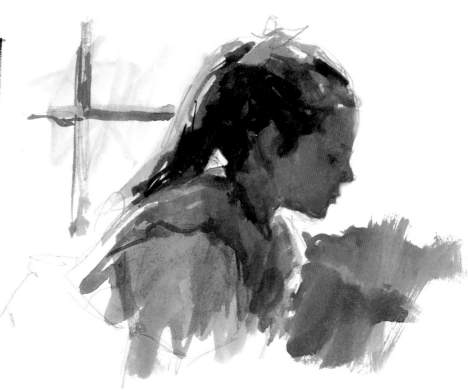

Here are two other ways I could have changed things. If I chose to have only the one window behind the figure to illuminate the room, the model's face would be dark, more a silhouette, more dramatic. The edge of the hair and bow would have nice highlights.

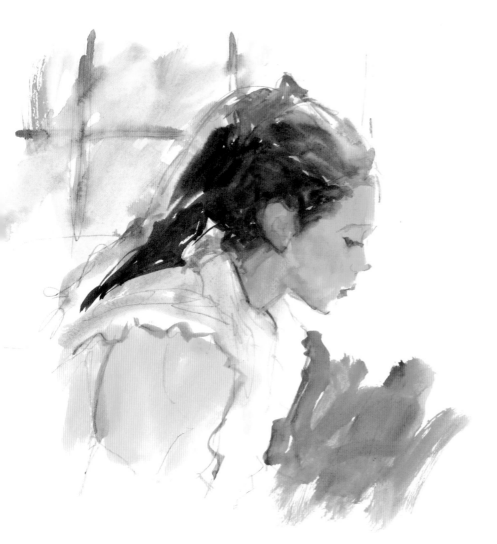

What if I added a window on the other side of the room facing the model? (Or possibly, strong artificial light.) Now, the model's face is light. The shadows depend on the angle of the light. The window behind her head will give the edges of her face and hair a very pretty halo effect.

Your Colors

Go for the bold!

W hen God introduced Adam to the first elephant, Adam asked why God called it an *elephant*. God thought for a minute and said, "I'm not exactly sure. It just looks like one."

Choosing colors is a lot like naming elephants. A great deal has to do with intuition and interpretation. Simply duplicating the colors you see in a photograph may not give your work the excitement you're looking for. It's just a starting point. Take a chance with your feelings and go for the bold.

Your first task is to feel the color *relationships*. What combinations of colors or what colors will best express the mood or feeling you want to express in your painting? What color combinations will accentuate the dramatic? Which colors should you exaggerate? Which ones should be neutralized that now seem to demand unwarranted attention? For instance, if a bright red sweater on a secondary character is attracting attention away from your center of interest, subdue *that* red or change colors.

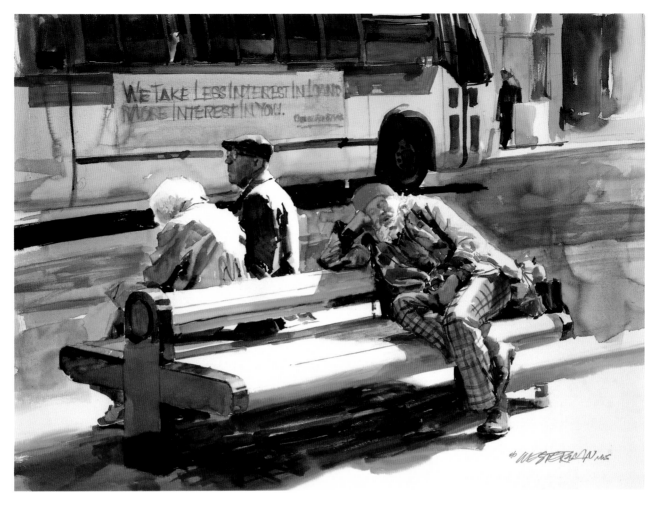

Campbell Soup Break, 25" × 33½"
Purple streets and white, light-struck sections combined with strong shadows are combined in a scene that in reality is not quite as colorful. The colors and my center of interest are designed to create a cheerful mood.

Color is related to its environment. You add life to your colors by connecting them with their complements. Compare the intensity and clarity of three colors against a white background with one composed of their complementary colors.

COLOR RELATIONSHIPS

Identity is related to environment. E.H. Gombrich points out that in order to see if a picture is hanging straight, you have to step back and relate the picture to the room. Colors must also relate to each other. Another analogy might be that your colors are like instruments of an orchestra. There must be harmony and contrast, and they must play to-gether to make something worth listening to or viewing.

Just as the definition of light requires a surrounding dark, a color doesn't really exist without either connecting somewhere with, or being surrounded by, its complement. Red on a white background doesn't have the same intensity it will when it connects with green. The green gives life to the red. Yellow is more brilliant when adjacent to or surrounded by purple.

Explore color relationships. It is not a red coat you see, but a red coat related to its surroundings. Should it be darker or lighter to flow into the mood, complement the feeling of depth, or connect in other ways to surrounding shades?

In some areas, the red coat may become greenish or grayed to blend

into its adjacent space. In its lightened areas, it may become yellowish and flow into a yellowish adjacent form.

In other words, to simply recreate the color you see in your photograph by mixing up a batch of grass or sky colors may be to shortchange the

Colors are like instruments of an orchestra. There must be harmony and contrast, and they must play together.

qualities of excitement and rich content possible by relating each color to the other colors in your painting.

Your color rough (see chapter nine) is the perfect stage to test fresh color ideas for your painting. Try to make colors more vivid or different, and consider the results. Try some surprising colors. For ideas, look over some great watercolors and oil paintings, and feel the strength of the colors. Look over your notated sketch. Let your imagination go.

COLOR QUALITIES: DEFINITIONS

Hue

The color itself—blue, red, yellow, etc.

Value

The concentrated color straight from the tube is either light, medium or dark in value. You can compare these values to the lightness or darkness in your thumbnail value studies. (See the color chart on the facing page.) You can also change a color's value by modifying its intensity with white (or black) paint or by diluting it with water.

A color may be darkened by adding its neighbor (adjacent color) or its complement (opposite). Adding the adjacent colors to yellow works best because adding its complement defeats the yellow and produces a muddy gray tint. To get a darker

value of yellow that will retain yellowness, add orange, burnt sienna or burnt umber.

Where a pure color is too dominant, a touch of its complement will neutralize it. For example, a bit of burnt sienna added to green warms up the green and keeps it from looking too raw. Mixing complements results in gray.

It's easy to remember the complement of a color without a color wheel. Since there are only three primary colors anyway—red, yellow and blue—the complement of one is the combination of the other two. Thus, the complement of red is yellow and blue, which makes green. The complement of yellow is purple, a mixture of blue and red. You now know all you need to.

Intensity

The range of a color from full

strength to its lightest value by diluting with water or adding paint.

Temperature

Is the color warm or cool?

Yellow is hot, blue is cool, and red can go either way—cool like phthalo crimson or hot like cadmium red. Add yellow to a cool red, and it jumps from cool to warm. To warm up a color, add yellow or orange.

Warm colors advance; cool colors recede. If you want to push something back, add blue. To bring something forward, add yellow, orange or warm red.

Outdoors, there are only two sources of light, the sun and the sky. Sunlight is yellow and affects objects with yellowness or warmth. Skylight is cool.

The farther objects are from you, the less yellow they contain. Eventually they become more and more

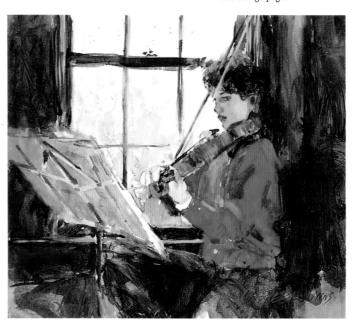

Violin Practice, 11½″ × 13″
The red sweater sings because it is bordered on almost three sides by complementary colors. The green shadows in the sweater also add life. The touch of blue in the music stand adds electricity to the orange pages.

tinged with blue, so that objects in the farthest distance appear purplish.

Near the sun, the sky becomes yellowish. That's why a sunny sky looks artificial without a touch of yellow.

For shade and shadows, add blue. A red in sunlight will look orange because of the added yellow. The same red object in the shade will appear bluish.

The generalization of advancing and receding colors applies indoors as well, although we don't have the same topical conditions. Window light is usually blue. Tungsten lightbulbs cast a yellowish glow.

That's the reality. Your reality, however, may be anything you choose that adds uniqueness or interest to your painting.

(Above)
Cool colors recede. Warm colors advance. To make a neutral red advance, add yellow. Make it recede by adding blue.

(Right)
Manganese blue and phthalo crimson make such wonderful music together. Look how the colors combine in places and separate out in others. A good reason to use this beautiful combination.

The values of saturated color. Here's one way to compare your full-strength colors to the lights, midtones and darks in your thumbnail value studies.

WHITE

CADMIUM YELLOW

GAMBOGE HUE

MIDTONE

ORANGE

PHTHALO RED

CADMIUM RED

RAW SIENNA

BURNT SIENNA

MANGANESE BLUE

DARK

CERULEAN

COBALT

ULTRAMARINE

PHTHALO BLUE

WINSOR GREEN

PHTHALO PURPLE

GETTING BOLD COLORS

In order to get bold colors, you have to go for it. That doesn't mean everything can be bold. It would only be a shouting match. Bold colors require neutral support.

To paint boldly, you must also have good, moist paints. One prob-lem workshop students have is the fear of wasting paint. They often work with dried-out colors in their palettes and wonder why their paintings have so little snap. Paint is meant to be used. It's always smart to squeeze a dab of fresh color into your palette before you start to paint. Moisten your colors by spraying between usings, and cover your palette to keep them workable.

Even when you're painting up a storm, the cheapest part of a painting is a little paint and paper. Your time is the valuable part. Don't be afraid to use plenty of paint.

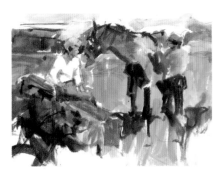

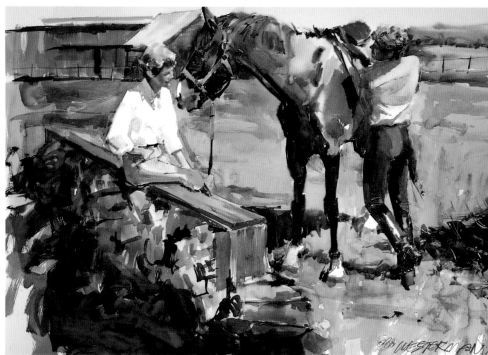

Saddling up by the First Jump, 25" × 34½"
A small change in color alters the mood. Notice how things cool down when we simply change the barn from red to blue. Dropping that red in the scene reduces the sunshiny feeling.

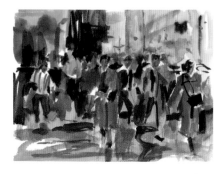

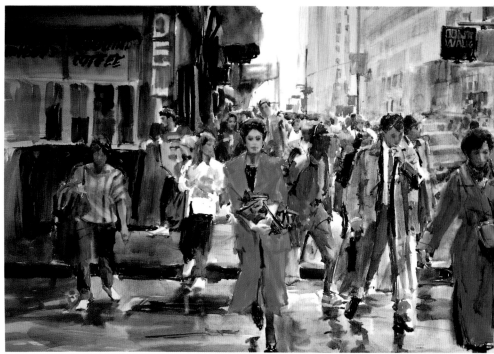

New York City – Woman in Red Coat, 24½" × 31½"
What if we had our leading lady exchange coats with one of our other actors? Not the same, is it? How we use color tells our viewers what's important. My central character would still be seen, but not with the dominance her red coat helps create.

FLESHTONES

I prefer translucent colors. A fairly good mix includes phthalo red or phthalo crimson, gamboge hue and raw sienna. I add cerulean blue to darken the mix if I want. In spite of its opacity, it's easy to control and requires only a touch to do its tinting. This combination is easy to lift if you want to lighten areas.

I remember in workshop demonstrations I've taken and taught, students often ask what particular pigment the teacher is applying. Is it cobalt, or ultramarine or something else? Well, in the case of my fleshtones, I've learned this: Any combination of red, yellow and blue will give satisfactory fleshtones. The only other requirement is permanence, and they all are permanent.

The flesh mix can be darkened progressively by adding cobalt or ultramarine blue in place of cerulean. Cobalt is very translucent. If you're going darker, use raw sienna, burnt sienna with cobalt, ultramarine (a warm blue) or phthalo (a cool). I like to use phthalo, but it's much harder to control, and as a stain, is harder to lift if you want to make changes.

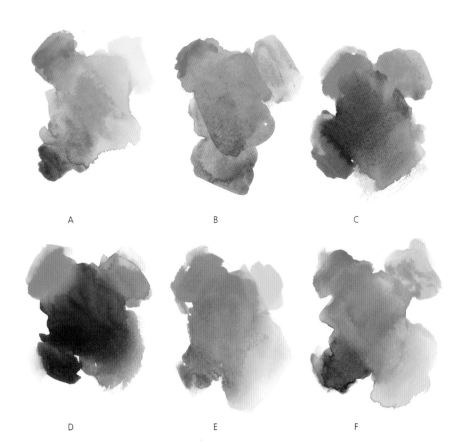

A B C

D E F

Some standard flesh tints include: (A) phthalo crimson, gamboge hue and cerulean blue; (B) phthalo crimson, raw sienna and cerulean blue; (C) cadmium red, raw sienna and cobalt blue; (D) cadmium red, burnt sienna and phthalo blue; (E) cadmium red, cadmium yellow and cerulean blue; (F) phthalo crimson, cadmium yellow and viridian.

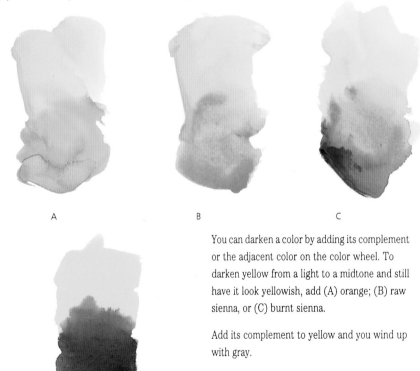

A B C

You can darken a color by adding its complement or the adjacent color on the color wheel. To darken yellow from a light to a midtone and still have it look yellowish, add (A) orange; (B) raw sienna, or (C) burnt sienna.

Add its complement to yellow and you wind up with gray.

YELLOW AND PURPLE

NEUTRAL GRAYS AND DARK MIXES

Neutral grays are made by mixing complements. I like to mix cerulean blue and cadmium red for a warm gray. Cerulean blue and burnt sienna make a cooler one. Orange with ultramarine blue makes a warm, darker one. Cobalt with orange makes a middle one. You get the idea.

Dark darks sometimes are a problem. I like phthalo blue with burnt sienna for a greenish dark. To get blacker, I will add a touch of crimson to that mix. To get warmer, I'll add a touch of cadmium red in place of phthalo red. Ultramarine blue combined with burnt sienna makes a good dark but can get too black for me. When I use these dark darks, I try to keep some separation in the colors, so you see touches of blue, red or burnt sienna, rather than just a flat color. Scrubbing with a brush on hot-press paper contributes to that effect.

An extra reminder: Any color you use should appear and reappear in your painting. No color should be completely isolated.

ULTRAMARINE AND BURNT SIENNA

CERULEAN BLUE AND BURNT SIENNA

ULTRAMARINE AND ORANGE

PHTHALO BLUE, BURNT SIENNA AND RED

CERULEAN AND CADMIUM RED

PHTHALO BLUE AND BURNT SIENNA

Some of my typical darks. Cerulean blue and cadmium red make a lovely, warm gray. I don't use black paint, because I want my darks to show some separation into their various colors.

Study for *The Refreshment Stand Is Closed*
I used a deep fleshtone on the figure to the left consisting of phthalo blue, burnt sienna and a bit of phthalo crimson. The other figure to the right, being in shadow, is a stronger mix of the same colors plus some cadmium red.

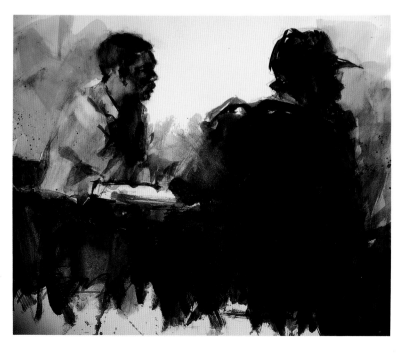

PERMANENT WATERCOLORS

Since all my paintings are guaranteed for a thousand years or a thousand miles (whichever comes first), I use only permanent colors.

Commercial artists don't need permanent colors. Fugitive colors are just fine because their original art is painted basically for reproduction. Once the original has served its purpose it may be destroyed. That's why you'll find a good many beautiful but fast-fading pigments produced by most watercolor manufacturers. Don't use them.

For us, watercolor should be permanent enough to last for generations. Look at the label or ask your dealer about the permanence of unusual colors you want to try out. For complete information on permanence of watercolors, see *The Wilcox Guide to the Best Watercolor Paints*, published by Artways and available through North Light Books.

My palette is made up of the following colors that work, mix well and resist fading:

Gamboge Hue. I use this translucent yellow for most mixes, particularly fleshtones, where I like the brilliance of the paper showing through.

Raw Sienna. Also translucent and good for fleshtones. I use it extensively.

Cadmium Yellow. Opaque but good for many things. Makes brilliant mixes. Great for foliage and grass mixes with phthalo blue.

Try this: On a dark, green-blue area (maybe representing trees or shadows), give a spray of water and dash on a bit of cadmium yellow. Spray again, so you get some nice little drips. The result (shown right) offers an interesting effect.

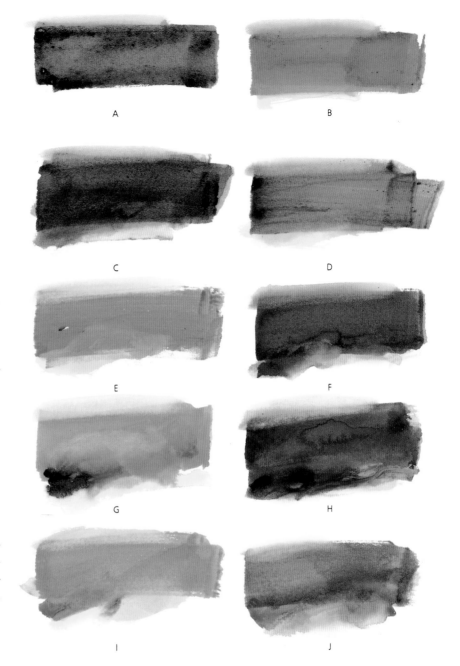

Some lively green mixes I use include: (A) viridian; (B) viridian and cadmium yellow; (C) viridian and burnt sienna; (D) viridian and gamboge hue; (E) gamboge hue and viridian; (F) phthalo blue and gamboge hue; (G) gamboge hue and phthalo blue; (H) gamboge hue, phthalo blue and burnt sienna; (I) cerulean blue and cadmium yellow; (J) cerulean blue, gamboge hue and phthalo crimson. Notice that you can get perfectly good mixes with the blues, yellows and reds in your palette without buying any special colors.

Opaque colors, such as cadmium yellow, applied to a moistened base color like phthalo blue, then lightly sprayed with water, create a nice effect.

Winsor & Newton Lemon Yellow Hue. My bandage color. Very opaque. I use this particularly for skin tones when I can't scrub off some stain that's ruining the area I want to finish. Very expensive, but a tube should last almost a lifetime. Naples yellow is darker and has a tendency to darken in time, but it also works this way and is cheaper. This is a must when you're working on a painting for a show that won't allow opaque white. Otherwise, add some white paint to your mix and get a similar effect.

Burnt Sienna. Mixes well with ultramarine blue for great darks; warms up cool greens and other colors; makes nice shadow color for figures when mixed with cerulean blue.

Cadmium Red for accents and mixes.

Grumbacher Thalo Red or Thalo Crimson for flesh tones and most red mixes. Warms up nicely with gamboge hue.

Winsor & Newton Quinacridone Permanent Rose makes a beautiful, clear pink.

I seem to have trouble finding the right blue, so I use almost anything, depending on the darkness needed.

Cerulean Blue. Opaque, easily controlled, easy to wash off, good for middarks in figures, makes a great warm gray with cadmium red, and is a great accent color. Don't buy the cheap variety, which might be called *blue tint*. It's just white paint with a little blue in it, and it doesn't behave.

Manganese Blue. Mixes beautifully with Thalo Red or Crimson to make a lavender or purple. The blue flecks seem to separate out somewhat. Very nice!

Cobalt Blue. For medium darks. Easy to control, translucent and very washable.

Ultramarine Blue. For most needs, including warm darks.

Phthalo Blue or Prussian. For cool darks. A little hard to control for skies, but makes a wonderful green-cast dark when you add burnt sienna. Also add red, and it goes to black.

Phthalo Green. I use this one occasionally mixed with gamboge or cadmium yellow to make great grass and tree colors. Warms up with a little burnt sienna, cadmium red or phthalo crimson. Add cadmium yellow, and it makes a brilliant light green.

Phthalo green and blue, being staining colors, are harder to lift. You can also make perfectly acceptable greens from the blues and yellows in your palette.

Winsor & Newton Permanent Designer White Gouache. Be sure to tone down white, or it will stand out like a sore thumb. If you dampen the immediate area before you paint it on, it gives you the good effect and takes off some of the curse. Perfect for the tiny highlight in the eye. Can't be used on paintings that go to some juried shows, which prohibit opaque white, another bandage color. Now, isn't that strange? Opaque white can't be used, but opaque cadmium colors and cerulean blue can be. Well, we don't make the rules, do we?

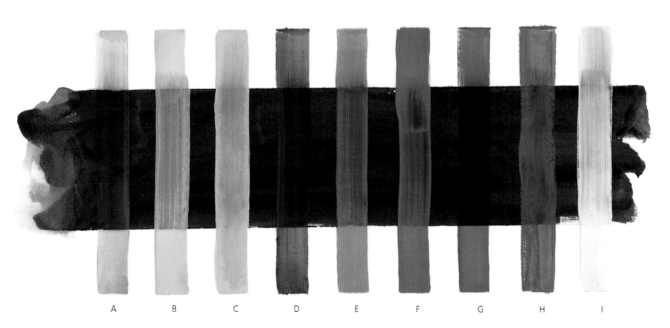

A comparison of the opacity of a number of colors we use. You can see why phthalo crimson and gamboge hue let the white of the paper shine through. (A) gamboge hue, (B) cadmium yellow, (C) lemon yellow hue, (D) raw sienna, (E) cadmium orange, (F) cadmium red, (G) phthalo crimson, (H) cerulean blue, (I) white gouache.

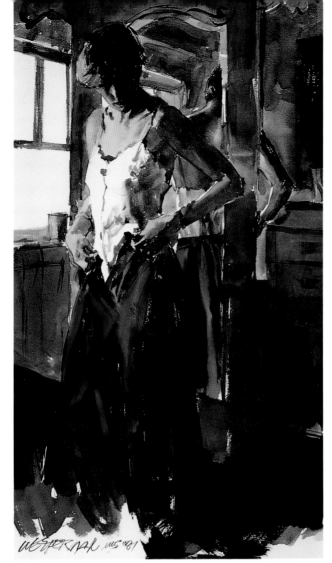

Crimson Skirt, 24½" × 13"
Change the color, change the mood. What happens when we shift the spectrum from low key to high key? Would the painting still have the same kick? You be the judge.

COLOR FADING

It pains me that watercolors are rarely displayed in museums. They are hidden away in dark drawers to prevent their colors from fading.

It's true that a watercolor will fade faster than an oil when both are exposed directly to the sun. Although composed of the same pigments, watercolor is applied as a much thinner film and doesn't have the heavy binder of oil to protect it.

Today, however, watercolors can be kept from fading permanently with new protective conservation glass and UV-filter acrylics. These new products block out up to 99 percent of the ultraviolet rays, which do the damage. Maybe it's time museums invested in reglassing their wonderful watercolors and started displaying them on their walls.

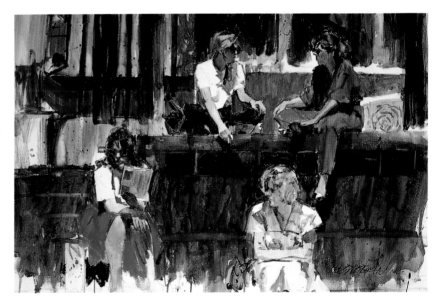

Max Passes Pioneer Square, 28" × 38"
Max is the local name for the light-rail system in Portland, Oregon, and I have one of their cars serving as background for a colorful scene of young people in the central square of the city. The hot colors represent life, a regular ingredient of the square.

PART THREE
The Westerman No-Fault Painting System

Mora, 14" × 21"

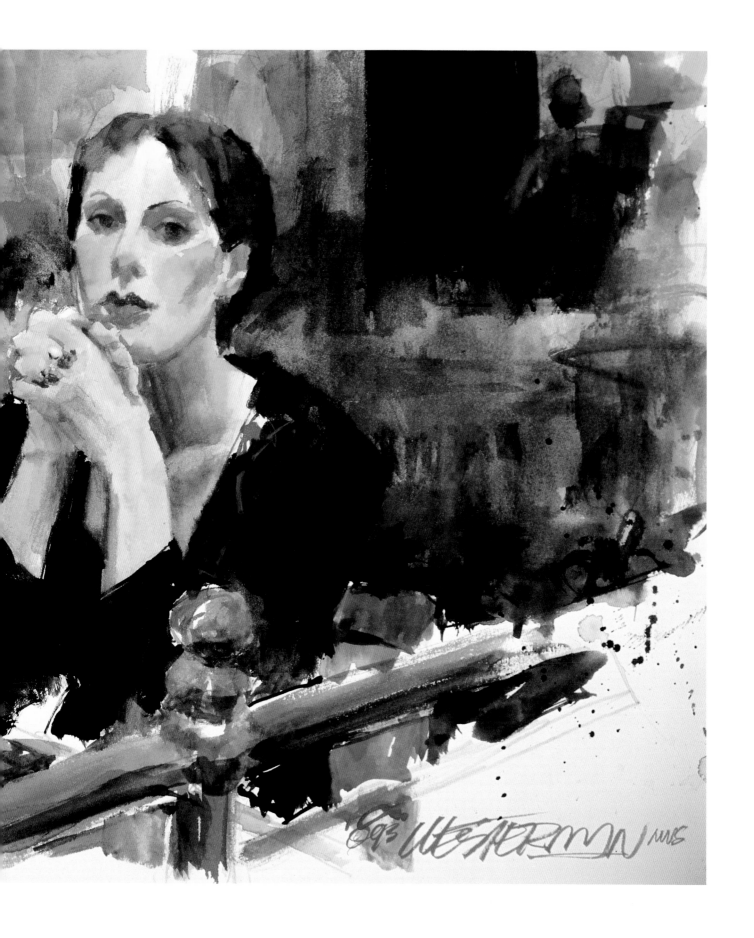

The Compositional Rough

Do you have a viable, exciting painting?

So, you have some material to work with, a few photos, something stirring your emotions, and an idea that looks good to you. You're in your studio or kitchen or wherever with a half or full sheet of watercolor paper, and you are itching to sketch and finish the perfect painting. Is this how you usually start?

I've gone that route — working from snapshots and ideas to finished painting in one giant leap. Sometimes it's worked. Most times it's resulted in more pressure than fun. I don't know how many times I've cautioned myself to look out for the next brushload for fear of losing the painting. (You know how much that can tighten you up?) Then I'd spend hours adding to or washing off this and that and, just maybe, figuring it out. Or, I might end up with some judicious cropping.

My biggest problem had been that I was not beginning with a composition. I was simply starting with an idea, some good photographic material, and enough confidence in my instincts to expect a painting to evolve. Sometimes it worked.

But for me, it resulted in too many unsolved problems at various stages in the work: uncertainty, sweat, lost paintings and plenty of self-doubt. I wanted to know that I could begin a work with a complete, exciting, dramatic, balanced *rectangle*, and not find out that I didn't have one at the end.

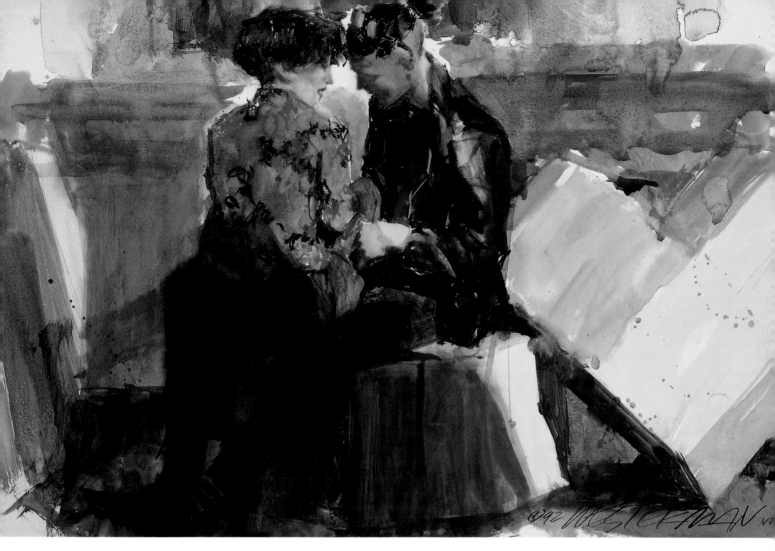

On the Square, 21" × 29"
This is one of a series I did of people in Pioneer Square in Portland. I think the main message here is that young people are beautiful regardless of how they cut their hair.

That's why I decided to paint in three easy stages. I found that it was simply easier for me to plan the arrangement of elements in my painting on small pieces of paper before I started the final work. The actual painting became much more fun, and I felt a lot more freedom and joy in the process.

I know of painters who, with years of practice, have learned instinctively what will develop without making preliminary sketches. I've also met artists who paint virtually the same thing over and over because of demand. They don't need to plan. They've done it before. But the best artists are the ones who are always doing something new, testing

their limits. And that takes planning.

In summary, I've seen enough painting failures in myself and others to want to choose this way to beat the odds.

MY THREE-STAGE PROCESS

My *first stage* consists of small value studies that enable me to put together the elements of my composition and develop a unified structure. I will add to or delete pieces and

The best artists are the ones who are always doing something new, testing their limits.

solve my design problems on a small scale before I do any "carving in

stone." It's easy to experiment at this level. These small studies don't take long to do, and they tell you a lot.

In my *second stage*, I transfer my design to a larger sheet of paper and choose colors that will add vitality or expression to the work. I will pretty much know before I'm committed to the final painting what color combinations I think will work.

The actual painting is my *third and last stage*, and that takes place after I have solved most of my design, color and painting problems. This leads to painting with a great deal of freedom and confidence.

PLANNING THE COMPOSITION

Our First Stage: The Value Sketch

Our first step in a painting is to design the structure. Let's start by looking over the photo material or sketch and the idea you're going to translate into a design. What things are necessary to get your feelings in your painting? What is the central element, and what is supportive? What things in the photo are superfluous or may actually confuse or interfere? Eliminate them. Don't be afraid to change the position of elements or add things that will strengthen your composition, heighten the drama, or serve to better clarify your statement.

Take a look at Edouard Manet's *Bar at the Folies-Bergères*, and notice that the reflection of the barmaid facing us could never have occurred there. If we had been facing the woman directly, her reflection would have been behind her. We would never have seen it. He changed that reflection in order to strengthen his painting. Yet we are willing participants, because seeing her back makes the work more exciting.

Your objective in creating a scene from your elements may require many creative modifications. Your viewer is willing to accept your version because he *wants* to believe you.

Now, make some more decisions.

Using the picture space, decide what you want to emphasize. A range of views from distant to close up and any stage in between is a factor you should consider for every picture you paint. How close do you want to be to the object? What object is most important? Is one thing going to fill up all the space? These are questions you need to explore.

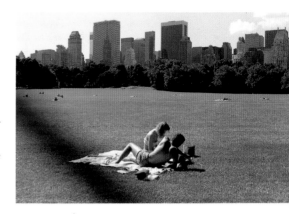

This photo might be the starting point for a painting called *Picnic*. I connected to the scene emotionally through contrasts of content, color and shape. I felt the opposition of restful space to mix of crowded streets and skyscrapers; soft, green lawn with hard, blue-gray boxes; small people against giant buildings. It makes an interesting enough photograph and a good starting point, but as is, it would make a poor painting.

To really see it, I have roughly reduced the photo to its two abstract shapes. One is a broad, horizontal stripe that includes buildings and trees. The other shape is a blob in the middle of a sea of light green, negative space. There are no connections, and neither shape dominates. The two pieces have identical interest. The blob gets its strength from a "bull's-eye" effect; the building-trees strip has size to draw the eye.

The problem: What is most important and should dominate, and what should recede? How do I tie these shapes together to make up an interesting, integrated rectangle? What if I linked the people blob to the building-trees strip by massing in some dark shapes like trees and shadows on the left?

Why doesn't it seem to work? I've connected shapes, but the buildings have remained the same size, and even though the figure shape has increased in size, too, both shapes are still fighting for attention. Another problem: The figures now seem to be floating, and I'm bothered by perspective.

There are many solutions, but the one I might have chosen was this: First, my figures dominate. I reduce and soften the buildings and make the treeline deeper to contrast my lights against some dark background.

I also add some tree shadows in the lower left to "ground" the blanket and connect it to the sides of the painting. This also lends some rhythm to the composition. If I make the blanket orange, I will use that color in other areas of the painting.

Now, I'm confident I could proceed to the finished painting with a reasonable chance of success.

OVERLAPPING AND CROPPING

Overlapping elements and making things smaller in size is a way of adding interest and suggesting depth. Overlapping creates larger structures. But be careful about overlapping and cropping that may lead to the loss of identity. Objects have to read. You must provide sufficient clues.

What brings your viewer to your center of interest? What shapes can you combine to create new and exciting forms? Is there a road through your painting you want your viewer to travel?

SUBJECT MATTER ISN'T ART, YOUR INTERPRETATION IS

Start by drawing a simple rectangle in pencil about 4″ × 5½″, which is in proportion to a full 22″ × 28″ water- color sheet. This is going to be your basic shape. However, you can change those proportions if a different shape works better. Decide whether things work best in a vertical or horizontal format. What's logical? What would be most dramatic? Try it each way until you're satisfied.

Don't use the edges of your paper or pad as the borders. You may want to change the shape of your rectangle as you proceed, and you can't do that with the edge of the paper.

A vertical shape in a vertical rectangle is a typical form for a portrait. Would a horizontal approach offer greater novelty and more imaginative opportunities?

In either case, both need horizontal and vertical anchors to unify the painting. Those anchors can be elements suggested in your photograph such as line, texture, or abstract shapes you create.

Next, you are going to translate

A starting point for a classic painting. The body of the model makes a good diagonal. A large dominant shape with smaller complementary ones. Nice action. Romantic.

How does it translate into a horizontal? I would abstract the background shapes or create a new, nonintrusive setting. For balance, I would center the head in the rectangle. I would add some connecting shapes to her skirt. This approach might take some thinking.

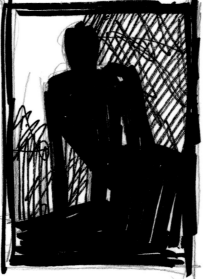

The vertical solution. I could make the model larger, more in command of the space. If I did, I would make connections to the horizontal and vertical edges, undefine the background, and create some lost edges and new shapes.

The vertical solution in rudimentary color. Could put more thought into that one.

what you see into abstract elements. You are going to look at things in a new way: in two dimensions.

Imagine the painting surface as a flat rectangle covered by flat, two-dimensional shapes you create. See your objects not as people or things, but simply as abstract shapes, such as circles, squares, triangles, rectangles, and jigsaw shapes. Alter, move, or combine them with other shapes to provide the best possible arrangement. Remember, you're not stuck with things as they are in a photograph.

All components of a painting are abstractions. Learn to see things in this way. Don't consider the details or allow them to influence you in seeing shapes. Try squinting or blurring the image to help you focus only on the major shapes at this level. Rely heavily on intuition to feel the concept.

See where you can create new forms. Can a shadow on one form be combined with a similar dark area it touches? Same thing for light shapes. Eliminate some lines and wind up with nice lost edges. Avoid

Here's a rough pencil sketch of a scene that I saw. People on steps, a wall in back of them. I liked the third figure from the left because of the way she placed her feet.

As a design, there are only two shapes, and lots of space between.

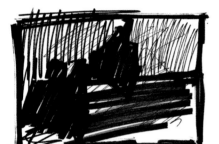

I connect the two main shapes, but the negative space doesn't work.

What if I added a vertical element in the negative space? A man (whom I borrow from another scene) walking toward us. It now makes a nice pyramid shape.

I jumped the gun and made a drawing of the revised scene. I now see a problem in cropping. Leaving space around the man and the woman at the top doesn't let the viewer see immediately my center of interest (see arrow).

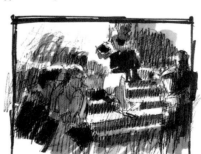

A little surgery with the borders, a suggestion of shadows and lights, which I can further define in color, and there is now no question of focus.

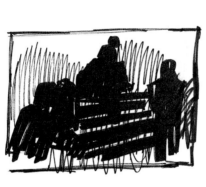

L.P.N., 15" × 11"
Most of our lives are spent waiting, and this is a pretty good example. Notice the connections to the sides with the bench and the red line. The legs suggest the base connection.

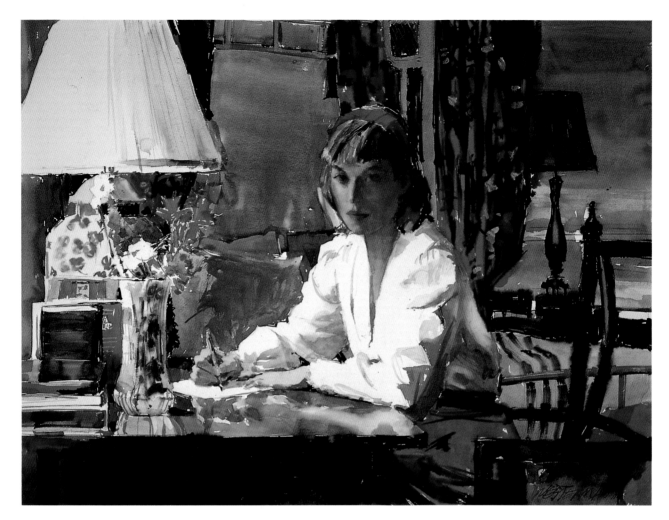

lots of small shapes.

Arbitrarily create some dark or light forms that connect with others. Make part of a light background a dark one if that will enhance the composition. Now look for some rich contrasts of darks against lights that can lead your viewer to your central idea.

Make your value study in white, black, and one or two tones of gray. Move things around or alter borders by erasing lines, or make a number of roughs until you're satisfied you have a good design. Cut pieces out and paste them on a new rectangle if you wish. If the value study expresses a cohesive, interesting, active composition in these *values*, you are ready to take the next step.

On the other hand, if after all your doodling you can't come up with a workable approach to a painting,

you may not have the right stuff to work with. Or, the solution is beyond you for the moment. Set it aside and come back to it later, or start with material that offers you a better chance for success.

I have photographs I took ten years ago because they suggested exciting possibilities. I've tried to make paintings of them during the course of time and have been unsuccessful. A painting I completed quite recently, which won a number of awards, was based on photographs I had been trying to paint off and on for years. It's just that I finally knew what to do, and that experience took time. I could have done something with it years ago and it would have been OK for what I was doing then. This time, I was proud of it, because I did things to that painting that took me this long to learn.

The Writing Desk, 26″ × 34″
The model and I "borrowed" a room in the Macmaster House in Portland, Oregon, a bed-and-breakfast with wonderful eclectic furniture, and created this "letter to a friend" scene. Since then, being too lazy, I've avoided detailed things.

The Color Sketch

Take the guesswork out of color selections

When you're satisfied that your value study is your best solution as a composition and your values read clearly, translate your thumbnail study into a color sketch. Make the largest dimension of your color sketch about ten inches or smaller. You want to take as little paper, time and effort mapping out and painting the color sketch as you can. The main objective here is to organize your thoughts and cover as little area with paint as necessary to develop your ideas.

Use the design you created in your thumbnail to lay out your color sketch. Don't rely on your photo except for necessary elements. At this point, your thumbnail probably doesn't look much like your photo anyway. You have moved things around to where they work and make a good composition. The figure on the right may now be on the left, or the hill in the background may be two hills, or whatever. Also, at this stage, you're not concerned with details like facial features. Concentrate only on the main shapes.

Start your color sketch by outlining a rectangle the same shape as your thumbnail drawing. Once you've decided on the shape, you have to stay with the same proportions. Obviously a narrow, rectangular rough is not going to turn out to be a square. So scale up your rough by extending one vertical and one horizontal line. If the painting is going to be a vertical,

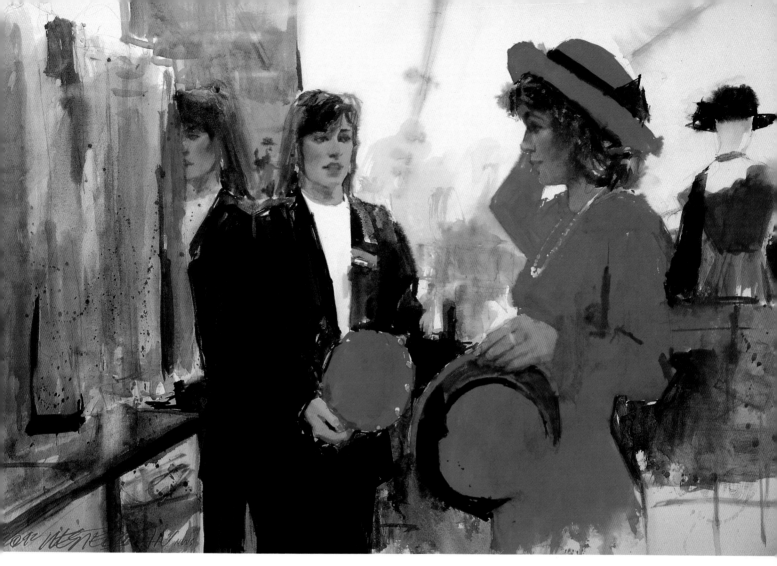

extend the vertical line ten inches. If a horizontal, extend that line ten inches.

Now, draw a diagonal line from one corner and through the opposite corner of the rough, and extend that out. Draw a line from your ten-inch mark to the point where it crosses the diagonal. That's your width. Draw a line down from the mark, and you have a rectangle in proportion to your rough.

You will be using the same scaling method going up in size to your finished painting.

Again, don't use the edges of your paper as the borders for your color sketch. Draw a good, dark line to define your shape so you can really feel the boundaries.

Your color scheme should reflect your lights, midtones and darks. Your job now is to develop colors that will express the values you've chosen.

Don't necessarily choose colors you see in your photograph. This is the time to introduce colors that better describe your feelings, work bet-

Your color scheme should reflect your lights, midtones and darks.

ter for the overall effect, or are imaginative and add spice.

For instance, a sandy beach can be expressed in a variety of colors, all the way from a cool gray, through the yellows and siennas, to the wonderful red we see in the work of the Spanish painter Joaquin Sorolla.

Shadows on buildings can be represented by what you think you know (dark brick) or by what you think would be unique. The light-struck shape on a face can be a light flesh

Hats and Scarves, 20″ × 28″

I had my model trying on hats, while the patient saleswoman offered the next selection . . . a common enough scene in a department store, but always charming.

The real problem in a painting of this type is to simplify the clutter of intruding merchandise and busy background and still have it read as "department store." I established the setting by using a hat mannikin connected to my center of interest, and lightly indicated scarves to bring the viewer into the reflection of the salesperson.

1. Extend the vertical line to 10"

2. Extend the horizontal line

Original Rough

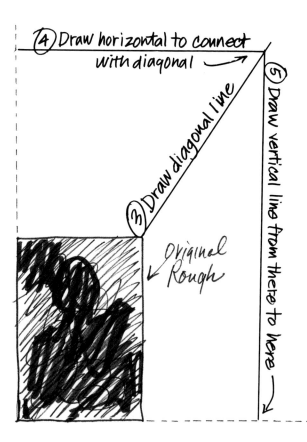

4. Draw horizontal to connect with diagonal

3. Draw diagonal line

5. Draw vertical line from there to here

Original Rough

color, or it can be pure white or light blue. By the same token, the shadow areas can be lighter or darker running toward the greens and blues.

Experiment now when it's fast and easy. Don't be afraid to take chances. You can afford this time to experiment. If it doesn't work, you can always wash it off, try other colors, cut and paste, or at worst, start another sketch.

I know you're chomping at the bit to lay on the color, but just a couple of suggestions: Colors you use in the background should also appear in the foreground. Using a bit of cad-

Experiment now when it's fast and easy.

mium red on a scarf in the foreground? Wash some into the background. No color should be completely isolated.

Here are five easy steps for enlarging your thumbnail:

1. Extend the vertical line to ten inches or less.
2. Extend the horizontal line.
3. Draw a diagonal line from one corner of your thumbnail sketch through the opposite corner and extend it out.
4. Draw a horizontal line to connect the extended vertical line with the extended diagonal.
5. Draw a vertical line down to connect that point with the horizontal line.

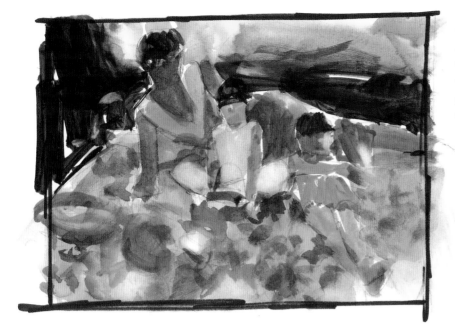

Color study for *Susan, Meriwether and Margo*
20" × 28"
Once I had decided the value study was OK, I had to develop some bright colors for the scene. The setting was the shade of some trees and the effect was too much toward the blue.

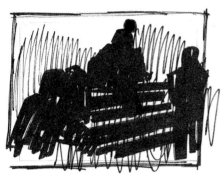

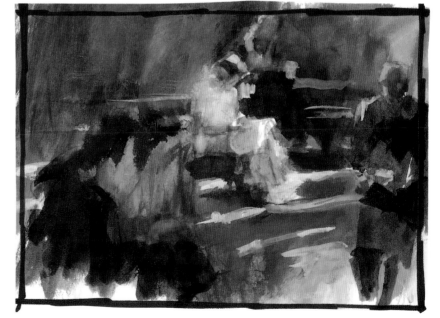

Here we're starting with a black-and-white value study. We need the information developed in our drawing to make a color sketch. My objective is to accentuate my central character. I thought a light area behind her, connecting to the light-struck part of her shoulder, might immediately direct the eye to her, but it didn't work too well. I played down the two women to her left, the woman behind her, and the man coming toward us, but I thought I needed to add more color, which I did. In the final painting, I think giving my central figure more lights and a more colorful costume will serve the purpose.

Color study for *Carnegie Studio*
The black-and-gray rough identifies my abstract elements, which include reflections of dancers in the mirror above my main dancer, plus another dancer on the right to add depth. Everything but my central dancer was either to be put into a larger shape or left vague. The problem otherwise is that all the details would overwhelm the painting.

I had returned to some photographs to get the information I needed for this color study. As you can see, I've tied the reflections together and connected the standing dancer with my center figure. She is the only figure that is fully developed. See the finished piece below for the final outcome.

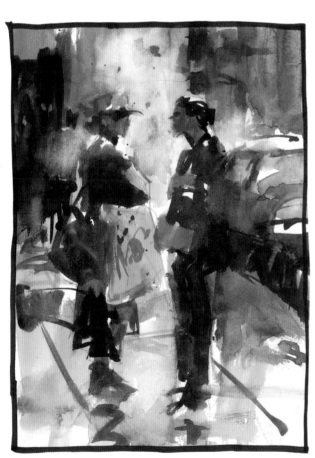

This is a study of two figures in a New York street scene. I've run a sort of shaft of light down the center of the study to give my figures some space. It really isn't necessary to be any more detailed than this. You can tell that's a car to the right, can't you?

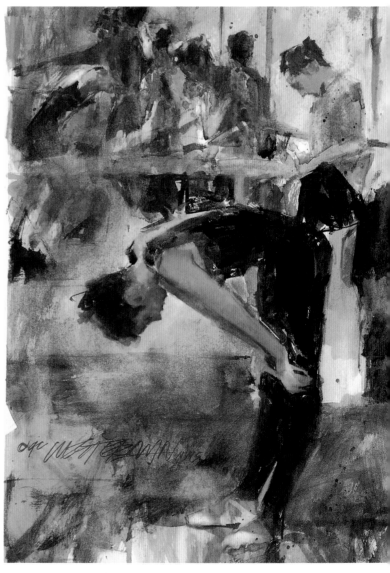

Carnegie Studio, 14¼" × 10"

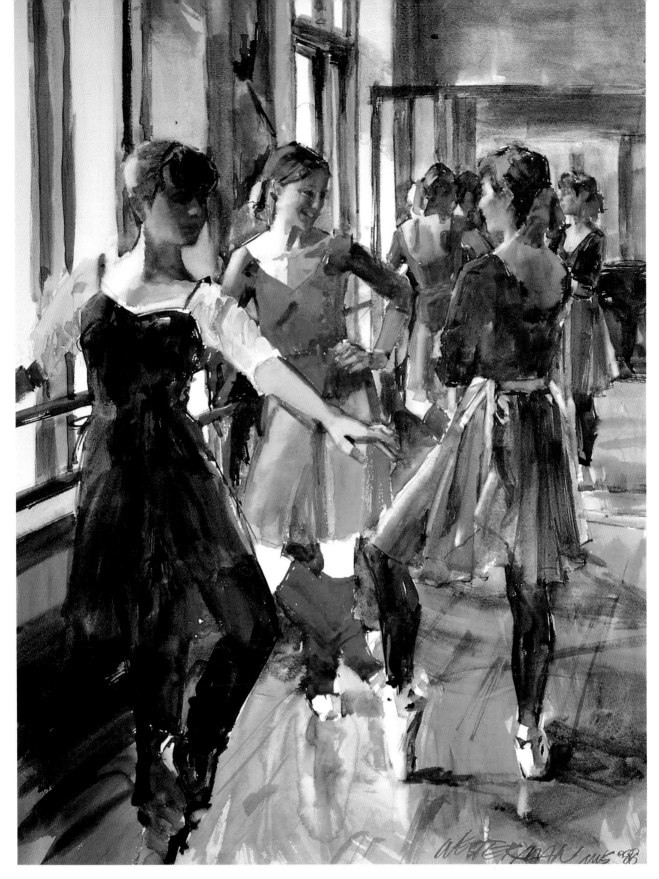

Ballet Friends, 33" × 25"

I particularly like this painting because of the stance of my dancer in red. The tilt of her head, hand on hip, position of feet, all show warmth and friendship. Had I to do it over, I would blur the reflections behind her, soften the figure in front of her, and make a stronger connection to the right edge of the painting using the dancer she is speaking to.

Now Paint It

The hard part is done . . .
now have fun

Welcome to the third phase of the Westerman No-Fault Painting System.

At this point, you've done the hard work. You've turned your emotional raw material into a workable composition with your rough. You've built a rectangle composed of abstract shapes with a recognizable center of interest and strong design elements.

In your color sketch, you've created a color scheme to make the final piece exciting and to express your mood. Your selection of colors corresponds to your mood and values. You've worked out most of the color problem areas you are likely to encounter when you paint full-size.

The only thing left to do is relax and enjoy the final painting you're going to do. The pressure is off, and the fun is on.

I call this last step *no-fault painting*. I simply mean that you're free to take chances, make mistakes. Whatever you do can be undone, changed, corrected, eliminated. Something new can be substituted. We're going to take advantage of all the flexibility watercolor has to offer.

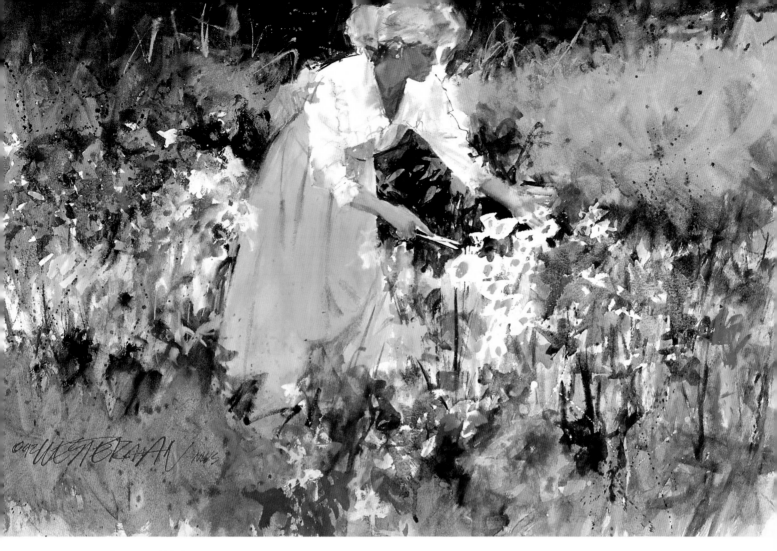

UNDOING WHAT YOU DON'T LIKE

Any paint except a stain can easily be washed off. If you want to change a large area, brush and work some water into and a little beyond the portion you want to lift. You can always restate the surrounding colors when you've made your changes and the paper is dry.

Sponge up the wetted area with absorbent tissue. One or two applications should do the trick.

Where staining pigments are used, it may take another washup. If your paper doesn't come white enough, the next step is a little scrubbing. In that case, wet the area and *push* the bristles, using absorbent tissue to soak up the wetted paint. To avoid overly damaging the paper surface, try not to repeat the procedure more than necessary. You may want to avoid phthalo blue,

Signs of Spring, 27″ × 39″

The drawing below illustrates what I had designed and painted as *Signs of Spring*. Unfortunately, it looked good in the first two stages, but no matter what I did to it as a painting, it just didn't work. At the suggestion of my wife, I washed out the smaller figure and wound up with a good piece. That's what this chapter is about. Painting for fun. You can always make changes to improve your watercolor. Can you tell where I scrubbed?

Now Paint It

A. GAMBOGE HUE

B. CADMIUM YELLOW LIGHT

C. RAW SIENNA

D. CADMIUM ORANGE

E. PHTHALO CRIMSON

F. CADMIUM RED

G. BURNT SIENNA

H. ULTRAMARINE BLUE

I. COBALT BLUE

J. CERULEAN BLUE

K. MANGANESE BLUE

Most paints wash off Lana hot-press paper easily. I didn't include the phthalo blue, phthalo green or Prussian blue. They take a little scrubbing. Strangely, the cadmium red looks like it didn't wash well. It usually does.

If you use staining colors, two or three applications of water may be necessary. Push the brush to get best results. Cover enough area with water and brush, then sponge up with a paper towel or tissue.

phthalo green and viridian. The others are easy to lift.

If you want to lift a small section, such as a line, use a small brush. You can use a larger one, but you'll have to restate the surrounding area. Go over the line and follow it up by pressing with a tissue. The paint will usually lift the first time.

If you're lifting a dark from a light fleshtone, and you can't get down to white paper or lighten an area enough to paint with translucent colors, do my bandage number. Make a flesh mix of cadmium yellow, cadmium red and cerulean blue. If that doesn't work, substitute Winsor & Newton lemon yellow hue or Naples yellow for the yellow. That should be opaque enough to work. If not, add a little white. One of those will work for you.

SCRUBBABLE PAPER

For our painting, I suggest a hot-press paper like Lanaquarelle, although their cold-press is also quite scrubbable. I think hot-press is easier to control than illustration board. With a simple wetting procedure, I can lay on a series of glazes and keep the underpaint from dissolving. On illustration board, unless you're lucky or use a gouache underlayment, the next wet glaze often erases the last one.

One of my teachers suggested that a painting should look good at every stage of the process. Unfortunately, that idea makes me nervous. I'm never quite sure whether the next stroke is going to be the right one or the one I scrub out. As for having my paintings look good at every stage of the way, I can tell you

frankly that much of the time my midstages look terrible.

Which leads me to a point I want to make while you are in the middle of your painting. Don't stop painting. Just let me whisper in your ear while I look over your shoulder, "Just because it looks pretty ugly right now, it doesn't mean a thing. You're going to bring this one off because you can change anything to make it work!"

Many painters want to quit when their paintings look like something to put under the car to catch oil drips. They're usually quitting too early. I don't mean to imply that from this point on you won't have any failures. All of us do, and you will too, so don't get smug. *But*, you will have fewer throwaways, fewer pieces that defy immediate solution, because you've done the groundwork.

Redhead, 14" × 10½", first version
I thought this had turned into a good painting, and I sent it to a show, where it didn't sell. When it came back, I had a chance to look it over and figure out something that had bothered me earlier but was unable to pinpoint. I decided her right shoulder pulls the viewer out of the painting.

Redhead, 14" × 10½", final version
Kill the right shoulder. Add some color, and connect the darks from her right shoulder back up toward her eye to make a better circular movement. Mind you, the changes were made months later, and the paint was removed easily and repaired.

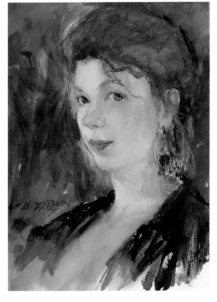
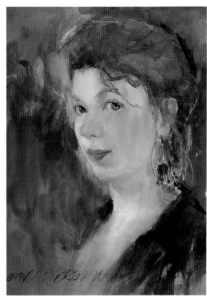

SCALING UP TO SIZE

Now, let's scale up our rough as a guide to placement of elements on the page, the same way you scaled from rough to color sketch. You can also adjust areas where they seem to need modifying and move things around a bit. The larger version will invite as much flexibility as you want.

When you go from a small sketch to a full-sized painting, you can develop colors and add elements and textures that you may not envision on a smaller scale. No problem. Stick pretty much to your basic colors, values and design, and forge ahead.

Refer to your photographic material to sketch in portions with more accuracy or for important details. Remember that when you use details from the photo, you are not going back to square one and reproducing a photograph. You already have a good design. Follow that.

Pencil in your lines dark enough so you can see them after they're covered with paint. If those lines are important and have become hard to see, redraw them. And when you're finished with the painting, don't erase all your lines. They add texture, give your painting expression, and show the viewer how you saw things—a sort of visible blueprint.

Now, tape your paper down on all four sides. Make sure that the masking tape is sticking to *all* of your paper and board before you start painting. The painting may look crinkled up while it's wet, but it will flatten down nicely when it's *completely* dry. Be careful to avoid tearing the paper when you remove the tape.

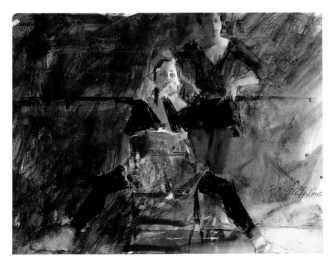
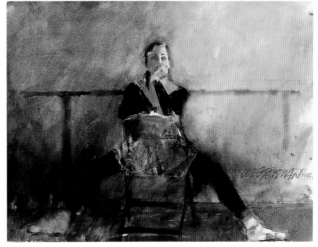

Florette's Daughter, 10" × 14", problem version
The background is a white wall. I've darkened it to make it more dramatic. I wanted a standing dancer to make my vertical connection, and I wanted to tie the two dark costumes together to make a new shape, but the painting just wouldn't come out.

Florette's Daughter, 10½" × 14", final version
The basic problem is that Florette's extended legs just won't allow a good vertical shape to connect. Also the muddy background used to kill the other figure hurt the painting. I washed out the vertical figure and the background, and washed in a little white.

WHERE TO START?

I always used to start where I expected the worst. If I was having problems painting faces, I would start with the face. If that didn't work, I could just turn the paper over and start again. (Not too happily, by the way.) If my problem area for the next painting was trees (or something that looked like trees) then, by golly, I started with trees.

Some time ago, I read about an artist who had trouble painting eyes. Guess what he started with?

When I found out I could wash off anything fairly easily and come up with a better solution, I relaxed. I now start by painting the largest

Take advantage of all the flexibility watercolor has to offer.

masses first. That's usually the background. Then I work my colors into the foreground, figure or whatever. Probably the best rule has you start with the largest brushes, painting the largest masses, then working your way down to small brushes and details last.

When you are putting paint on the paper, lay it on like you mean it to be there. Mix up puddles big enough to paint your shapes. And don't just pat the color on, or dab, or potchky. Be brave, not timid. You have nothing to lose but your fear.

If it's a dark background, I will probably connect it to a similar dark of the figure. I will break off the dark tone a distance from the fleshtone.

That will leave a gap I can fill in later if I want, or I may continue it into part of the hair, for example.

If I start with the background and work into the foreground, I will run some of my foreground colors into the background wash while the paper is still wet. Those portions give me some spots of blending. I'm not going to worry about continuing that tone throughout each shape. I can always come back to that later. I just want to lock some of my colors into the background wash.

If you feel rushed that way, load your brushes with prepared color and set them aside. When you've finished a wash, and while it is still wet, pick up the brush with the right color, add the tone, then go to the next brush load.

Otherwise, wait till the background tone dries. Dampen the area, and add the blending colors when the sheen dulls, and the blending result will be pretty much the same.

When I want to go back and paint the enclosed area of a shape where I have a soft edge, I will moisten the edge where the blending took place earlier so that my dry-brush work doesn't end abruptly as a line. The result will be a combination of soft

When you are putting paint on the paper, lay it on like you mean it to be there.

edges where this takes place and hard edges where the paper hasn't been premoistened.

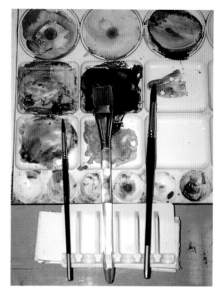

If you don't want to rush adding colors to your wash, have a few mixes ready and your brushes loaded. Lay on your wash, brush in a portion of the adjoining areas, and let the colors blend in spots where they touch the wash.

DEMONSTRATION
Theresa II

This is my starting point — the photograph of my model and the color sketch I made as a second step in my process.

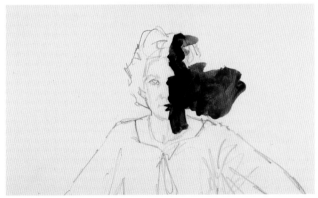

Step 1. I have made a careful drawing and have decided to leave the light side of her face white, so I'm starting the shadow side by running some darks into her hair, face and neck. A little sloppy, I'm afraid.

Step 2. Here, I make up a puddle of a dark composed of cobalt blue, phthalo crimson and gamboge hue, and scrub it into the background to give me a sense of contrast.

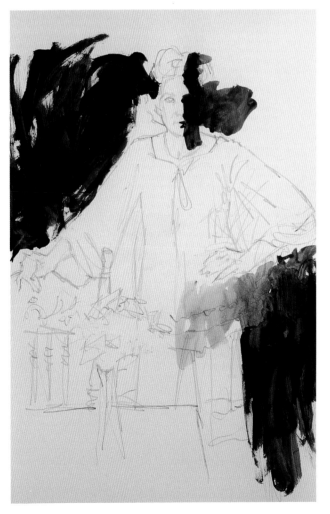

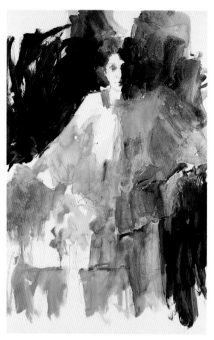
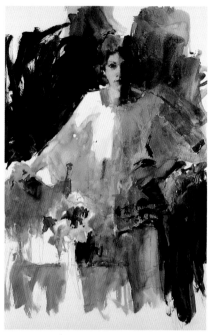

Step 3. While the dark background is still wet, I add some of the colors I will use in her left sleeve—raw sienna, cerulean blue and phthalo crimson—and let those colors flow into the dark space. I also add her right eye socket, which I should have done in the first place.

Step 4. I build up the colors of the painting, adding raw sienna, manganese and cerulean blue, and phthalo crimson, letting some colors flow into others and leaving the light-struck portion of her face white. I've softened some heavy shadows and added more hair color.

Step 5. I realize a white, light-struck face wouldn't look dramatic, just ghostly, so I add a fleshtone wash of gamboge hue and phthalo crimson and fill out some of the other connecting colors in the painting, leaving white paper just in my center of interest.

Detail. One way of adding a soft-edged tone (red on cheek) over a dry section is to run a light wash of water over the area with my hake brush, wait a moment, then add some cadmium red and work that into the area of the cheek. If it's too light, I wait until it dries and repeat the process.

Theresa II, 21" × 14"
I've added some more color to the face, flowers, etc., and have started fussing with and overworking the eye. In general, the painting looks OK. I have given the painting a definite mood through subject, design and color. I have a confined center of interest, connecting shapes, and good movement through lines.

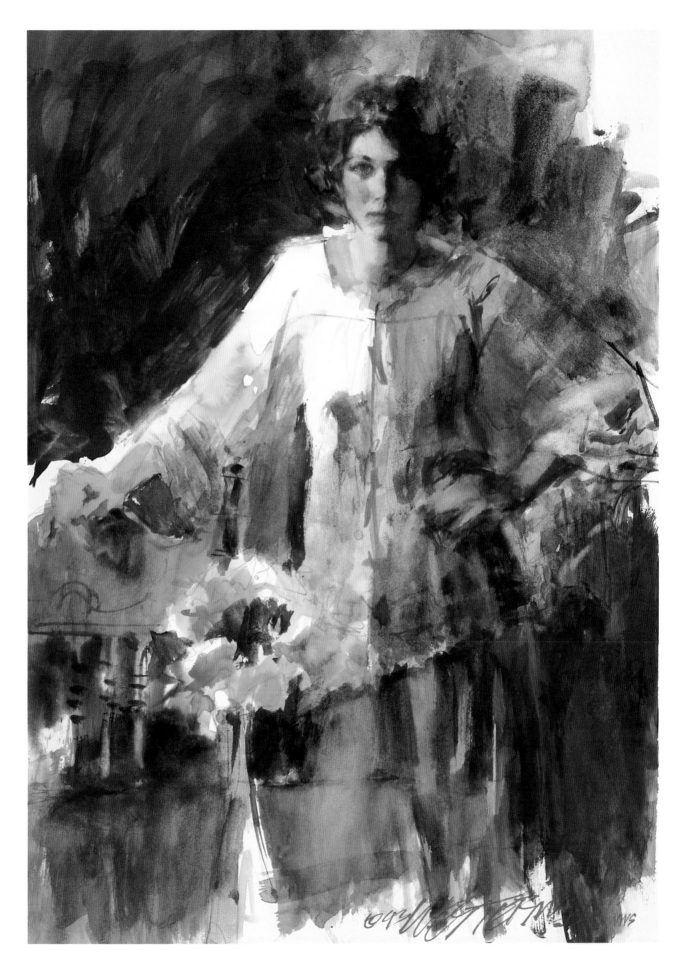

Now Paint It

PAINT LIGHT TO DARK OR DARK TO LIGHT?

I was taught to place my light washes down first. The reason, of course, is that with an unforgiving medium, you can always go darker, but you have a harder time going lighter or regaining your whites. The Old Masters resorted to white paint for the latter.

With experience using the right paper and exploring the forgiving nature of watercolor, I've changed approaches. I've found that I get a better idea of my contrasts as they develop by alternating dark and light areas.

Sometimes I paint the dark wash first, let it dry, then add the light wash and let some of the dark one bleed into that. Other times, I lay on the light tint and let some dark creep into it while it's still wet. Other times, I paint a dark stretch so it doesn't touch a light area. It tests my contrasts, and there is no bleeding.

GLAZING

If I want to cover a painted section with another tone, particularly one with a soft edge, I glaze it this way: First, I use a 2-inch or 3-inch hake brush with its soft bristles to lightly stroke some water over and beyond the entire surface the new color will cover. While the area is still damp, I introduce the new color with a round brush and carefully move the tone around a bit to form the new shape. The result is that the edges of the glaze disappear into its background with nice, soft edges.

SOFT EDGES AND MASSED SHAPES

There are times when I want soft edges or a softening of details where painting them in dry brush would make them too interesting. I don't want things like piano legs, window mullions, wall corners, groups of items on a table, or groups of people in the distance to attract undue in-

terest. It really could be anything. It depends on the subject matter in the painting.

I cover the area with a wash of clear water or an appropriate color. Then, while that section is still damp, I will paint in the lines, sections or pieces I want to keep loose. The neat part is that the paper dries unevenly while I'm working so that some of the parts I'm painting have sharp edges while most blend into the wash. If I want to strengthen something, I can always restate it by wetting the paper again and adding more paint where it's appropriate.

Where those details are to appear over an already applied color, I will make sure the underpaint is dry, then use my glazing technique with the soft bristles of my hake brush.

There are also times when I will give a bit of spray to the details before they dry, to blend things in and get some drips and texture.

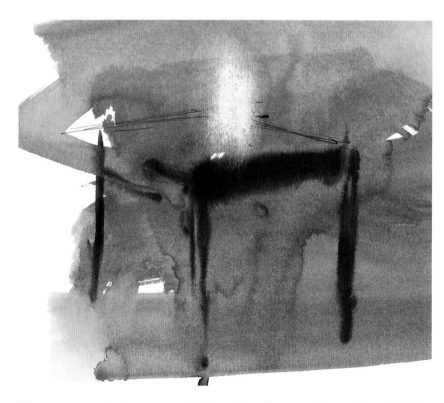

Where you are massing shapes or suggesting lines of lesser importance, lay on a flat wash of color, and while it is still wet, paint in your lines and let them fuzz out. You can always restate a portion later if you want or scrub out some lights.

OTHER SOFTENING EFFECTS

I use another approach where two shapes composed of two different colors don't merge, yet I want a portion of their edges to blend. As usual, I paint the first wash past the line where the two colors merge. While that first wash is still wet, I will paint a bit of the other color at the edge of the second shape so that it bleeds into the first wash. Then I leave it and start another section. I may not want much more blending than that. I will come back later to that part and give it a little water glazing so the blended area also merges with the rest of the shape, which I will finish in dry brush.

The beauty of watercolor is that it allows this merging of some details and edges, which gives uniqueness to your painting. It also prevents your piece from looking like a bunch of cutout chunks.

Blend one color into another or keep colors separated. You can always change your mind.

Want to connect dried colors? Just brush them in and work the two colors together, or use your hake brush to wet the overall area and add your colors to the wetted portion. They'll blend together nicely.

FRISKET

There are times when I want to keep small details in the painting, but it's too much bother to paint around them. That's when frisket can come in handy. I apply this rubbery stuff on lines or portions I want left unpainted. When it dries, it seals the surface, and the paint rolls over it. Peel it off after you finish your painting (make sure the watercolor is dry), and you've got white paper.

After I peel off the frisket, I put some water or a light tone down over it and wash it in a little to loosen the hard edges that enclose the section.

Avoid leaving frisket stuck to your paper for more than a day or so. Left longer, it is said to discolor your paper. It's also harder to remove if it's been on too long. Make sure you get it all off. Rubbing it off with your finger is slow. A rubber-cement "pickup" lifts the stuff much faster.

Apply frisket with anything from a brush to toothpicks, knives, edges of cardboard or plastic. If you use a brush, immediately rinse it in a little bottle of soapy water. If the frisket dries on a brush, you can clean it with rubber cement thinner, but that's a lot of bother.

MAKING WHITE PAINT BEHAVE

Think of frisket as preplanning and white paint as postplanning. You can always slap on some white paint at the end of a painting, particularly for making white lines or spots. However, you have to take some precautions to keep these pure white parts from standing out like searchlights.

Lay down a light wash of water, then paint in the white lines. That allows some of the white to bleed. Apply it over a spray so that some of the white dribbles into the background, or add a tint to the white so it doesn't look so obvious.

I've introduced frisket to the paper with a knife for thin lines and with a brush for larger portions. After painting over, I remove the frisket and the effect is far too stark.

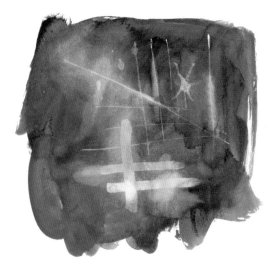

To soften the area, brush some water or paint over the frisketted lines, and the result is much more agreeable.

White paint has the same problem as white left from a frisketted area. Both stand out like sore thumbs.

Before you add white, moisten the paper with water and break up the intensity of the white. Lightly spray the white after and make interesting patterns.

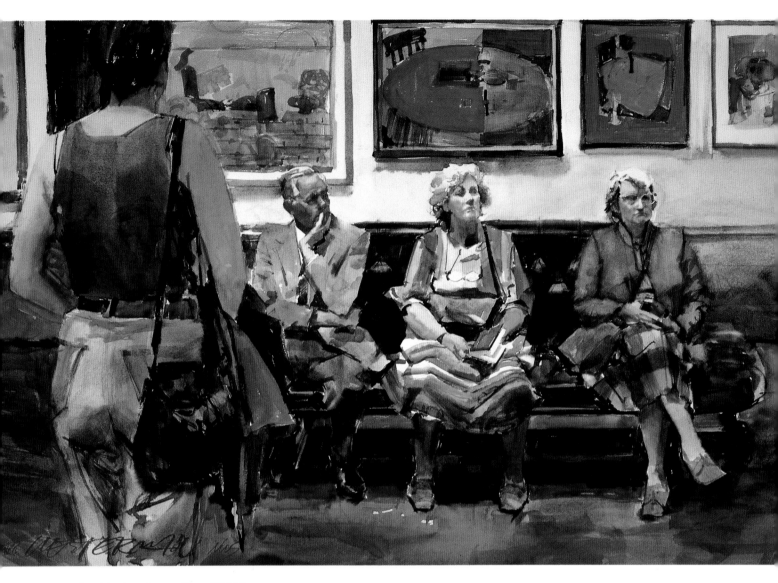

Royal Academy Summer Show, 19" × 29"
I sometimes call this *The Wrong Room*, because the expressions and body language of my principal subjects show distaste and confusion. I can almost imagine them viewing these abstracts and asking themselves, "This is art?" I added a standing figure to strengthen the vertical connection. I could have lost some detail and connected shapes better to improve the painting.

MAGIC TRICKS I AVOID

So far, I haven't touched on masking out areas with masking tape, adding snowflakes with coffee grounds or salt, using razor blades and other tools for scratching things off, or other various magic tricks for creating texture or line.

I don't use razor blades and sharp, pointy objects to create lines. I don't want to gouge the paper with marks which I might find later I don't need or want and there's nothing I can do to hide them. I don't use masking tape, because it may leave a residue, and I don't use salt or coffee grounds because I'm not sure of their long-term effects.

WHEN TO QUIT FUSSING

Most painters don't know when to quit (and quite often that includes me). Many just keep polishing and polishing until the painting looks overworked and gets stale.

My last piece of advice in this chapter is to go on to the next painting. I know it's hard to do. Overworking a painting, however, often hides the charm and snap it would have otherwise. So don't polish it to death, attempting to reach perfection.

Primary and Secondary Figures

Solitude, 20" × 29"

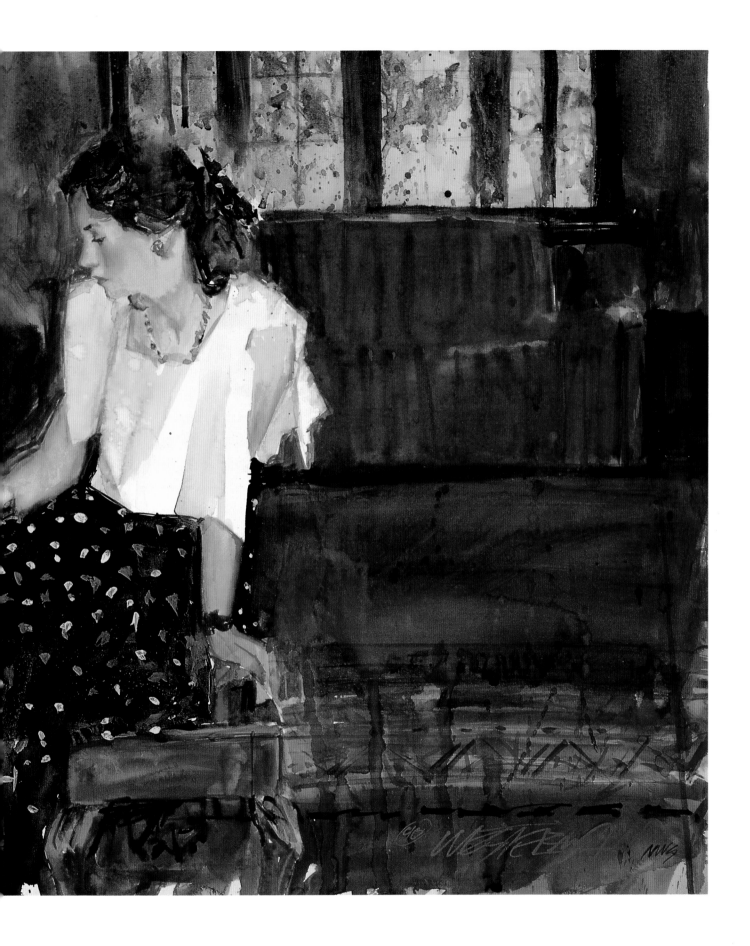

Painting People

including portraits of family and friends

Oliver Cromwell told his portrait painter to include his warts and pimples or he wouldn't pay for the portrait. He considered anything less than an exact likeness flattery.

Don Bernetti, an eighteenth-century portrait painter, claimed in 1756 that the essence of portraiture didn't lie in catching an obvious likeness. He thought even a mediocre painter could do that. He claimed that expressing temperament and character were the essentials for seeing the portrait as a living face.

The most telling portrait is essentially not a copy, but an interpretation, an expression of feelings. In addition, a classic portrait will also tell us as much about the artist as it reveals of the sitter.

The artist has to produce more than the physical entity. She has to create the image, drawing from her knowledge of the subject and her experience of life. She has to create not just a likeness, but a work of art.

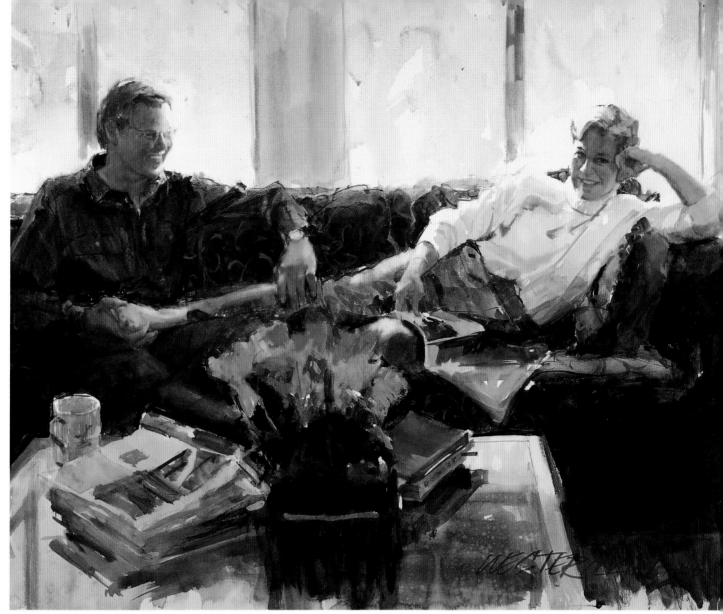

Jim and Marg, 17" × 39"
I worked from photographs taken in the winter, when the daylight was blue, and bare, dark tree limbs were the view from the windows. I had a handsome, loving couple to work with, and I just added the yellow sunshine. Note particularly the lost white edges on the faces, which add sparkle.

How other people look in photographs.

How we look in photographs.

MOST PEOPLE TAKE "AWFUL" PICTURES

Most people seem shy and reluctant to pose for portraits. They *know* they don't take good pictures and they think their portraits will look as bad. Invariably, each person in a group photo, when asked if he likes *his* picture, will always say that the pictures of everybody else are "just wonderful, but I look terrible. I never take a good picture."

The truth is that we never see ourselves as others see us. From childhood on, we seem to focus on a succession of unsympathetic mirror reflections. From baby fat to pimples, to hair that won't behave until it thins and falls out. Sometimes we have to put on those darned glasses just to focus, and they make us look even worse. It takes a pretty strong person to put on a happy face. So, with that kind of background, how do you expect your sitter to relax, enjoy posing and anticipate good results?

CONNECTING FEELINGS

My approach to painting people is not to strive for a perfect likeness. I want my subjects to say, "You've really captured me," meaning I've revealed their spirit.

For the same reason, I don't reproduce facial lines and blemishes. There are other ways to suggest character. I don't faithfully reproduce pimples common to adolescence. Instead of focusing on small specific physical details, try to express the feelings communicated to you by the people you paint. Your painting is going to reflect those feelings.

Relax them by explaining that you're an artist and you can make your subject look like a movie star if you want. Never mind the photograph. You can add a mustache, beard, longer or shorter neck; you can make them taller, shorter, fatter, thinner, younger, older, anything. No problem.

Then have fun. Spend some time with your subject, asking questions, trying to understand feelings, finding common ground. A well-known portrait painter once said that he could get a likeness in thirty minutes. I think it takes longer for a brief look at the surface, let alone to get

into the mind.

Start by telling your sitter or buyer that the finished portrait will not be a perfect likeness. Say you will paint it to express emotions and it will be timeless, as a work of art

The most telling portrait is essentially not a copy, but an interpretation, an expression of feelings.

should be. If that's OK, it will allow you to be much more creative and will take a lot of the pressure off. If what is wanted is a picture-perfect likeness, recommend a photographer. It's much cheaper.

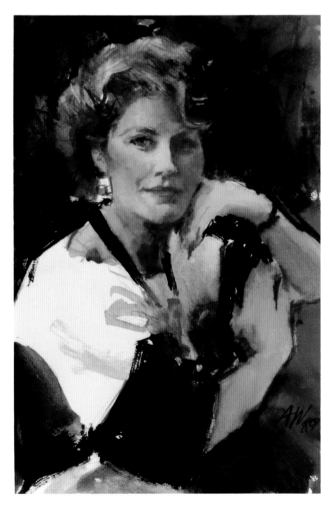

Barbara Nelson, 12" × 8"
I think the combination of pose and hot background tell a lot about the independence and strength of the sitter. I particularly like the hands. They're sometimes hard to paint unless you keep them simple, but they add a great deal of interest.

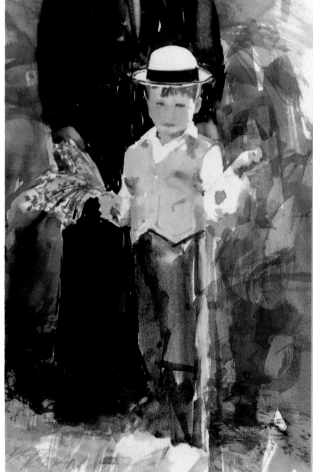

Breton Youngster, 26" × 24½"
The less fussing you do with a child's face, the better it will look. Here, all you really need are pink cheeks, eyes and mouth. No lines, no development of nose. Notice that the background figure reads clearly just by the showing of hands.

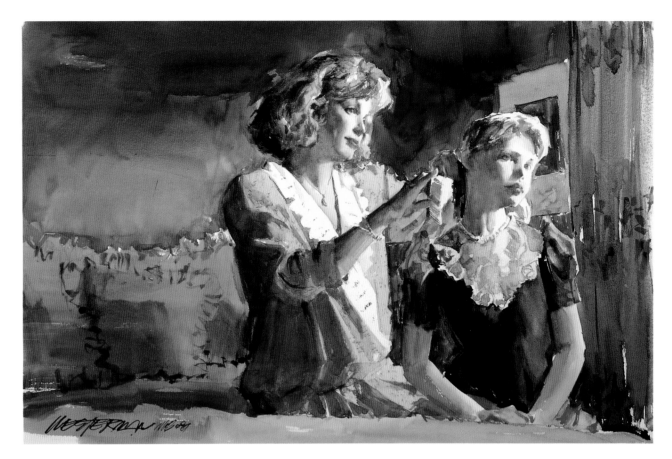

GETTING IDEAS

You've probably amassed a number of figurative painting concepts over the years, but there is a treasure trove of posing ideas and settings at hand. Study the work of some great portrait artists by visiting your nearest museum, or look over reproductions of their paintings. You'll find a rich source for handling backgrounds, hands, poses, and other elements. Notice the expressive use of hands. Among others, look over the portraits of Rembrandt, Velasquez, Bellows, Serov, Vuillard and Sargent.

John Singer Sargent's portraits don't reveal much emotionally, but they're wonderful for designs and painting skill.

In the portraits of Valentin Serov, character comes alive. There is most often a depth of emotion that radiates from his subjects.

Vuillard paints in a much different way, frequently with little or no details of facial expression. Yet we are told a great deal about his subjects'

Doris and Kiley, Easter Sunday, 16½" × 25"

The painting was to be a secret gift to his wife on her fortieth birthday. How do you keep a secret from the sitter? So I asked Doris to pose for some paintings to be sent to a California gallery. She graciously complied and cried in surprise when this was presented at her party.

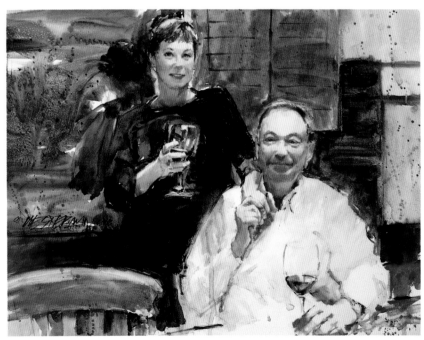

Judith and David, 21" × 27½"

This wonderful couple are wine connoisseurs who love to cook and spend much of their time in the kitchen. What better way and place to pose for a relaxed, pleasant portrait?

lives in their surroundings by the way they sit, stand and gesture.

BACKGROUNDS

Your first task is to get your subject in an appropriate, compatible setting. The background you choose needn't be portrayed accurately, so don't get caught up in the perfect stage set. Use the setting to *suggest* objects or spaces or abstract shapes to complement your figure. Keep it loose.

A "limbo" background is often used for portraits. It is simply a neutral setting. It can be made up of complementary colors, gradations of tone, texture, unobtrusive creative shadows, or things just out of focus.

In an exterior setting, perhaps among flowers, or in a park, use suggestive colors and loose shapes. Minimize hard edges of trees or flower shapes to block out intrusive elements. Simplify architectural backgrounds. Loosen up straight lines, squares, rectangles, windows and the like. Try not to let straight, hard lines touch your figure. A light wash over the area before you paint in the lines and angles will keep them slippery. You can always restate lost portions when they are important.

A model in an interior scene requires some choices, such as living room, bedroom, kitchen, family room. A child, playing on the floor of his room, surrounded by some toys, with his dog or cat . . . these are all possibilities. But don't focus on the setting. Just suggest it. Use a few clues to give you a background without distracting details.

The deciding question is, What is a natural setting?

DEMONSTRATION
Robin

I had a pretty good idea what I was going to do when I designed this rough and color sketch for the portrait of Robin. I wanted to make a vertical painting to emphasize her stature and to make it colorful, appropriate to her youth.

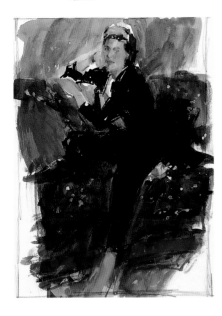

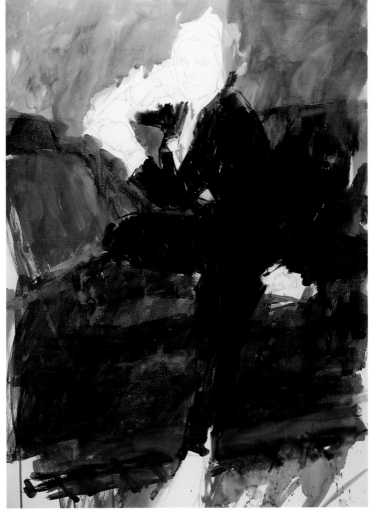

Step 1. The pose took place in my studio, where the background is a light-well with industrial windows. Since my center of interest is Robin's face and hands, I wasn't careful about sloshing some colors around, tying the dark of her back into suggested shadows. I changed the blue pillow to red to add color and to connect with the red of the floor.

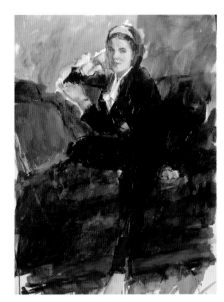

Step 2. Time to develop the face and work on the fleshtones of hands and feet. Notice that I've kept the background color away from her right arm. I might have connected the colors later, but I kind of liked the effect of the white space.

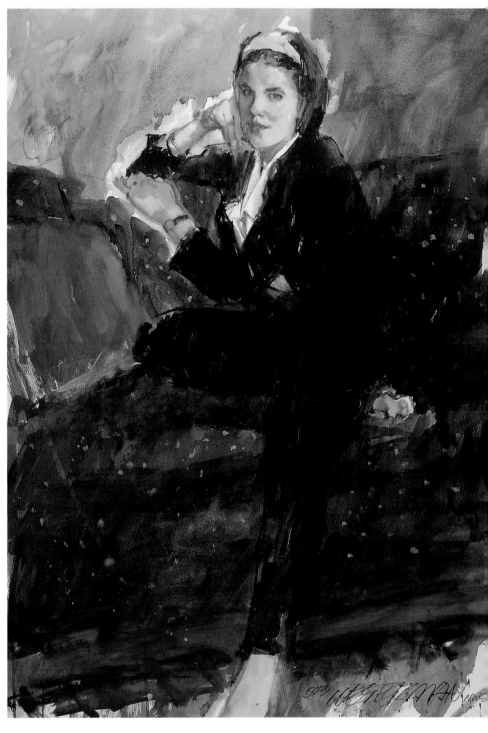

Robin, 29″ × 20″
I was planning to do a little fussing, but the painting went so nicely that the only thing I could think of doing was to add polka dots to the sofa and sign my name. I probably should have used the opportunity to simplify her fingers.

DO THE CLOTHES FIT THE SCENE?

I don't recommend that little boys wear suits and ties for a portrait. They don't look like little boys. They look like little men. When kids wear play or school clothes, they feel comfortable and are easier to relax into suitable poses. Little girls (like my granddaughter, Lauren) often like to wear pretty dresses, but if they would rather wear sweats, that's just fine. Ask the parents. You want your subject to look and feel as much at ease as possible.

I usually prefer to have my models wear clothes they like. I will ask what feels right. Frequently a woman will bring two or three outfits with her, and we'll both decide. If I have a preference, I'll say so.

I often use models to create dramatic scenes that are not portraits. The story might also build in my mind after seeing the results of some of the poses.

Sometimes the model brings clothes to act out a kind of part she wants to play. It may be a line from a song, a physical attitude from a scene remembered; it may be playful or pensive. There's an actor in all of us. The playacting is almost always fun, and the attempt at the painting and the results are usually exciting.

DOWNPLAYING MINUTIAE

The colors of the costume and background are not critical. Often I will change the colors anyway. The design of the costume is not a deciding factor, either. If done well, the clothing will be suggested, and frills and minutiae will be very much downplayed. Back in the old days of portraiture, distinguished sitters wore all their finest jewels and costumes. The artist was expected to paint them accurately so that the spectator would be overwhelmed by the picture of wealth and power. (Like the story of the aging wife who asked the artist to portray her wearing tons

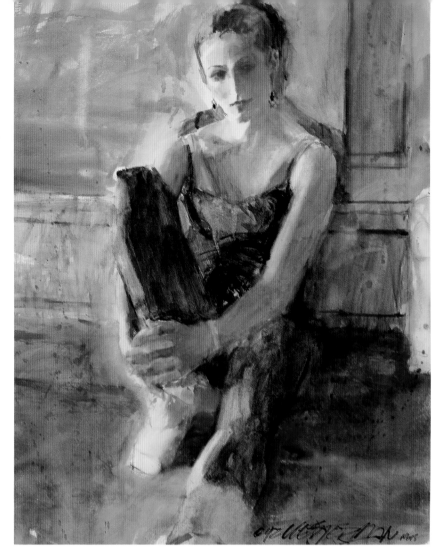

Nicole Resting, 28" × 21"
Here I used the white of the paper as the light-struck side of her face, and it worked. Sometimes the effect can be quite exciting. I also created a little glow with a lost edge where the white of her face connects with the white background.

Nani and Nani, 28" × 21"
I love to paint children with their grandparents. Portraits are usually of one or the other, rarely together. The connection is loving. The contrast is beautiful.

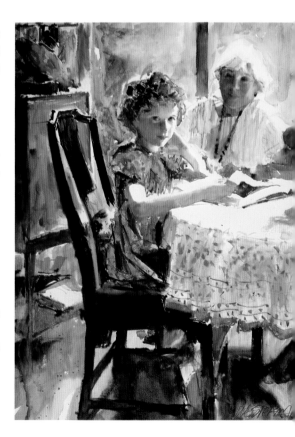

of imaginary jewels, so that if she passed on and her husband remarried, his new wife would go crazy looking for them.)

On the other hand, sometimes the costume is the reason for the painting. A hat brim that veils the eyes; a colorful bandanna, a big, overwhelming coat where the head just peeps out . . . all make up the stuff of an exciting painting.

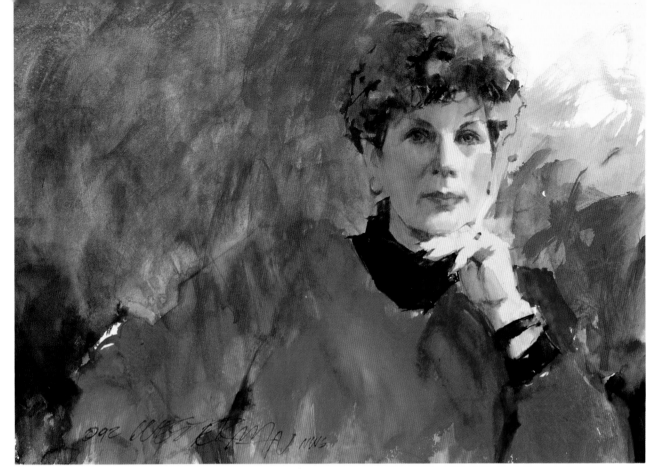

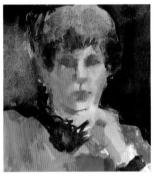
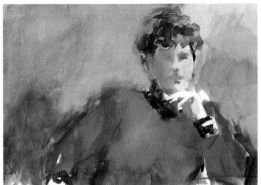

Judith Smith, 20" × 28"
Another surprise portrait. Judith, a teacher, thought she was posing for a commissioned piece to be sent to a private school. I had her adopt all sorts of teacher poses, then I had her relax into this position, and it became the portrait.

At first, I thought to make it a square (far left) with a dark background, then decided on the horizontal as a better composition (left) where the focal point—the head and hands—make up such a good balance with the large, negative space.

NATURAL-LOOKING LIGHT

Whether you're working with tungsten interior light or exterior sunlight, try to keep the light on your model looking natural. If you're working indoors, there should be a dominant light and a "fill" light. The "fill" may keep shadows from going too dark. A normal, interior-lighting plot has the same kind of natural feeling you would find outdoors. That means there is only one strongest light.

A light shining at face-height and directly in front flattens the face and eliminates shadows that define the planes. It makes the face hard to read. Flash has the same effect and should be avoided. A light shining up into the face from below gives a Halloween look.

Flat lighting is often complimentary. High, overhead light that produces deep shadows in eye sockets, and side light that makes half the face light and the other half in shadow is very dramatic. A shadow that continues from the nose into the lips and even below is a no-no. The nose shadow should end before it reaches the upper lip.

Outdoors, where light and shade conflict on a face, don't take the shade too literally if it confuses your form. Where there is a reflection into the face from clothing or an adjacent structure, avoid making the reflective light important. Keep it subtle or just eliminate it.

Eliminate any kind of form on the face that confuses your basic structure. Dappled shadows on the face cast by straw hats in sunlight may be a tour de force of patient painting for the artist, but the muddle competes unfairly for interest.

EASY POSES

Show the client or model some sketches or photos that suggest poses. Have the model sit, stand, slouch, lean or take whatever position would feel comfortable. If you don't have some idea in mind, the best poses may come from inside your subjects. Let them follow their natural flow and be themselves.

If you are going to use a camera, it's OK to waste film. Take plenty of pictures so that your subject gets used to the camera clicking and just focuses on posing. Even professional models need time to loosen up.

With children, you're better off taking photographs. They hold still only long enough to get you started, then lose interest rapidly and you're stuck. It also might be smart to have a parent around helping.

If you want to get the youngster into the mood, draw some pictures for or of her. A few drawings will often connect the two of you and make the process more fun. Watching someone drawing and painting is like magic. When I was in a foreign

The raw material is for your eyes only. The finished painting is for the world. It will stand or fall on its merits.

country and couldn't communicate with some villagers, I took out a pen and paper, drew a few sketches, and we spoke the language of art.

If you're taking in a large scene, a camera with a moderate, wide-angle, 35mm lens is just fine. If it's going to be a portrait, avoid getting too close and trying to fill the viewfinder with the subject's face. Just remember, the closest thing to the lens—the nose—will be the biggest.

A standard 50mm lens sees the image much as your eye does and is more appropriate. A 70mm lens is even better.

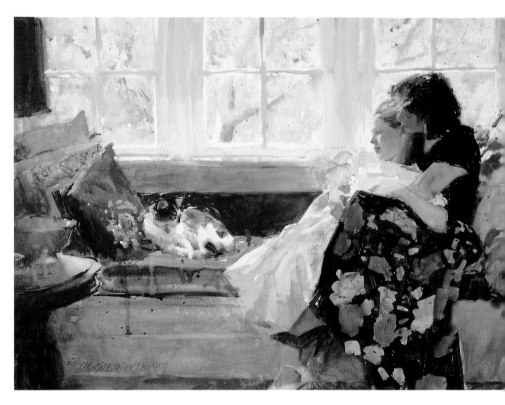

Noel, the Cat, 22″×28″

Noel held his poses quite well because he happened to be high on catnip at the time. In this painting, I made some suggestion of trees and leaves outside, which I seldom bother to do. I had to use dark space with the lamp shade and table on the left to balance the large, strong area of interest on the right.

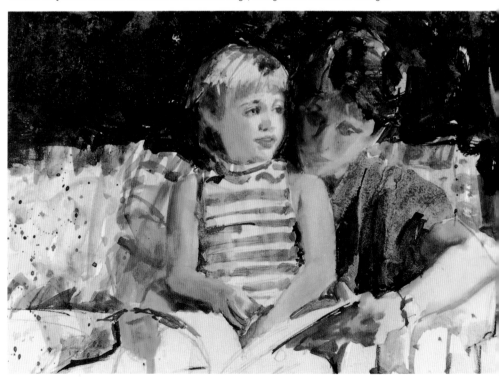

Lauren and Judy, 12″×16″

I like this painting of my daughter and granddaughter because I confined the interest to a small area—Lauren's head and shirt—and I did a neat job on my daughter's hand. You can tell it's "hand" with just a suggestion of color.

Hilary's Reflection

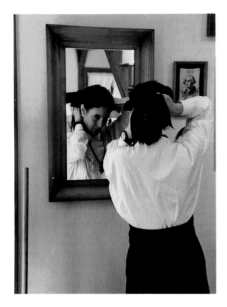

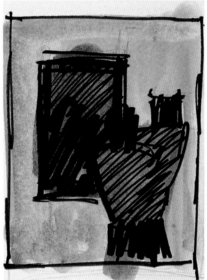

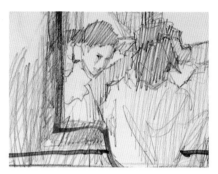

I decided to challenge myself to develop a painting in spite of this problem. The area I believed was most interesting was the young woman's reflection, and I centered on that. I chose a horizontal approach and designed horizontal and vertical connections.

This is the photo I started with — a model fixing her hair bow in a mirror. I thought it might make a good demonstration of how to overcome some problems.

When I analyzed it, I saw it was only a blob in the middle of a space. The girl may be beautiful and the reflection may be pretty, but as an abstract shape, it's just a blob, and abstract shapes are all we have to work with.

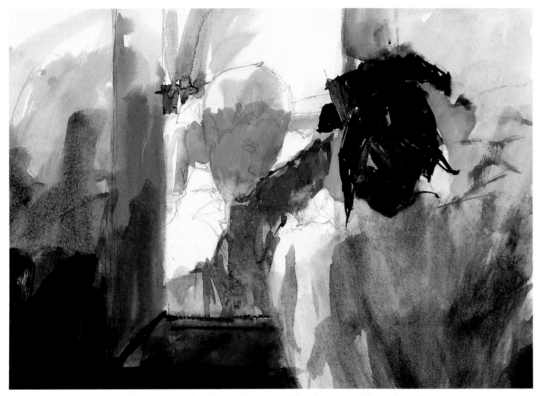

Step 1. I've laid on some colors including her face in the mirror. When I connected that color with her shirt, it drained the color from her chin, but not to worry. That's easy to remedy with a later brushload. My horizontal connection is the dark space on the left.

Step 2. After a lot of fussing, it looks too dark and dingy. I've had to kill her blouse facing us. The light color was just too strong. But now it looks dirty, and the painting is not terribly interesting. Also, the sleeve in the mirror doesn't make the arm look right.

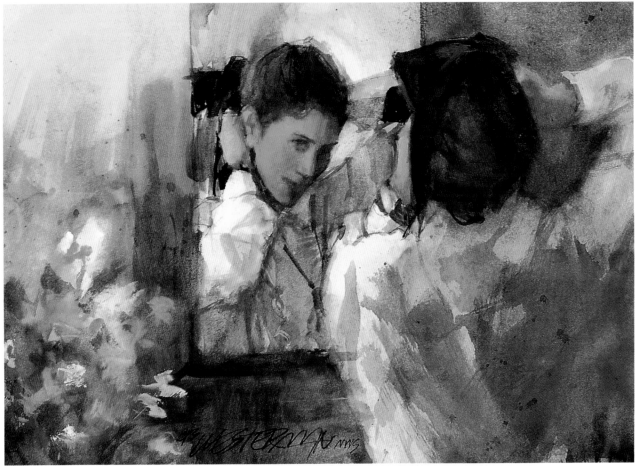

Hilary's Reflection, 14½" × 10"
How about some flowers? I've lightened things up and cleaned up her sleeve by adding some tone to give the feeling of the arm extending, but there's too much of the figure's back showing, and it won't work by cutting some off. Well, I've signed it, so it must be done.

PAINTING A FACE

When painting a face, I go either of two ways. I will start with the shadow side as I did in the demonstration, Theresa II, in the last chapter. Or, I will start with the light side by mixing up a puddle of light fleshtone. I will cover the entire face, neck and hand (if the hand touches or is near the face), then go into the hair and background. I will leave only large, light-struck areas the white of the paper. Otherwise, little lights on the cheek will be covered with the flesh mix. I can lift them out later.

I have at times left the light-struck portion of the face the white of the paper for dramatic effect. In this case, I've decided to tone the entire face.

When the light fleshtone is completely dry, I will add my shadow tones with the same approach I used before, of painting eye sockets, into hair, etc., that I followed when painting the shadow side first. Again, the hard edges on the rounded portions of the face, such as the forehead and chin, may be softened with a moistened brush.

Soft-edged features of the face, such as pink cheeks, blue or green touches, portions of the eyes and lips, are added as glazes. I will moisten the overall area with my 2-inch hake brush, then lightly work my color in with a regular round brush. Too much pressure or scrubbing will remove the underpaint.

When you're painting a face, don't leave holes for the eyes and light-struck areas on the cheek, either in the light or shadow sides. Paint it all in. The fleshtones you use in the rest of the face also cover the eyes. Look at some George Bellows portraits to see how blue he made the "whites" of the eyes. We can lift light-struck areas later if needed.

I often touch a small brushload of the clothing color to mix into the connecting portion of wet neck paint so that the two blend at the meeting point. Then I leave it to dry. I will come back to the clothing later and connect more paint to that area, leaving that nice soft edge into the shadow fleshtone.

If I have removed the underlayer, leaving a noticeable bald spot, I will let the paint dry completely and turn to another portion of the work. Touching up an area that is still wet simply lifts away more paint. A little patience does the trick. When the problem section has dried, I will moisten the overall area with the hake brush and clear water, then blend in with the proper tone.

PAINTING HANDS

Use the shadows on the various parts of the hands to state the forms without going into detail of fingers, nails and the like. If you can, use obvious colors to denote fingers as a group rather than delineating each individual finger. It's actually a rarity where all the fingers and the thumb are outstretched. Introduce finger fleshtone or shadows into the surrounding area to make the hand sit in its environment.

The best way to express hands is to keep them simple. You needn't show all the fingers to suggest a hand. Maybe we should take a tip from cartoon characters who never had more than three fingers.

DEMONSTRATION
Painting a Face

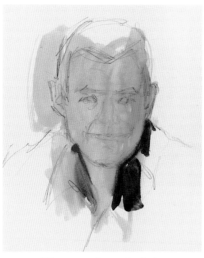

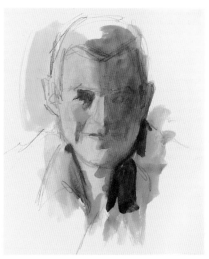

Beginners often make the mistake of laying on a fleshtone, stopping at the chin, avoiding the eyes, leaving bare the highlights on the cheeks and sometimes the nose, forehead and chin. Don't do that or you will turn into a frog.

Step 1. When you paint on the fleshtone, go into the hair, the neck, past the face, and into the costume, and do it right. If you want to, you can always pick out the highlights later.

Step 2. Now the shadow side. Cover it all from the hair on down, into the neck and the costume, and into the eye socket on the light side. Notice with just this simple design, you get a real feeling of volume?

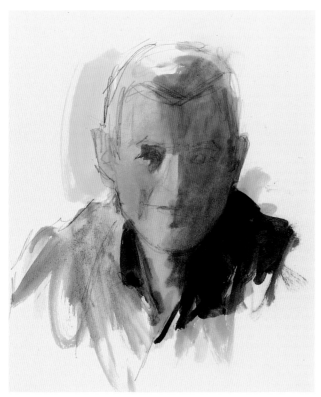

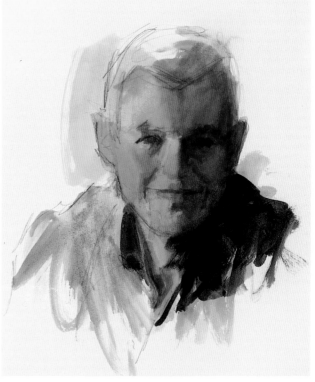

Step 3. Now I wash some red into the cheeks and forehead, and add cerulean or manganese blue around the jaw and chin, wetting the area with my hake brush first, then adding the color.

Step 4. I darken the area around the nose and eye socket in the shadow side because that's what we see; brush some color into the shirt; add some touches into the hair; and get some red in the ear to make it look natural. I'm fussing too much at this point.

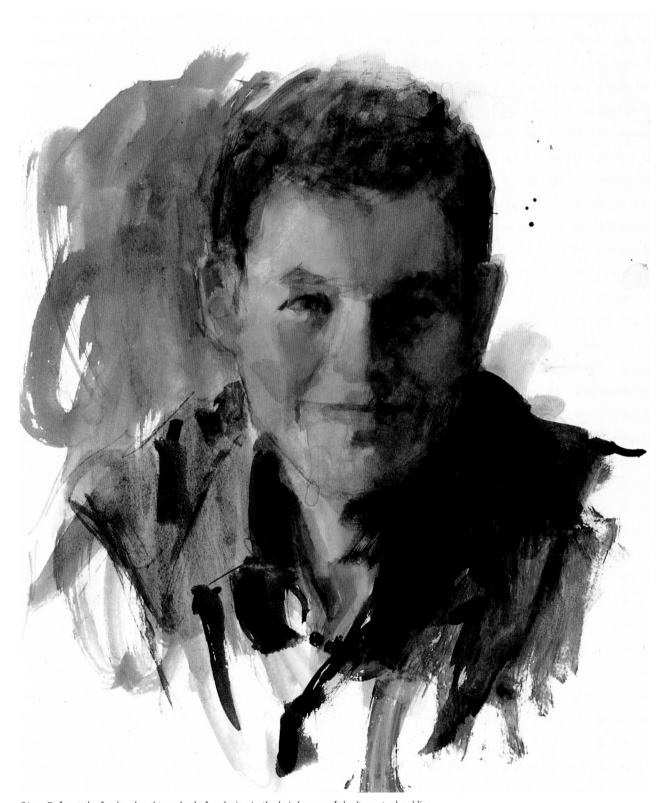

Step 5. I wet the forehead and temples before laying in the hair because I don't want a hard line between the hair and the skin. It would look stark—sort of like a toupee. Since this is an imaginary figure, I think I'll pretend the hair is brown and curly. I run some of the hair color past the light side of the face to make a good background.

Painting the Scene

Where figures are incidental

If you're like me, you've collected a mountain of photos you plan to get to someday. This is that "someday," so dig into your scenes of restaurants, parades, county fairs, children, pets and farmers. People—happy and sad.

Choose a photo that reflects your feelings. Then ask yourself, if you paint what you feel with directness and economy, will your spectator share some of your emotions? What will it take to create a unique painting? Will the idea work from just the one photo? Will you need to combine portions of other photos, adding additional figures or things to make a good composition? Will you want to pose friends or pets to complete the painting?

You now know you are not stuck with the one photograph for your painting. You may combine photos, sketches, posed models—anything you need to make your statement. The principle applies to every facet of the process, from what you put in to what you leave out. You can change the light, shadows, color, anything. The end result is all that counts. Shadows can be created (if they seem appropriate). Areas can be made darker to build a dramatic atmosphere. You can gray elements down or make distant objects hazy to evoke the reaction you want.

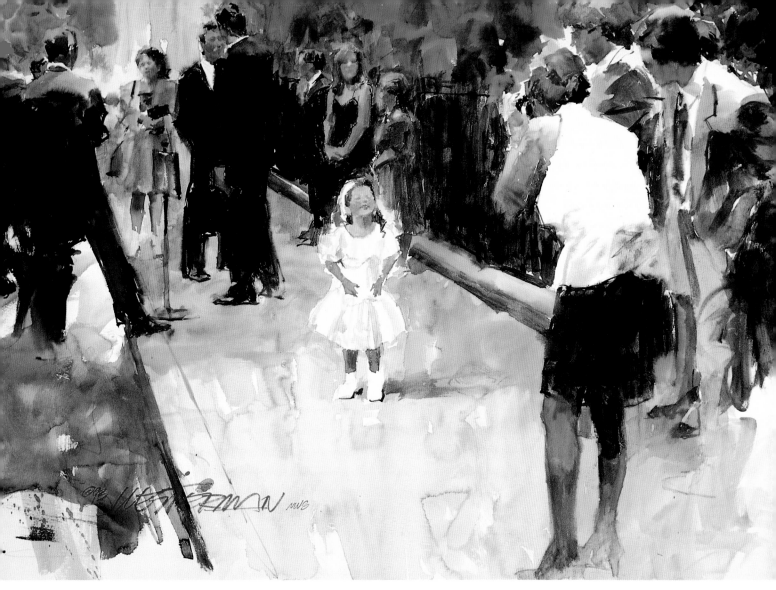

We're creating our own movie, and our actors and locations are of our choosing. Our scene doesn't have to be necessarily identifiable, like it was Thirty-fifth Street, or Mt. Watchamacallit. The vision we are creating has to do more with our subjective emotions.

As I said earlier, the raw material is for your eyes only. The finished painting is for the world. It will stand or fall on its merits. You don't owe the public an explanation. Why and how you created your work is your business.

THE THREE-STAGE PROCESS

Once you've decided on the idea and the material, start on your abstract thumbnails. Make perhaps several thumbnails until you find one that works best. Find out *now* if the idea will make a painting. What elements will you include to make an exciting composition? How can you simplify your material? How can your shapes combine with others to create new shapes?

Next comes the color sketch, then on to the full-sized painting.

If nothing really works at the design stage, it actually may not work, or you're just not ready. Set it aside and try something else.

Wedding Pictures, 29" × 21"
What could be happier than a wedding? And what could be prettier than a flower girl even when she's making faces for the camera? Keep the painting light, colorful, and focus on your principal actor or actors and leave the crowds loose.

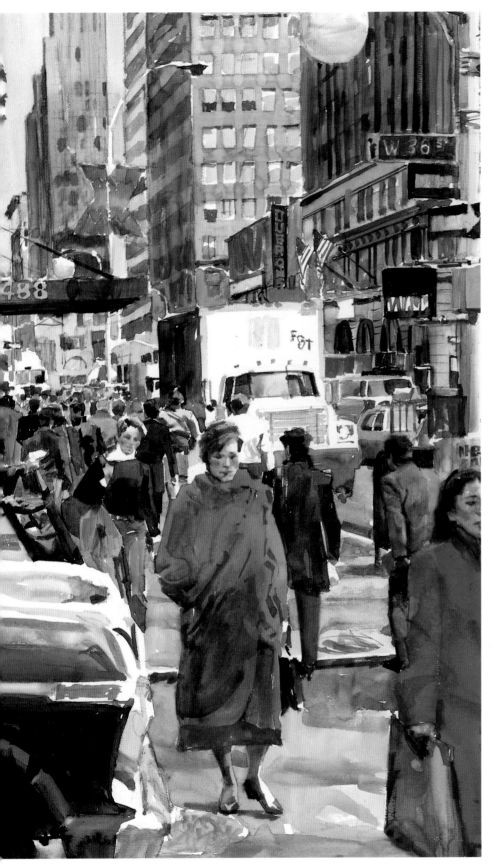

ADDING SPICE

Give your secondary figures only enough strength and interest to complement your statement. Don't overburden the painting with excess baggage. When your figures are going to be used simply to flavor a given scene, try to avoid any kind of real detail. The figures at that point should be suggested through heavy emphasis on gesture, or they should just be chunked in. Fussing with facial expression only attracts unwarranted attention.

Chunking in a distant figure often is done with an economy of brushstrokes and exaggerated body gestures—with a bit of red or another color for a head.

SEEING THE FOREST, NOT THE TREES

Since the eye will go to the area of greatest contrast, individual figures surrounded by a contrasting light or dark are going to attract attention. If that's not what you want, play down those figures by connecting their shapes to other background shapes and to each other.

Where the figures are grouped or where you want them connected, enclose them in an overall background tone. This is especially true where you have crowds of people serving as background. Don't paint in all the little people individually or your viewer will see trees instead of forest. To suggest a crowd, mass the group in a background color and shape. Leave a few light spots to suggest some light-struck areas, and use the background, whatever color that is, as the middle value for all your figures. Use dark accents as needed. Your figures are now expressed in about three values: a few light-struck areas, mostly midtones and some darker accents.

West 36th Street, 25" × 36"
This is a kind of composite. The people in the painting never came together as they do here, but they all fit. The feeling was what I was after—a big city, late-in-the-day resignation and fatigue.

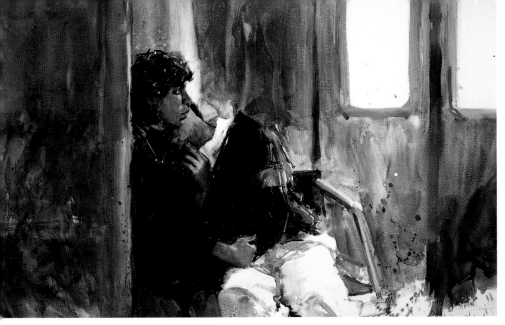

"R" Train to Brooklyn, 19" × 27"
A young couple in a subway train. She stays awake watching for their stop. In this painting, less is more. So little is really delineated; most of the space is splashes and dribbles, but it says all I wanted to.

Hard Rock Cafe, 38" × 24"
An example of strong darks, large midtones and a small light. I could feel the warmth of the late afternoon reflected in the warm colors and the bit of sunlight cracking through the gaps between the buildings. Notice that in spite of big, colorful flags, the eye goes directly to the figure approaching us.

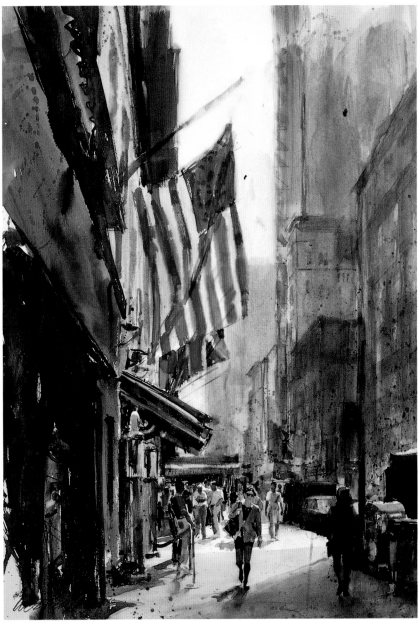

DEMONSTRATION
"Chunking" Figures Together

These are the rough and color sketches for *Carnegie Studio*, as seen in chapter nine. Figures reflected in the mirror have been massed into a single shape as a background. I added the figure to the right to connect her dark costume to that of the stretching figure and create a new shape.

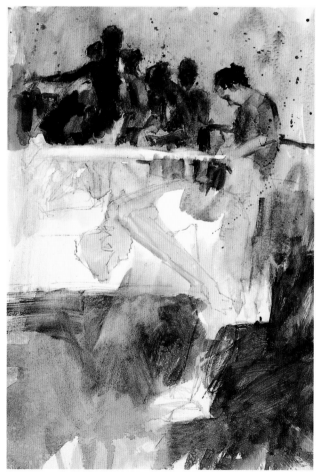

Step 1. I have made a careful drawing and have started the painting by chunking some blobs of loose color on the background figures and scrubbing some color into the floor and to the right edge of the painting. Some of the background color is washed into the fleshtone. One concern is how to make the stretching dancer interesting and obvious as my focal point. I will leave some whites around her head.

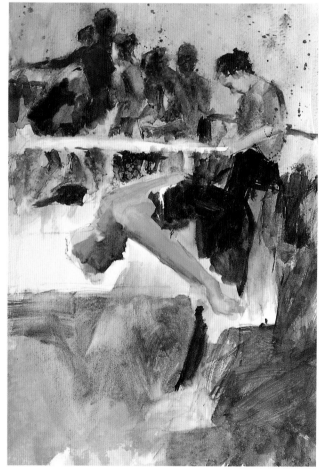

Step 2. I give the central dancer a deep red on the face, deepen her fleshtone, build the dark of her costume, and let it flow into the standing dancer, then out. I do some carving on the background figures by wiping out small lights. Also, I work some color into the costumes and add cerulean blue and gamboge hue to the floor.

Step 3. I thought this painting was done until I saw a slide of it projected to a class I taught. I had left the ballet barre white, just as I often leave little shapes showing the white of the paper. When I saw it enlarged, I realized how much attention it drew away from my focal point.

Carnegie Studio, 14¼″ × 10″
So I killed it without remorse. I scrubbed in some more blue and goodbye ballet barre. Notice that with that darkening effect, I also pushed back the reflected dancers and increased attention to the main dancer. On goes the signature.

BODY LANGUAGE
TELLS THE STORY

I've done several paintings of people using phones on street corners, and not one of them could *see* their party on the other end of the line. So, how come all the people were waving their arms and getting physical while they talked on the phone, just as if they were talking in person?

Easy. We are used to explaining, emphasizing, pleading, yelling, crying, and laughing with both words and gestures. That's why we do it even when no one is watching. That's the reason dance and pantomime and Charlie Chaplin can tell a whole story without a word spoken. Gestures can say it all.

You set the mood for your figures with gestures. Where facial expressions distract in smaller figures, gesture and the attitude of the body are telling.

Don't be afraid to exaggerate. Shove the arm out a little farther, make the lean a little greater. A figure expresses emotion through body language, gesture, clothing, setting, etc. You can picture the mood of an individual even when you're not face-to-face. More than one artist's work I've seen had blank faces without features, and there was still plenty of suggestion of mood.

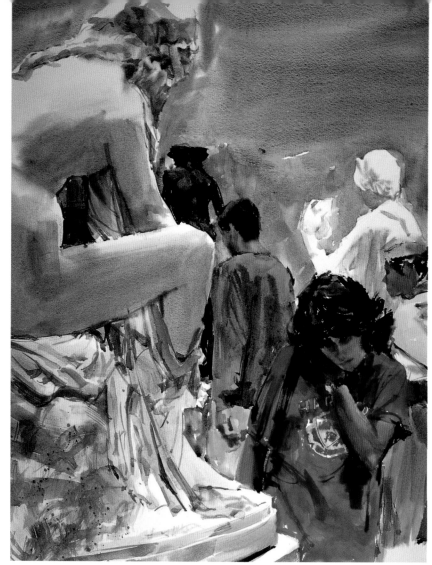

Musee d'Orsay, 28" × 24"
People often speak without words. Just watch their gestures when they're on the phone. See how they move and wave their arms and hands as if the one they were speaking with could see the action?

The girl in the red t-shirt is my focal point. I also added red to the background to connect the red in her costume.

The Village, 19" × 22½"
You see? The figures don't need eyes—just the suggestion of sunglasses or eye sockets says it all in this painting of Greenwich Village. So where are the crowds, the buildings, the cars? Who needs them? I wanted to convey a feeling in time, and I didn't want to have a bunch of extraneous objects intrude on the simplicity.

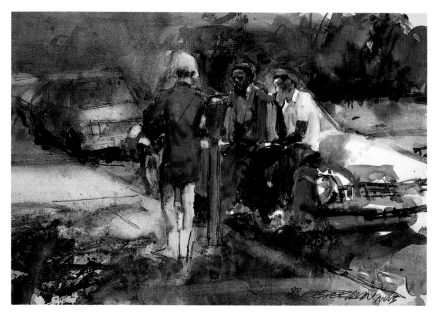

Paint Watercolors Filled With Life and Energy

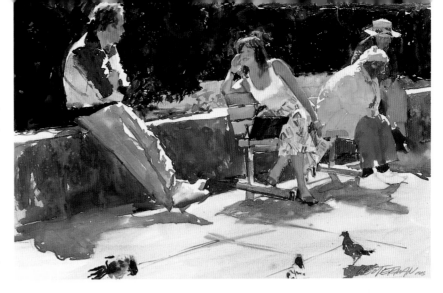

USING LIGHT AND SHADOW

Concentrate on major shadows to define forms. The effect is one of immediate identification. Fussing with little shadows here and there reduces clarity, so keep to the larger, more obvious shapes. For the face, describe the planes to establish solidity. Paint in the eye sockets (*not the eyes!*) and shadows as they occur on cheeks and under the nose and lip. Smaller details are more appropriate for a portrait.

In a daytime street scene, the main light may come from overhead. When that happens, the forehead and the advancing plane of the nose will be light, and the flesh from the eye sockets to the chin will be darker. A face in this type of light will read immediately if a dark tone expresses the shadows in eye sockets, under the nose, upper lip and lower lip, as well as the shadows at the chin and down into the neck.

Students often make shadows on the face much darker than they really appear. I've had some paint them almost black, but it looks crude and unreal, and those spots stand out like little bull's eyes. Use a lighter value, and keep it subtle.

With overhead light, these areas are light-struck: the face; the shoulders, diagonals or horizontals, such as leading parts of arms and legs; possibly hands; the upper edges of things being carried. Observation will tell you what to do.

Avoid complicated renderings of light and shade. They weaken recognition of forms. When in doubt, tell yourself that less is more.

CITYSCAPES: THE PROBLEM OF BUILDINGS

I have painted a number of scenes of the city in which crowds of people are dwarfed by skyscrapers. The city gives me the feeling of a canyon in which the living inhabit the canyon floor. The tall structures have a commanding, overwhelming, some-times ominous presence. They look like the controllers, and the little figures, the drones. Sometimes the feeling varies, but I always focus my attention on the people in the street for my interest, color and excitement.

The buildings, like any other background from beach to park, serve only as settings for the stories developed around my figures. But, when you work from photographs of buildings, you have a problem. The camera distorts the images and makes the structures look like they're falling over. You can paint it that way, but that's not how the eye sees it. I like my buildings to look vertical. The leaning looks like reproduced photographs to me. So, if you're going to follow my example, straighten up the perpendiculars.

The other problem is mechanical—the curse of all artists. Just like Mrs. Gargle's famous 50-carat diamond ring. Showing it to her friend, she explained that it came with a curse. (The curse happened to be *Mr. Gargle*.) This time, the curse is perspective. Often, you can fake it. But when you're dealing with a number of buildings, the deception has to be acceptable.

If you need to resort to perspective layout, here's how. In two-point perspective, which deals with the face and the side of the building, remember that the horizon will always be at your eye level. If you're not

Union Square 88, 20″ × 28″
You can tell it's a hedge, but it's really just some phthalo blue, gamboge, cadmium yellow and red all scrubbed and spattered. I never try to make the greenery real. I put a hint of eyes in my dominant figures, but the background ones hardly have faces, yet they look just great. You don't need a lot of details to tell your story.

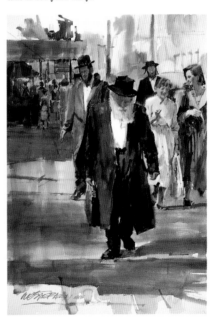

The Pishka Collector, 16″ × 24″
This is a Brooklyn scene. The central figure might simply be a scholar, but he reminded me of the small, bearded, kindly figures who went from house to house collecting pennies and nickels from the blue Pishka (charity) boxes for the poor. A number of shadows connect to my figures and make horizontal patterns in this vertical composition.

sure, you can find eye level by seeing where two lines converge, such as the roof line and the lineup of a lower row of windows. Extend those lines out. The point at which they meet is the vanishing point. There will also be a vanishing point for the faces of the buildings, but I don't bother with that one. It's the sides that are most obvious, as the illustration suggests. As I said earlier, the sides are always vertical.

Getting along without mapping out perspective is easier if the windows, exterior ornamentation, and the various other trappings of the

building are kept loose. I recommend this wholeheartedly. I try to suggest windows, and, in general, keep the structures fairly vague. I don't want to call too much attention to the buildings anyway, or they steer the eye away from my real center of interest—the people.

I also try to make my buildings dramatic. I often paint a dark side of the street and a light side, darkened doorways, and good blasts of neutralized color and strong shadows, if they're appropriate.

By moistening the paper before I start some building edges, I mini-

mize the outlines of my buildings where they may lead the eye out of the painting. This way, I soften the edges and keep them hazy. I often dampen the paper before laying on windows and other building ornamentation. I rarely color the sky in these scenes. If I do, you can bet the color won't attract attention.

A last word. Don't mix straight lines made with a ruler and freehand ones in the same painting. Use one or the other. The mix looks like a mistake.

DEMONSTRATION
Painting a Cityscape

This is the rough that shows buildings on the dark side and a lighter side of the street; figures occupy a darkened base. The sky will be left white, as if there were a bright haze.

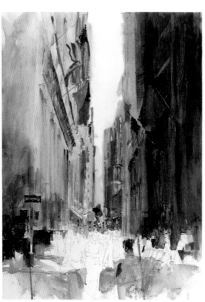

Step 1. I have penciled it out and put in some frisket for some nice, light details, but that turned out to be a mistake. As soon as I laid in my darks with ultramarine blue and burnt sienna and removed the frisket, the details looked too busy. I just wanted a feeling in the buildings, not a real copy. The lighter side of the street is predominantly purplish—manganese blue and phthalo crimson.

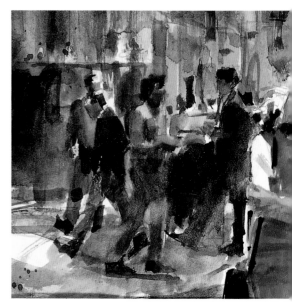

Step 2. Another example of chunking in secondary figures. You want those characters to be there but not important. See? Drop in an overall tone, and put them into it. You can always carve out light-struck portions with a wet brush and a tissue if you want. Make figures with dashes for heads and broad strokes for bodies, and try to lose portions of them in each other or in the background.

Step 3. My central figures are more carefully painted. These figures came from two separate photos, neither of which were on this street, but they expressed in the most direct way the feeling I wanted to convey of "people who get things done." Notice how I grounded my central figures by tying the gray in her costume to the background, and losing part of the man's suit in the color of the street.

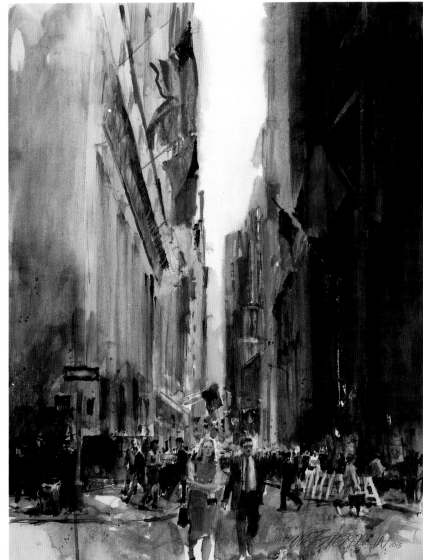

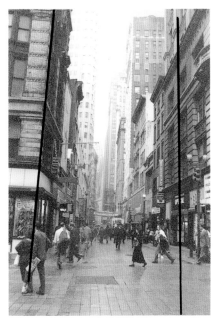

An example of camera distortion. The higher you point the camera, the greater the distortion. It makes the buildings look as though they are going to fall into the street. The eye sees them as vertical, so paint them that way.

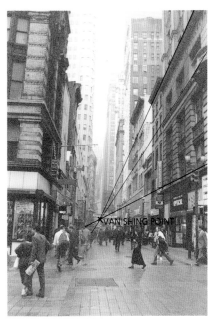

VANISHING POINT

Wall Street, 28″ × 21″

Not a very original name, is it? I made one final change in the painting when I found that the white of her blouse and the white I left around her were making her look too strong for the painting. I washed some blue over that portion and into the man, and it wound up looking more homogenous and acceptable.

If you're not sure of the vanishing point for drawing details in your buildings, draw a couple of lines from the roof or a line of windows, and where they meet is the point where all others should meet.

OTHER BACKGROUNDS

If your setting is trees and greenery or flower beds (in fact, this suggestion might apply anywhere), keep it simple. If there are trees, soften the interesting limbs and foliage. Keep the greens and browns neutral backdrops to your action.

The same applies to flower beds. Focus on flowers and they become too interesting, and it's hard to see anything else. For greenery in general, don't be afraid to create shadow shapes that can be used to lead or draw attention to your figurative action. The shadows can also neutralize details that are otherwise intrusive.

Summer Afternoon, the Tuileries, 24" × 36"
I certainly didn't make the landscape interesting, but I think the monument may be more distracting than it seemed when I painted it. I suggested a light area in the trees behind the sculpture to make a vertical connection in the painting. The thing I did best was to give lots of sparkle to my figures, using the white of the paper for light-struck areas.

Crown Heights (or a Butcher and a Baker)
22" × 28"
Another cheerful composite painting in which figures have been borrowed from other scenes. My focal point is isolated by white space. The elements on both sides of the painting are strongly connected to larger shapes to make a good design.

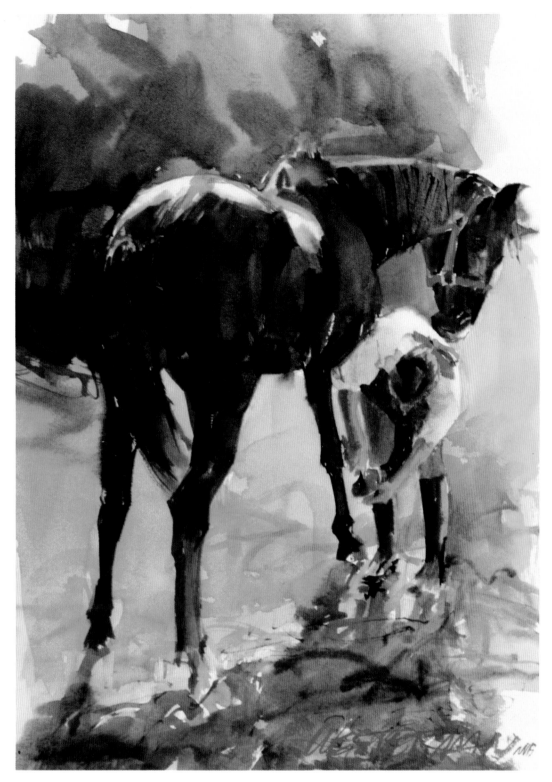

OUR FOUR-LEGGED FRIENDS

Dogs and cats add interest to our figurative scenes because pets are so much a part of our lives. But unless they are really central to our action, the trick of using them in a painting is to remember that they serve only as accents.

Make sure the *form* of the animal is recognizable. Shape is more important than features. If the photograph or sketch isn't revealing enough, pose an animal to give you a recognizable shape.

If it's a cat you need, borrow the neighbor's. Use a can of tuna to get the cat to hold still, then sketch or shoot some quick photos. In your painting, don't make the cat so fuzzy that the viewer can't identify it. Make sure it has good structure, and keep the coloration fairly flat. Avoid details. Don't let the animal receive more attention than it deserves.

Tying It All Together

The Kiss, 20″ × 28″

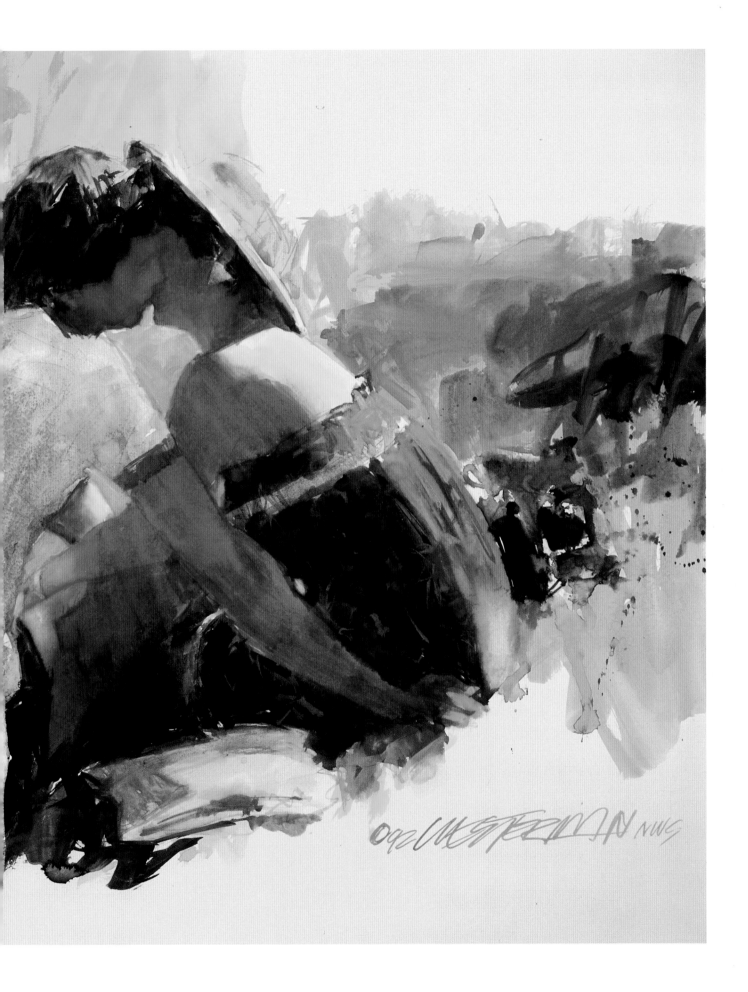

How to Be Your Own Best Critic

Most times, you know when you have a good painting. If you have a well-composed rectangle, a single center of interest, good shapes and readable values, you're pretty much in clover. But sometimes the painting just doesn't feel right, and you don't know what's wrong or whether it can be saved.

Of course, you could always ask your teacher or another artist you respect, but don't ask your family or friends. They won't want to hurt your feelings, or they won't know anyway.

Instead, try on a second hat in which you are the show judge who has just rejected this piece. As the judge, it's up to you to tell the sensitive artist (also you) what didn't work and what might be done about it. Are you ready to play both parts objectively? Start with these eight questions.

EIGHT PROBLEM-SOLVING QUESTIONS AND SOME SOLUTIONS

1 Is there a good idea here? Or, has this painting been done a hundred times? How is this one much different from the last ninety-nine? Is it boring, or is there something unique that might be developed?

Solutions: Take a chance. Look for ways to take this piece out of the realm of the commonplace. Try more-exciting colors; crop; use chalk or crayon to make it a mixed-media piece; paste scraps of paper on it and create a collage. Look at the work of other artists and come up with new ideas. Ask yourself, What would Sargent or Rembrandt or Diebenkorn do with this one?

2 Is there a cohesive rectangle? Or, is there a scattering of isolated parts? Is there a real or suggested connection to all four sides of the rectangle?

Solutions: Try connecting isolated parts. Try making some vertical, diagonal or horizontal thrusts to the top and/or sides of the painting.

3 Is there one dominant idea expressed by shape, color, value? Or, are other elements drawing attention away from the primary focus and confusing your spectators?

Solutions: Make sure there is a center of interest and that all other elements are truly subordinate. Reduce or eliminate unnecessary details or portions that are attracting more than their share of attention. Wash off or tone down competing elements.

FOUR QUICK WAYS TO SPOT A PROBLEM

1. Try squinting. It blurs details so you see only the major shapes in the painting. Something out of balance? Bad placement of elements? Is there a cohesive rectangle?

2. Turn the painting upside down. Or, try reflecting it in a mirror to see it in a different way.

3. Crop the painting. Try moving two halves of a mat around to cut out wasted space and focus interest.

4. Come back later. Leave the problem painting and work on another. The problem and possible solution may be more apparent with time.

4 Is there a balance of color? Or, is there an isolated color drawing more interest to itself than it merits?

Solutions: Neutralize any overwhelming color that is inconsistent with the painting. Repeat colors in the painting.

5 Is there a balance between positive and negative space? Or, does the painting appear to be weighted too far to one side as if it were ready to tip over?

Solutions: Add more positive space or scrub some off. Add some texture, and create a larger negative area. Try some judicious cropping.

6 Does the painting have an entrance and an exit? Or, does it leave the viewer hanging?

Solutions: A line or gradation of tone can be used to bring the viewer to your focal point. A window, door, or a bit of sky offers a nice exit.

7 Do the figures look like they belong? Or, do they look like cutouts?

Solutions: Look for adjacent light or dark colors in the background that you can connect to the lights or darks of your figures. Invent new shapes.

8 Are your backgrounds really backgrounds? Or, do they draw too much attention? Does a background color, interesting shape, or a scattering of eye-catching objects interfere with your focus or cause conflict?

Solutions: If the background features competing structures like little white roofs, interesting, sharply defined figures that are of little or no importance except as part of a crowd, then go for the kill. Mass the figures in a neutral color, wash off some of the detail, and see if that helps. Darken rooftops that attract unwarranted attention even

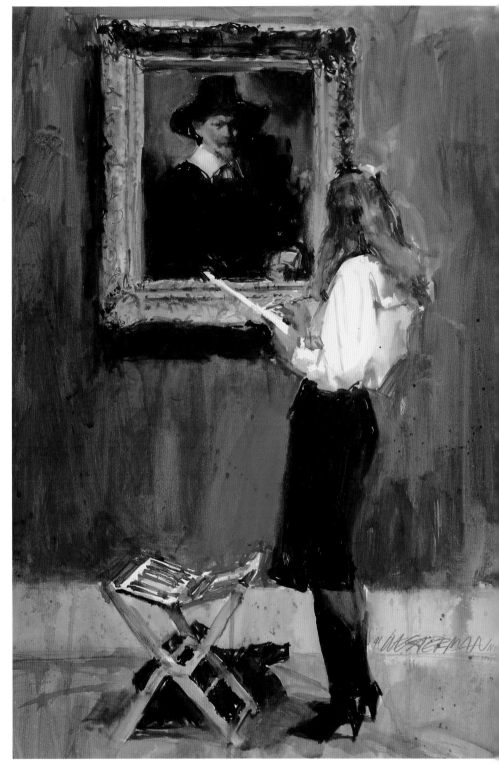

Man With Glove, 27″ × 20″

though reality says they could be white. Lose interesting lines that interfere. Wash them off or cover them up. You can always restate them if need be.

Six Things to Remember

and sixteen rules to forget

When I first started painting in watercolors, it seemed every self-help book I turned to had important rules designed to keep me out of trouble. In time, I found out that many rules dealing with technique or style would change and could easily be dismissed. The real rules that will never go out of style are simply ones grounded in common sense. I've listed the ones I think you need to live by, and the ones you can use for the bottom of your bird cage.

REMEMBER THESE

1 *Paint only those things you feel connected to.* Your viewers will sense your commitment or lack of it. That goes for commissioned portraits and landscapes, too.

2 *Consider the uniqueness of your idea.* What approaches can you take to make your finished work feel fresh? Express your concept and feelings in a new and different way.

3 *See your work as a rectangle,* not as a person or thing in the middle of a rectangle. If it won't hold together as a rectangle, it won't matter how well you did Aunt Milly's face. It still won't be a painting.

4 *Simplify!* Use only those details that help you tell your story.

5 *Use light like a film director.* Don't waste it. Make it move your audience. Make them feel what you want them to.

6 *Use color with boldness.* Don't whisper when you can sing. Don't be afraid to use colors that surprise and shock. That's why you're a painter, not a mortician.

FORGET THESE RULES

1 *Be careful to avoid "ouzles" in your painting.* Don't worry. I remember reading about these nasties and was very careful to avoid creating water spots. Now I work hard to build them into my paintings. Drops of clear water splashed on damp colors add texture, curious and wonderful separations of pigments. It's one of the exclusive qualities of watercolor.

2 *Design is simply a matter of picking the right formula.* Not really. There are some basic structures, but most times the subject suggests its own design. Just keep it simple. My designs just build as I work my elements into interesting arrangements.

3 *Watercolor is an unforgiving medium.* Nonsense. It's one of the most flexible mediums—particularly if you use a good hot-press paper, Bristol board, or some cold-press papers. You can paint, wash it off, restate and wash again.

4 *Expensive brushes are better and last longer.* Not necessarily. I used to think sable was like diamond—forever. The Kolinskys I bought didn't last any longer or hold their points any better than my good-quality, plastic filament bristles. Experiment a little to find brushes just right for you.

5 *Paper must be stretched before painting.* Not true. Taping down 140-lb. or lighter paper with masking tape keeps the paper as flat as it needs to be. Three-hundred-pound paper stays flat nicely when taped at the edges.

6 *Don't use opaque white paint. That's cheating.* A silly rule aimed to prove how difficult it is to paint in "transparent water-color." The Old Masters used white paint. Many of our best colors like cerulean blue; the yellow, red and orange cadmium colors; and yellow ochre are as opaque as white.

7 *Always erase your pencil lines.* Not necessary. Leave them in. It shows how you think, makes your work more human, and adds interest and texture.

8 *Be careful with the paper's surface.* I remember reading that you shouldn't erase too much or you might damage the surface. Good watercolor paper can take a lot more abuse than that—scrubbing, bristle brushes, anything, as long as you don't go through it. It's the results that count.

9 *Be neat and tidy.* Wrong. Be as messy as you always dared to be. You're an artist now. Fingerprints, pencil marks, erasures, all can add interesting textures and contribute toward your crazy, wild-animal artistic reputation.

10 *Don't waste film, paint, paper or other supplies.* You can't hoard your supplies and learn anything. Better to waste film than lose a great shot. Paint and paper are cheap and meant to be used.

11 *Don't paint from photographs.* Paint on the scene or work from photos. Go either way

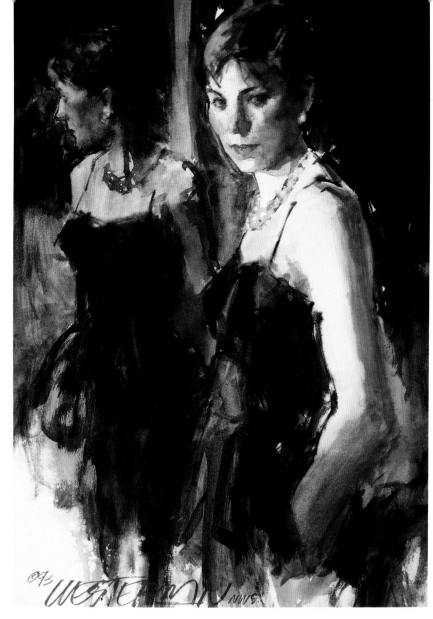

The Necklace, 21" × 14"

without guilt. Live action will give you a bigger image and a better idea of true colors, but most artists also work from photos that allow them to merge images and create their own colors.

12 *Always work light to dark.* Not true. It's a little safer, but not as exciting as it is going back and forth. Paint some lights, then add darks to see your contrasts develop as you go.

13 *Make every brushstroke count.* No. If you're worried that each brushstroke has to be perfect, you'll play it safe, not learn any-

thing and go nuts.

14 *Watercolor requires tremendous control.* Not true. If you don't like it, wash it off.

15 *Don't paint a vertical subject in a vertical format.* Not necessarily. This style is pretty standard for portraits. Just be sure there are good vertical and horizontal connections to make the piece cohesive.

16 *Always stay inside the lines.* The term "crossing the line" suggests adventure. We have to get over our habit of treating lines as sacred.

Ten Ways to Get Unstuck

Why write about getting unstuck when this book is supposed to make you happy as a clam and successful? Well, consider painting, like writing, a lesson in humility. To grow as an artist, to go past your present limits, you have to take chances that aren't always productive. But, with every chance you take, you learn something whether you succeed or fail. If you play it safe, you learn nothing but fear of the unknown. Failure is as much a part of the life of an artist as success.

In this book, we have explored ways to avoid problems by working in progressive stages; and once you've hit problems, how to change things by scrubbing and lifting. But what happens when a problem won't resolve itself, or you get a rejection from a show, or a gallery owner says, "No thanks," and you want to quit?

Everyone is going to hit the wall at one time or another. The question is, "What are you going to do about it when it happens? Well, you might try these Dr. Westerman prescriptions, guaranteed to work.

1 Visit an art museum. There's nothing like seeing originals in all their glorious color, which can never be duplicated in a print. Check out an art show in your area. Study the paintings that give you ideas and get you excited enough to go back to work.

2 Visit your library or bookstore to look over art books, or go through your own collection for ideas. Imagine how the artists you admire might have solved the kind of problems that are stumping you. Look for scenes, use of light, color, interaction of characters, and other interesting elements.

3 Get away from it all. Go to an art supply store. See what's new in brushes, paints, papers or whatever. Maybe you need

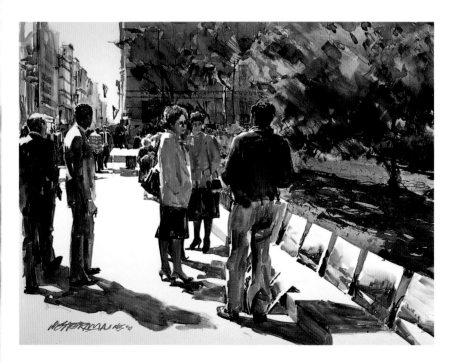

The Art Market, 24" × 32"

company to break the silence of creation. Have coffee with a friend. Sit in a park and watch people go by. Go to a movie. Play some music.

4 Go through old and current art magazines at your nearest dealer. Get some ideas. Look even at the really awful stuff that appears regularly and tell yourself, "I can do better than that with my eyes closed."

5 Return to that painting you put aside long ago, and see if it somehow doesn't look better than you first thought.

6 Try something you don't normally do. Paint something just for fun. Do a nice, loose, washy watercolor. Use colors you don't normally use. Use cool colors where you might normally use warm ones and vice versa. Play with the paint; see what happens. Loosen up. Don't try for perfection. Have some fun. After all, that's what it's all about, isn't it?

7 Try different papers. If you find that beautiful, white piece of watercolor paper before you too intimidating, remember, it's only paper. And both sides are the "front."

8 Attend a workshop. That usually will get the motor humming again. Maybe you need a fresh slant. It's also a lot of fun to be around people who share your interest. To find workshops, look over artist's magazines or ask your local art society for listings.

9 Go through old photographs you haven't attempted before and tackle one.

10 Get started. Don't wait for inspiration. Bob Kaller, whose galleries I started with in San

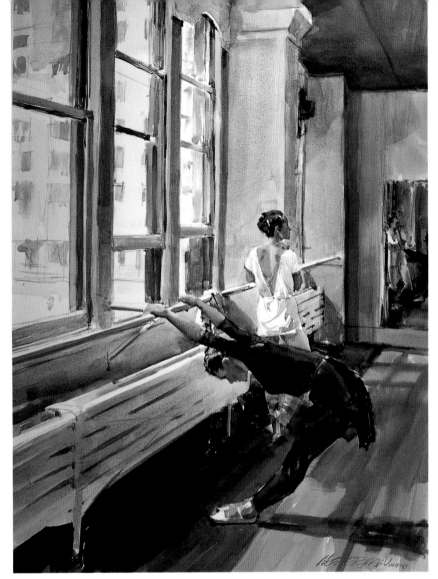

New York Conservatory, 36" × 23"

Francisco and Carmel, told me if I was going to be a painter, I would have to paint every day. No exceptions. No waiting for inspiration. Same goes for you.

Take that as basic truth: You can't wait until you feel good to paint, or when you are truly inspired, or until you are ready to do the ultimate masterpiece. You've got to paint every day—whether you want to or not. Spend a little time doing whatever it takes to help you go back to work when you are frustrated, hit a block, or have just thrown away (literally) a day's or a week's time with what looks like a loser.

Enough time wasted. Shoulders squared, smile on lips, brush in hand. You're an artist. Go to work!

Dealing With the Gallery

To get gallery representation, your first task is to make a thorough search of galleries in your area. Make sure you know the ones who can and do sell your kind of work. Obviously, dealers who specialize in big, abstract oils are less likely to sell smaller watercolors. That doesn't mean they can't. They're just not primary prospects. Try for the best possible.

Don't ask dealers for the names of other appropriate galleries where you might show your work. In my experience, they don't know or don't want to take the time to give you good information. Find out on your own.

Once you've compiled your list, you'll have several options available for getting established with a gallery. You can send a letter with several slides and a self-addressed, stamped envelope. In your letter, briefly describe why you want that particular gallery representation and what you can do for the gallery. Enclose any supporting material about you, such as brochures, prints, reviews, etc. Address it to the owner (make sure you get the proper name and title), and ask for a convenient get-together time when you can show your paintings.

Include a one-page resume or biography. Make sure your slides are identified by your name, image size and title, and are protected by a plastic sleeve.

Or, consider the more direct approach. I took my slides and expectant, happy face to thirty-four consecutive dealers and learned thirty-four different ways they could say, "No thanks." But the next time, I had a few paintings in the trunk of my car. I asked at two galleries if the owners would like to see my paintings. One said no. The other took three of the six I showed and asked for more, and the relationship lasted for twelve years, until the owner's death. So, what's the moral?

I obviously favor the more direct contact. Go at a slack time when you're not in the way of customers. Have at least five or six paintings to show your range, and ask the dealer when it would be convenient to look them over. Bring a bio and other pertinent material.

You also have to learn not to take rejection personally. If the dealer says "No thanks," she isn't saying you're bad. She's just telling you in her own way that she doesn't think she can sell you.

YOU AND YOUR GALLERY NEED EACH OTHER

Don't misunderstand. I'm 100 percent for the gallery system. It can be fair to both artist and dealer. Running a gallery is an expensive proposition. Your surroundings have to look uptown, and you have to be in the right place geographically to attract the right sort of collectors. The price of real estate and rents in that kind of setting is high.

One dealer told me that it cost him twelve dollars per nail per day to hang a painting. Maybe it costs more today. Also, dealing with the public can be exhausting. In short, he deserves his money.

In the meeting when you are showing your paintings, don't be bashful about prices or the value of your work, or what you can do for the gallery and why you want to be represented by it. Talk about your paintings objectively, as if you were an agent rather than the sensitive creator.

You and the dealer both need each other. He needs salable art, and you need representation. If he thinks he can sell you, he'll be interested.

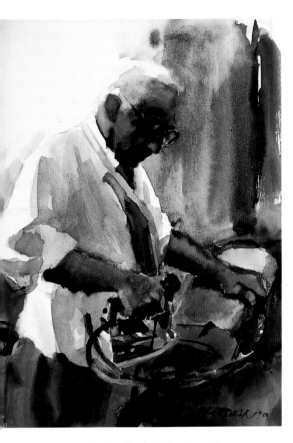

Heinz Jacob, The Tailor, 15" × 11"

If he doesn't, try elsewhere. If he's going to handle your work just to be nice to you, neither of you is going to get anywhere. You'll wind up in the stacks, and he'll waste storage space. He has to really want you to successfully sell you. So don't worry about getting your feelings hurt. It's only business.

AGREE ON A CONTRACT

Now that you've been accepted, there are a couple of things to include in the mix. A firm contract that spells out the duties of both parties. Write *The Artist's Magazine* for a copy of a generic contract if your gallery doesn't supply one. There should be a contract for the benefit of both parties because it saves misunderstandings and allows a smooth flow of business. If the gallery is reluctant, explain the benefits. If the dealer says no, go elsewhere. It sounds suspicious.

On that note, if a dealer wants your work, find out something about her reputation. Ask the artists she represents. Ask if she pays promptly. Find out about her financial standing. It's no honor to be with a gallery that is about to go under, tying up your paintings in litigation.

If you are accepted, you'll find out there's also a nice piece of serendipity connected with a good gallery. Dealers from other cities visit each other and see your work. Don't be surprised if a dealer from Omaha tells you he saw your stuff in San Francisco and would like to represent you.

KEEPING TRACK OF PAINTINGS

Keeping track of paintings is an important function. I use a combination of slides and prints for identification. On a 3x5 card, I list a number I assign to the painting, the year painted, the title, size of image, framed size, the price, the gallery or galleries where the painting is or has shown, and when sold. Ask the gallery to include your numbers in their statement of paintings they sell.

Also ask your gallery to provide you with the names of your collectors as purchases are made. It's the law, anyway. I am now in the almost impossible process of compiling a list of collectors and the titles of my paintings they own. I should have done it long ago, but learned my lesson when the owner of some galleries where I exhibited failed to supply me with the names of my collectors. After his death, there were literally no usable records.

Some dealers fear that if an artist knows collectors' names, he will circumvent the dealer and sell directly. I don't begrudge a dealer her suspicion, but an artist who does engage in unethical practices is both untrustworthy and foolish, because it's hard to keep secrets. His reputation for dealing under the table will eventually come out in the open, and a dealer with any sense will refuse to develop a market for him.

On the other side of the coin, a dealer is expected to play fair, too. Her records, including the list of buyers, the paintings they bought, and the prices they fetched, must be open to the artist. Usually the artist establishes the price with the agreement of the gallery. The artist has the right to see that his prices are adhered to in sales of his paintings.

An arrangement between a gallery and an artist is a partnership in every sense of the word. The gallery needs the art, and the artist needs the outlet. Mutual trust is at the core of a successful relationship. Sometimes you get burned; most times not. If you can't trust each other, get a good contract, know a good lawyer, or get out of the gallery.

PRICES ARE A TWO-WAY STREET

What price art? How do you fix a value on your work? One way is to set your work at the lowest possible price to get started. Another is to make it consistent with the quality of work you see in the gallery. You make the choice, but a good gallery owner will help with suggestions.

In the typical price structure, the gallery takes about 50 percent of the gross price agreed upon. On occasion, I have heard of galleries taking two-thirds of the retail price. That works this way: The dealer asks the artist for his net price, then doubles or even triples that amount. A painting that returns $1,000 to the artist becomes a $3,000 sale. The gallery gets the difference.

The only saving grace is that the gallery gets twice as much. But the gallery creates a market for $3,000 paintings. When the market builds, the artist has gained a reputation, and his paintings sell at a high price. The gallery probably isn't going to say no and lose a good source of income if the artist says he's not satisfied with the arrangement and wants half instead of a third.

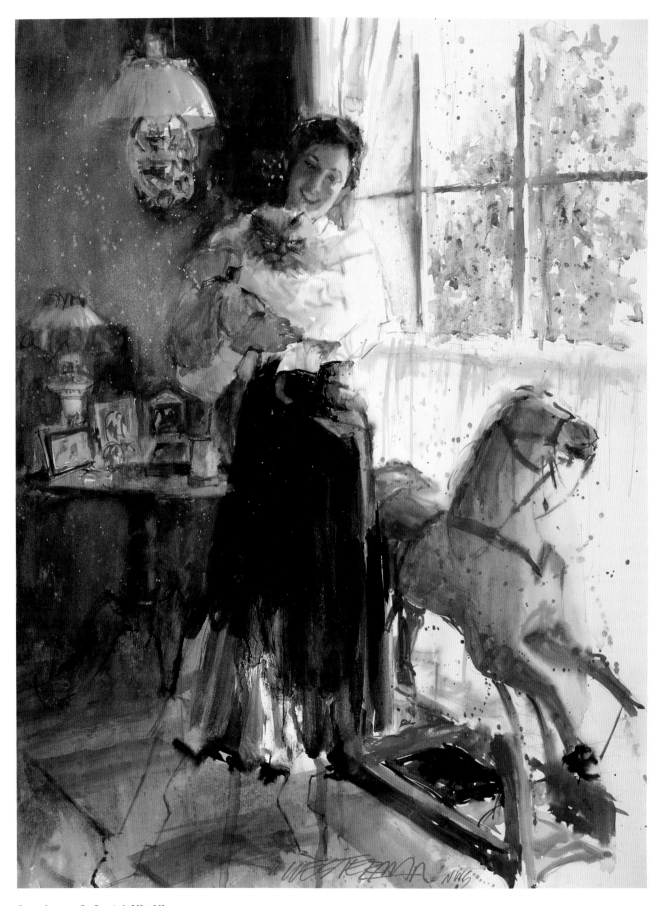

Cyrus Loves to Be Carried, 20" × 20"

A Few Parting Thoughts

Over the years, I have asked watercolor painters about their backgrounds. I can count only a small number who received academic art training and then became professional artists.

Almost all of us have eclectic backgrounds. We might have expressed an interest in art as children, but we spent most of our adult years in other occupations. And now we're racing against time to paint with some facility, pictures flying around inside our heads waiting to be freed. To make our present ability approach our aspirations takes ambition, training, a desire to take risks, to explore, to endure failure, and to hope for success.

It is this need that calls us to attend workshops, to experiment, to practice drawing, and to find forgiving watercolor materials and methods that work best with our limited time and training.

DON'T WAIT FOR TALENT TO COME KNOCKING AT YOUR DOOR

Don't envy anyone else's talent. You've already got more than enough for this job.

Sometimes I get the idea that a lot of people think the dividing line between a good painter and a lesser one is talent. The ones who believe they lack the talent give up before they begin to test their uniqueness.

Talent is overrated. The most talented are often lazy, because things come too easy for them. They don't have to work hard at their craft. Actually, where talent is well distributed in a family, the least talented often become the most successful. Ambition, determination, and just plain hard work can more than compensate for a lower rating in the talent department.

One study found that some of our greatest entertainers, for example, were the least talented members in their families. They just had the drive.

SO YOU DON'T DRAW LIKE NORMAN ROCKWELL?

Jackson Pollock had two brothers who drew better than he and were making a living in commercial art while he was struggling for a buck. Pollock could hardly draw his way out of a paper bag, yet he is the one who will be remembered for his unique contribution to art.

Van Gogh ridiculed his own ability. He didn't think he could draw, let alone paint. He capped a lifetime of confusion with some of the greatest works ever created.

Whistler took a long time painting portraits—sometimes up to a year. It drove his sitters crazy. Part of the reason was that his drawings were often out of whack, and he spent a lot of time reworking, trying to get them back. Genius, yes; absolute perfection, no.

What's the point? You don't have to draw or paint like someone else to succeed. Just register your feelings and express your perspective.

Don't be a Rockwell. He already did it. Your figures can be as distorted as it takes to make a statement. Little heads, big bodies, exaggerated gestures, faceless figures— anything goes to express emotion and build a good design.

What we lack in talent and training, we make up for in rich, personal experiences that give color and meaning to our observations.

Suggested Reading

Armand Hammer Foundation. *Honore Daumier*. Los Angeles, 1981. Catalog of the exhibition of the Armand Hammer Foundation. Look how he exaggerated gestures to immediately convey the feelings of his characters.

Blake, Wendon, and Croney, Claude. *The Complete Watercolor Book*. Cincinnati: North Light Books, 1989. About painting landscapes, it makes a good source for figurative backgrounds. Croney is a master.

Clarant, Jane. *Los Genios de la Pintura Espanola, Sorolla*. Madrid: Sarpe, S.A. de Revistas, 1983. Written in Spanish. Reproductions of paintings are excellent for this master of sunshine.

Clifton, Jack. *Eye of the Artist*. New York: Watson-Guptill Publications, 1984. Easy reading, well illustrated, short and sweet. This has everything you want to know in a nutshell, from basic shapes to perspective, drawing, shadows and everything in between.

Collins, Amy Fine. *American Impressionism*. New York: Gallery Books, Div. of W.H. Smith Publishers, Inc., 1990. Printed in Spain and beautifully illustrated. Look particularly for Cecilia Beaux and her painting, *Ernesta (Child with Nurse)*.

Easton, Elizabeth Winne. *The Intimate Interiors of Edouard Vuillard*. Houston, 1989. Published for the exhibition at the Museum of Fine Arts.

Friend, David. *Composition*. New York: Watson-Guptill Publications, 1975. A standard class workbook.

Gombrich, E.H. *Art and Illusion*. New Jersey: Princeton University Press, 1972. The history of pictorial representation, changing styles, psychology. Imitating nature is just an illusion, and if you want to know why, this is the book for you. Thoughtfully written and illustrated to hook your imagination.

Gruppe, Emile. Edited by Charles Movalli. *Gruppe on Color*. New York: Watson-Guptill Publications, 1979. Mostly landscape, some figures, but good ideas on color theory and approaches.

Harrison, Helen A. *Larry Rivers*. New York: Harper and Row, Publishers, 1984. Very expressive, figurative images. Look how much he can leave out of his paintings and still say everything we need to complete his images.

Henning, Fritz. *Concept and Composition*. Cincinnati, Ohio: North Light Books, 1983. An understandable approach to making paintings work.

Henri, Robert. *The Art Spirit*. New York: HarperCollins Publishing, 1984. The supreme teacher and his ideas and feelings on art.

Hoopes, Donelson F. *Sargent Watercolors*. New York: Watson-Guptill Publications, 1976.

Levine, David, and Buechner, Thomas S. *The Arts of David Levine*. New York: Alfred A. Knopf, Inc., 1978. If you already have a copy, you're lucky; otherwise, get one. His work is something you should look at regularly.

Milner, Frank. *Degas*. New York: Gallery Books, W.H. Smith, Publishers, 1990. Wonderful, large illustrations; good color.

———. *Toulouse-Lautrec*. New York: Smithmark Publishers, Inc., 1992. Great ideas, colors, designs.

Nicolaides, Kimon. *The Natural Way to Draw: A Working Plan for Art Study*. Boston: Houghton Mifflin Co., 1990. The absolute best book with lesson plans for learning and sharpening your drawing skills.

Nordland, Gerald. *Richard Diebenkorn*. New York: Rizzoli Intl. Publications, Inc., 1987. His color sense is electric, and his designs are inspirational.

Peel, Edmund. *The Painter: Joaquin Sorolla y Bastida*. London: Phillip Wilson Publishers, Ltd., 1989. The paintings don't have the vivid color or snap as those in Clarant's book; however, the text is in English for the language-impaired.

Poore, Henry Rankin. *Composition in Art*. New York: Dover Publications, 1976. Short, clear, easy-to-follow manual on composition.

Powers, Alex. *Painting People in Watercolor*. New York: Watson-Guptill Publications, 1989. One of the best for good ideas.

Preston, Stewart. *Vuillard*. New York: Harry N. Abrams, Inc., 1985. A concise edition by Preston, printed in Japan by Thames and Hudson, Ltd., London.

Ratcliff, Carter. *John Singer Sargent*. New York: Abbeville

Press, 1986. Many excellent illustrations.

Reid, Charles. *Portrait Painting in Watercolor*. New York: Watson-Guptill Publications, 1973. All Reid's book are good, and he's one of the best.

————. *Flower Painting in Watercolor*. New York: Watson-Guptill Publications, 1979.

————. *Portraits and Figures in Watercolor*. New York: Watson-Guptill Publications, 1984.

————. *Pulling Your Paintings Together*. New York: Watson-Guptill Publications, 1985.

Roberts, Marie MacDonnell. *The Artist's Design: Probing the Hidden Order*. Walnut Creek, CA: Fradeama Press, 1993.

San Francisco Museum of Modern Art. *Wayne Thiebaud*. San Francisco: 1985. Colors so rich and juicy. Look how he juxtaposes colors to make them vibrate. Wonderfully imaginative San Francisco street scenes that actually make you dizzy. Well worth studying.

Sarabyanov, Dmitri, and Arbuzov, Grigory. *Valentin Serov*. New York: Harry N. Abrams, Publishers, 1982. Absolutely masterful portraits. A turn-of-the-century Russian master who truly captures and projects the feelings of and for his sitters. Of the many, I can't get over his *Girl With Peaches* and his portrait *Nadezhda Derviz and Her Child*. Fantastic!

Schroeder, Alan. *Ragtime Tumpie*. Boston: Little Brown & Co., 1989. A child's book with great paintings by Bernie Fuchs. Look at his wonderful lost and found edges, dynamic color and fantastic animation.

Silverman, Burt. *Breaking the Rules of Watercolor*. New York: Watson-Guptill Publications, 1983. A great artist and a wonderful writer.

————. *Painting People*. New York: Watson-Guptill Publications, 1977.

Stuckey, Charles F. and Scott, William P. *Berthe Morisot—Impressionist*. New York: Hudson Hills Press, Inc., 1988. Her painting *The Cradle* knocked me over. Her work is still fresh as ever. Find the freedom in your watercolors that she exhibits in her oils.

Thomson, Belinda. *Vuillard*. New York: Abbeville Press, 1988.

Whitney Museum of American Art. *John Singer Sargent*. New York: Harry N. Abrams, Publishers, 1985. A retrospective at the Whitney with essays that dig deep into the work and the mind of the man.

Wilcox, Michael. *Wilcox Guide to the Best Watercolor Paints*. Cincinnati, OH: North Light Books, 1991.

Willis, Lucy. *Light: How to See It, How to Paint It*. Cincinnati, OH: North Light Books, 1991. Includes excellent paintings by John Ward, Doug Dawson, Charles Sovek and Andrew Macara.

Wolfe, Tom. *The Painted Word*. New York: Farrar, Straus & Giroux, 1975. A hilarious look at the hype art world by a master iconoclast.

Young, Mahonri Sharp. *The Paintings of George Bellows*. New York: Watson-Guptill Publications, 1973. Beautiful reproductions of a skillful reporter. Look especially at the eyes of *Lucie* and see the whites painted blue! There's a lesson to be learned from his later paintings, in which he watered down his natural ability by getting embroiled in obscure theories of design and color.

Index